Art and Rivalry

Art and Rivalry

The Marriage of
Mary and Christopher Pratt

CAROL BISHOP-GWYN

ALFRED A. KNOPF CANADA

PUBLISHED BY ALFRED A. KNOPF CANADA

www.penguinrandomhouse.ca

Library and Archives Canada Cataloguing in Publication

Title: Art and rivalry : the marriage of Mary and Christopher Pratt / Carol Bishop-Gwyn.
Names: Bishop-Gwyn, Carol, author.
Identifiers: Canadiana (print) 20190129336 | Canadiana (ebook) 20190129344 |
ISBN 9780345808424 (hardcover) | ISBN 9780345808448 (HTML)
Subjects: LCSH: Pratt, Christopher—Marriage. | LCSH: Pratt, Mary, 1935-2018—Marriage. |
LCSH: Pratt, Christopher. | LCSH: Pratt, Mary, 1935-2018. | LCSH: Artist couples—Newfoundland
and Labrador—Biography. | LCSH: Painters—Newfoundland and Labrador—Biography. |
LCSH: Printmakers—Newfoundland and Labrador—Biography. | LCSH: Newfoundland and
Labrador—Biography. | LCGFT: Biographies.
Classification: LCC ND249.P7 B57 2019 | DDC 759.11—dc23

Text design: Jennifer Griffiths
Cover design: Terri Nimmo
Cover images: (wedding photo) courtesy of the Pratt family; (watercolour drops) © Shelly Still,
(blue paint) © Pinghung Chen/EyeEm, both Getty Images
Interior image credits: All photos are used courtesy the Pratt family collection, except "Donna
posed with Christopher . . . ," "Cristopher Pratt communing . . . ," "Daughter Anne Pratt . . . ,"
courtesy of the late John Reeves; and "Opening reception. . . . ," "Family gathered to honour . . . ,"
"Anne, Mary and Barby . . . ," "Christopher with Donna Meaney . . . " courtesy of the author.

Printed and bound in Canada

10 9 8 7 6 5 4 3 2 1

Penguin
Random House
KNOPF CANADA

To Penelope Grace and Edward Oscar,
Works of art.

Contents

Preface

CHRISTOPHER PRATT WROTE *the slogan "Life is not a rehearsal" on his studio wall. This stark warning was meant to remind him that we are given only one chance at life and so should live our lives to the fullest. Rather than be passive and indecisive—and he was guilty of both at times—we must not fear change. Most people find change difficult, and this is especially true of Christopher Pratt. The celebrated painter leads a cautiously prescribed life. His late wife, the painter Mary Pratt, avoided change also, but did so less by prescribing the conditions in which she raised their four children and pursued her art than by ignoring certain unpleasant realities about their marriage. Despite their reticence in facing difficult issues in their personal lives, they boldly assumed places on the public stage and became two of Canada's most successful visual artists of the late twentieth century.*

·

MARY PRATT CROSSED the wooden bridge over a little stream that ran between her house and her studio, which sat deep at the back of a rural Newfoundland property. She carried a tray of

photographic slides handed to her moments before by her husband. Over more than a decade spanning the 1960s and '70s, Christopher Pratt had shot dozens of nude studies of a local girl, Donna Meaney, chronicling her change from naive teenager to sexually aware woman. Originally hired as the family's live-in domestic helper, Donna had eventually taken the role of Christopher's studio model and muse.

By the mid-1970s, like so many outport Newfoundlanders, Donna and her family began to seek work outside their community. The Meaneys went to Labrador. Donna flitted back and forth, and during her sojourns back to Mount Carmel—and much to Mary's annoyance—she spent a great deal of her time with Christopher in his studio. When her visits became less frequent, he hired other local girls to draw and paint. He was left with these images of Donna.

Christopher told his wife he no longer needed these slides because he now preferred to work with a model in person. Mary had recently developed her photorealist technique of projecting slides onto a canvas in order to create an image to paint, and he wondered if she had any use for this collection. If not, he would destroy them.

Mary took these Kodachrome transparencies, spread them across her light box and studied them. The slides of the attractive, full-breasted girl, unashamed of her nudity and looking directly at Christopher as he snapped pictures, confirmed what she already suspected: Donna and her husband had been lovers. In offering her these images of his naked muse, was Christopher oblivious to her awareness of the affair? Perhaps he knew very well and was trying to make a point. Regardless, Mary decided to take up Christopher's challenge and use the slides.

Artist couples have famously shared models, or at least similar subjects, before. The late art critic John Berger suggests that the American abstract painters (and spouses) Jackson Pollock and Lee Krasner, for instance, used their treatment of closely related subjects to talk to each other. In reviewing an exhibition of the couple's works, he wrote: "He paints an explosion: she, using almost identical pictorial elements, constructs a kind of consolation."[1] But for Mary to paint a woman she knew to be her husband's lover sent a radically different sort of message between spouses. Art historian Victoria Scott has described what followed Mary's acceptance of the slides as "an awful Canadian melodrama."[2] Mary Pratt was always self-referential in her work, and with her ensuing Donna paintings she set out to prove to the art world and her husband that she was the superior painter, more powerfully capturing the essence of Donna's sexuality than Christopher could.

Christopher had never escaped his reliance on the mathematical constructs behind his highly structured images. In his student days at the Glasgow School of Art, he had learned to draw nudes in the classical style. But when he tried now to loosen up and sketch in a more personal, expressive manner, his figures coarsened with a tinge of the lewd. As with all their work, Mary's nudes were visceral and organic, Christopher's intellectualized and measured.

.

ALTHOUGH CHRISTOPHER AND Mary Pratt lived apart for over twenty-five years, their names remain entwined in the public imagination. They are recognized as that painter duo who lived together as near recluses in rural Newfoundland. Both soared to

fame in the Canadian visual art world while defiantly working in unfashionable realistic styles. Not only do their paintings hang prominently in commercial and public art galleries, but images rendered in their distinct but equally iconic styles have appeared on posters, book covers and even postage stamps.

Christopher's approach is ice; Mary's is fire. Christopher applied his spare, angular style mostly to depictions of architectural forms. The buildings, rooms and landscapes that are his most enduring themes are rendered in cool tones of grey and blue. Mary's photorealism celebrates the vividness of the domestic and ordinary—glowing, translucent jars of red, yellow and orange jams and jellies, or filleted fish lying on plastic wrap, ready for the frying pan.

The delicate balance between the need for solitude to make art and the close quarters required to raise a family or sustain a conjugal partnership is bound to add strain to any relationship between artists. The Pratts and Pollock/Krasner are only two among many married couples in which both partners enjoyed equally successful careers in visual art. Canadian contemporaries include Michael Snow and Joyce Wieland, Bruno and Molly Lamb Bobak, Paterson Ewen and Françoise Sullivan, and William Perehudoff and Dorothy Knowles. Across the Western art world, numerous couples, including Frida Kahlo and Diego Rivera, Pablo Picasso and Françoise Gilot, Barbara Hepworth and Ben Nicholson, Alfred Stieglitz and Georgia O'Keeffe, have fascinated art enthusiasts.

The book *Artists in Love: From Picasso & Gilot to Christo & Jeanne-Claude: A Century of Creative and Romantic Partnerships* by Veronica Kavass expresses this problem succinctly. Mixing art and love "makes for an insanely volatile cocktail of madness,

masochism and mayhem. And once in a while they live happily ever after."[3]

The 2013 award-winning documentary *Cutie and the Boxer* introduces Noriko Shinohara, the wife (younger by twenty-one years) of Japanese Neo-Dadaist art celebrity Ushio Shinohara, who moved to New York in the 1960s to hang out with the Andy Warhol crowd. (Ushio is best known for his signature boxing paintings, which he creates by lacing on a boxing glove, dipping it into a can of house paint and then pummelling a huge canvas with dramatic blows.) Noriko, like Mary Pratt, created art while raising a son and dealing with her husband's chauvinism, with the added problem of his alcoholic wildness. Noriko has summed up the dilemma of two artists in the same marriage: "We are like two flowers in one pot. It's difficult. Sometimes we don't have enough nutrients for both of us. But when everything goes well, we become two beautiful flowers. So it's either heaven or hell."[4] The Shinoharas' tempestuous union survives, happily or not, and Noriko came into her own as an artist after depicting their marriage with her successful stylized ink-line cartoons of herself as "Cutie" and her husband as "Bullie."

When Bruno Bobak and Molly Lamb married in 1945, they were on an equal footing as professionals, both having served as official artists of the Canadian military during the Second World War. During their sixty-seven-year marriage, they raised a family and travelled frequently to Europe, maintaining balance between their careers by treating any individual travel grants or fellowships as mutual opportunities. Eventually they settled in Fredericton, where Bruno became the director of the University of New Brunswick Art Centre and Molly taught and held exhibitions. Painting in separate studios at opposite ends of the

companionable home they lived in for over fifty years, they gave themselves the space to invent their own unique styles.

Occasionally, for the sake of the union, one artist—most often the woman—sacrifices her art. This occurred more frequently before the emergence of second-wave feminism in the late 1960s. Rhoda Wright met Alex Colville when they were among the ten students in the 1938 inaugural year of the fine arts programme at Mount Allison University in tiny Sackville, New Brunswick. Rhoda chose to be a wife and mother, although she never stopped drawing and became the lifelong muse of her painter husband. Colville painted his beloved Rhoda for seven decades, spanning her youthful athleticism, through her child-bearing years to her struggles with her arthritic elderly body. Reviewing a posthumous retrospective of Alex Colville's work at the Art Gallery of Ontario in 2014, critic Robert Fulford wittily observed that the artist's unembarrassed celebration of married life appears radical in the context of twenty-first-century art.[5]

The careers of some artist wives are casualties not of their husband's earning power and the need to care for children, but of the husband himself. Pablo Picasso destroyed Dora Maar's career as a successful surrealist photographer by publicly belittling photography as a lesser art form. At the beginning of their relationship in 1936, Maar used Picasso as her muse. She photographed him on a beach, evoking the Minotaur, an object of constant fascination for the Spaniard, clutching a bull's skull while his manhood prominently bulged in his bathing trunks. The image perfectly captured his machismo, but he didn't let the flattery moderate his opinions of the medium; he declared every photographer to be an artist eager to be realized, crushing Dora's spirit and leading her

to abandon photography for a return to painting, a medium with which she would find less success. On the other hand, Françoise Gilot, mother of two of Picasso's children, stood up to his disparagement, leaving him and continuing to paint.

The American realist painter Edward Hopper, one of Christopher Pratt's favourite artists, married fellow classmate and established painter Josephine Nivison. Hopper denigrated his wife's art, calling her ability "a pleasant little talent." Nivison's spirit was not so easily extinguished, however. She retaliated by insisting that she be her husband's only female model and taking over the management of his lucrative career.

Sometimes the wife's talent was derided by her marriage to another artist, and sometimes the object of derision was the marriage itself. Adultery played a role in the breakup of Mary and Christopher's fellow Canadian artists Michael Snow and Joyce Wieland, as well as Paterson Ewen and Françoise Sullivan. While Diego Rivera's promiscuity had annoyed Frida Kahlo, his sleeping with her sister drove her to divorce him. Eventually these two most revered painters of modern Mexican art remarried, their mutual attraction as enduring as it was tumultuous. Pablo Picasso's marriages and long-term relationships, with the exception of Gilot, always ended when he had tired of one woman and had taken up with another one or two.

Many undiscovered or less-recognized artist wives of famous male artists have been slowly finding their way into the public eye and are only now being honoured in their own right. Art historian Bridget Quinn was moved to write *Broad Strokes: 15 Women Who Made Art and Made History (In That Order)*[6] when, as an art student, she was shown a slideshow with a work by Jackson

Pollock followed by another by Lee Krasner, whom the professor identified as Pollock's wife. But rarely has an artist wife seized fame while being married to her already-famous artist husband. This is exactly what Mary Pratt did.

The Pratt marriage began with a shared belief in the talent of Christopher Pratt. Mary ensured that her husband had the time and space at home to pursue his artistic career. In the early years, this partnership satisfied them both. She never wavered in her belief that after raising their children she would also become a full-time painter, but she could bide her time.

The bloom came off the rose with Christopher's betrayal. Self-sacrifice turned to resentment. Mary took those nude slides offered to her by Christopher and proceeded to use them in a defiant act of one-upmanship. Her Donna paintings aside, Mary's anger, jealousy and sadness scream out from several still-life canvases painted during the late 1980s and onward. *Threads of Scarlet, Pieces of Pomegranate* (2005), portraying two pomegranates, one intact and the second split open, exposing scattered seeds and running red juice, actually embarrassed Mary when she recognized it as a blatant message of tragedy and brokenness put on public display. Christopher continued on regardless, enjoying his stature as one of Canada's bestselling artists, painting many now-famous images of Newfoundland landscapes, boats and the deserted American naval base in Argentia.

For well over a decade, the Pratts experienced immobilizing stage fright when asked to address their increasingly troubled domestic situation. They demurred, they ignored, they lied; but history offered many paths for artist spouses turned against one another, and whatever trouble roiled beneath the surface of their celebrated marriage, the sheen was clearly coming off. Their

professional lives flourished, however. In a remote corner of Newfoundland, in a house at Salmonier where some of the most extraordinary art of Canada's late twentieth century had been produced, competitiveness had trumped love, but jealousy and rivalry were fuelling two most unlikely successes.

Plump Fredericton Fruit and Newfoundland Mud Trout

CHRISTOPHER PRATT MIGHT thank Mount Allison University for his success. Had life sent him anywhere else in September 1953, he'd never have met a young Mary West. Without her, it's doubtful Christopher would have defied his family and their very conventional Newfoundland merchant-class ways to become an artist. Mary might spare a thought for the old university herself. Had she gone anywhere else that autumn, she would have most likely become what she dreaded: a Sunday painter and the wife of a prominent and wealthy Fredericton professional.

The distinguished little university was the first in the British Empire to award a bachelor's degree to a woman, but Mary chose it in no small part because her uncle was vice-president and her father a long-time board member. Moreover, its fine arts programme was at the time Canada's best, offering some of the country's most talented instructors. Lawren P. Harris, son of his Group of Seven namesake, was appointed head of the department in 1946. The greater attraction was Alex Colville, a Maritimer who would go on to become Canada's best-known twentieth-century painter. Both Harris and Colville had been official war artists,

witnessing some of the most unimaginable brutalities inflicted on mankind. They brought to their students a worldly-wise maturity and hard-won insight into the importance of making art.

Christopher had enrolled in pre-engineering at Memorial University in St. John's, Newfoundland, for the 1952 academic year. He had done so to please his father, who very much wanted his son to take over the Pratt family wholesale hardware business. But Christopher was a reluctant engineering student and spent most of his time painting watercolours. He performed poorly in his courses, though one had proved very much to his liking: the manual drafting course taught him to create technical drawings using instruments such as straightedges, T-squares, protractors and compasses. Christopher lasted only one academic year at Memorial, but those skills would eventually serve him well.

Next, Christopher entered pre-medicine studies at Mount Allison University in September 1953. Having dispensed with the question of an engineering degree, something he had undertaken to please his father, Christopher had now acquiesced to his mother's aspiration that her son become a doctor. Or so it seemed. In New Brunswick, the eldest Pratt boy was far from the watchful eyes of his family.

Whether Christopher ever intended to study medicine is moot; he registered only for humanities courses. There was little doubt in his mind that he wanted to paint, though he had no idea if art could amount to a real profession. In St. John's, where he had grown up, there was not a single public or commercial gallery; nor were there any in the entire province. In fact, the only original painting Christopher could ever remember seeing in his childhood was an image of the local landscape displayed in a reception room of

the Anglo-Newfoundland Development Company in Grand Falls.[1]

At the beginning of the 1950s, there were maybe three New-foundlanders who called themselves professional artists. Helen Parsons and Reginald Shepherd, who each had the advantage of cultured parents—Helen's father had been a St. John's lawyer and Reg's father a teacher—met while studying in Toronto in the late 1940s at the Ontario School of Art. They married and returned to St. John's, where they established a school to support their painting careers. The Newfoundland Academy of Art opened in 1949 in downtown St. John's in a three-storey clapboard building at 51 Cochrane Street, with classrooms and an art supply shop in addition to studios and living quarters. Although offspring of wealthy families attended their Saturday morning classes, Christopher was not among them, probably because he was too old. His mother sent Christopher's younger brother, Philip, for weekly instruction in drawing, which he enjoyed.

The third such professional artist in Newfoundland at the time was Rae Perlin, born in St. John's in 1910, a child of Jewish refugees who escaped the Russian pogroms. She learned to draw in childhood and was determined to become a professional artist. She moved to New York and qualified as a nurse in order to finance art classes. She studied there and later in Paris and England. When she returned to St. John's in 1959 to care for her elderly mother, she became the art critic for the *Daily News* and the *Evening Telegram*, establishing herself as an important figure in the province's visual arts community.

A very few other Newfoundland painters, such as Harold Goodridge and Les Gourley, sold works locally to wealthy buyers for the going price of $50. But as Christopher was settling in for

his first year of study at Mount Allison, the Shepherds and the still-absent Perlin were the only Newfoundlanders with any claim to the title of professional artists.

At Mount Allison, Christopher beat a hasty path to Lawren P. Harris's studio with a few examples of his work. He arranged to audit art classes three afternoons a week. Harris and another instructor, Ted Pulford, asked to see his most recent works and Christopher wrote to request that his parents borrow back several of his watercolour landscapes from Les Gourley, who had been trying to sell them on Christopher's behalf.

Added to the fact that he took no science courses that year, Christopher's request that his paintings be sent to Mount Allison ought to have suggested to his family that he had reservations about the idea of becoming a doctor. If they had an inkling that their son had other things on his mind, and perhaps a course of study besides medicine, their suspicions would soon be confirmed.

Mary, on the other hand, had no doubts about her choice of education. In the autumn of 1953 she was a first-year student in the Fine Arts Department, pursuing the ambition that had begun when she picked up her first crayon at the Mother Goose Kindergarten. "My kindergarten teacher was Mrs. Bunker. Trained in Boston, she brought music, art and literature to her students. This early introduction to colour, rhythm, and stories had a lasting effect on me because it was an introduction to formalized thinking —I was three years old."[2] To inspire such a detailed recollection of early childhood in a former student, Mrs. Bunker must have made a great impression on young Mary.

During Mary's primary school years at Charlotte Street School in Fredericton, art featured prominently in Mary's life. She had set up a makeshift studio in her bedroom cupboard, taping paper

to the wall, using clamshells as her palette and storing her little bottles of Carter's paint in a special box. By 1946, at the age of eleven, she was painting well enough that her *Sugar Maple Workers* was accepted in an international exhibition of children's paintings at the Luxembourg Museum in Paris.

During her teens, Mary had studied with several progressive Canadian artists who visited Fredericton to teach summer courses at the Art Centre of the University of New Brunswick. The centre had been established in an abandoned nineteenth-century observatory on the campus by three women: Margaret MacKenzie, wife of the UNB president, and artists Pegi Nicol and Lucy Jarvis.

Nicol had married Norman MacLeod, whose family was part of the New Brunswick establishment. During the 1940s, she and their daughter Jane spent summers in Fredericton with Norman's mother, and in the fall they rejoined her husband, who worked in New York City. Motivated by her exposure to the American art world and a wide circle of Canadian painter friends, Nicol brought a modern, energetic perspective to the insular and conservative citizens of Fredericton. She rocked the boat with her bohemian style of dress and choice of living accommodations, which ranged from a wooden shed one summer to Lady Beaverbrook's university residence another year. Her fellow instructor, Lucy Jarvis, was an art teacher from Nova Scotia who became head of UNB's new full-time fine arts programme in 1947. Her Saturday public classes drew eager artists from across the city, among them a high school student named Mary West.

The UNB summer classes had offered Mary a broad view of the trends in twentieth-century art. In 1950 she studied with Alfred Pinsky, one of the Jewish Painters of Montreal group, who, along with his artist wife, Ghitta Caiserman, had founded the Montreal

Art School. The next summer Mary attended classes given by Fritz Brandtner, a German-born, mainly self-taught painter who had been strongly influenced by cubism and German expressionism. Mary did not feel comfortable with these painting styles, but did credit Brandtner with opening her eyes to different approaches in viewing and representing space.

Mary encountered more than just new ways of painting; she also met strong, independent women artists, some single, others, like Nicol, married. This group of social-activist painters challenged the sort of domesticity for which Fredericton destined even a talented and socially privileged young woman like Mary. But like Brandtner's treatment of space, the examples of these women did little to change Mary's ways of thinking. True to her family's establishment point of view, she showed little curiosity in the lifestyles of this free-spirited group.

Mary was more comfortable in the classes of John Todd, an illustrator who had trained at the Pratt Institute in New York City. After Todd established a studio in Fredericton, Mary took classes with him every Friday night. Among other recent developments in art, he introduced her to the new appreciation of photography in the world of illustration and advertising. He suggested Mary clip photographs from the weekly magazines as a source of inspiration for her drawings. In fact, Todd even encouraged Mary to go to New York to train as an illustrator. Her parents quashed the idea of their daughter living alone in New York City and learning a commercial trade, but Todd's idea that Mary use photography as a reference for her art was never forgotten.

CHRISTOPHER WAS SIXTEEN when he first experienced the creative challenge of drawing and working with watercolours. An emergency appendectomy in the summer of 1952 forced him to convalesce at home instead of going on the usual hunting and fishing expeditions with his pals. To help her son pass the lonely hours, Christine Pratt[3] paid a visit to Ayre's department store and bought him a set of Winsor & Newton watercolours and Series 7 sable brushes.

Many artistic careers have had their roots in youthful convalescence. The best-known case is that of Mexican Frida Kahlo, who in her late teens was immobilized in a body cast after an accident. She spent hours in bed, painting while lying on her back. Group of Seven painter Lawren Harris, deemed by his mother to be a sickly child, was cosseted at home. To escape the tedium, the boy drew what he observed around him, along with sketches of family and friends who came to visit. Alex Colville nearly died from pneumonia in his childhood and took up drawing during a six-month recovery.

While Christopher's mother had little appreciation for high culture to pass on to her son, she did possess an artistic flair displayed in her home decor. She had studied watercolour painting at finishing school, and a couple of her works hung in the Pratts' home. As a youngster, Christopher had spent pleasant hours helping her make ornate decorations and cards for Christmas, many bearing his drawings of houses covered in snow.

Any cultured artistic influence on the young Christopher came from his father's side of the family. The Pratts basked in the reflected glory of Christopher's great-uncle and one of Canada's greatest then-living poets, E.J. Pratt. Christopher's grandfather James, a successful hardware merchant and older brother of E.J.,

took up painting after his retirement, building his own studio. He introduced his grandson to the world of European art with his subscription to the Book-of-the-Month Club "Metropolitan Miniatures" series (1947–56), which reprinted thousands of American and European art masterpieces. Each issue included a gummed sheet of twenty-four colour illustrations that could be pasted onto the corresponding page of text. Before the advent of television, these sticker books provided entertainment for children and adults. That summer James brought his convalescing grandson an informative book, *Water Color Painting*, by a well-known American artist, Adolf Dehn.

Christopher entered the Newfoundland Government Arts and Letters competitions and in 1953 won first prize for a seascape, *Shed in a Storm*. The following year another of his stormy sea scenes, *The Bait Rock*, featuring a besieged shore tree, again took first prize. In 1955 he won again, for *A Cove in Winter*. Christopher received his first-ever review in an editorial in the St. John's *Evening Telegram* of March 26, 1956, which noted that the unnamed judge had praised Pratt's artistic abilities. While these early amateur watercolours are atmospheric and romantic, they reveal Christopher's lifelong obsession with Newfoundland's barren landscape, and the beauty and menace of the ever-present sea.

Not even two months into his pre-med year at Mount Allison, Christopher's gambit to become an artist was under way. Whether it was his own idea or a response to urging from Christopher, Lawren P. Harris wrote a letter to Jack Pratt in late October 1953 suggesting that he allow his son to switch from pre-med to fine arts. Christopher has kept that letter, which contains the ringing endorsement that "we all [Harris, Ted Pulford and Alex Colville] believe that your son's technique, though of course capable of

development, is even now most remarkable." Jack Pratt didn't even respond to Harris. Years later, Christopher told art historian Joyce Zemans that his father had wondered if Harris "had all his marbles." Clearly under the mistaken impression that Christopher could be influenced by his parents while he was in New Brunswick even though their views had not prevailed a year earlier in Newfoundland, Jack wrote to his son, telling him to get on with his pre-medicine courses.

MARY WEST'S AND Christopher Pratt's journeys to Mount Allison had followed very different paths. For a start, they were born in different countries. John Christopher Maxwell Pratt was born on December 9, 1935, in Newfoundland, which had only the year before relinquished its status as a dominion of the British Empire and reverted to British control. In 1949, when Newfoundland became Canada's tenth province, he was thirteen. His relatives, determinedly anti-Confederation, wore black arm bands to mourn the decision.

Mary Frances West was born on March 15, 1935, in Fredericton, New Brunswick, a riverside university town established mainly by United Empire Loyalists, with a cathedral punctuating its low skyline and elegant rows of large Victorian houses lining leafy streets.

What they grew up with in common was a sense of entitlement: both were children of the establishment in their respective cities. Mary's father, William (Bill) West, came from a large family that owned a farming and lumbering business. Intelligent and hard-working, after returning from active combat in the First

World War he resumed his education and graduated from Yale University with a law degree. Once back in New Brunswick, West established a law practice in Fredericton and eventually entered politics, running for the Conservative Party and rising to the heights of provincial Attorney General and deputy premier.

Mary's mother, Katherine McMurray, had a family legacy of scoundrel establishment husbands. Her great-grandmother Mary Grey, who came from a prominent Philadelphia family, had married a New Brunswick doctor, Hayward Colborn, and moved with him to Fredericton. According to family lore, Colborn ran off with a maid, abandoning his wife and children. In turn, Mary's grandmother Edna married a dentist, Albert McMurray, the son of a wealthy Fredericton family. He died early from drink, leaving his widow to raise three girls: Margaret, known as Auntie Tom, Katherine and Mary. The McMurrays took Edna and the girls into their imposing home, where she served as an unpaid housekeeper. An imposing figure herself, Edna strove to uphold her dignity, eventually becoming the president of the local Imperial Daughters of the Empire (IODE), a role that earned her a Member of the Most Excellent Order of the British Empire (MBE) for her war work.

Katherine McMurray broke the family mould by marrying her trustworthy boss, Bill West. Unable to afford the costs of a university education, Katherine, better known as Kay, had trained as a secretary and taken a position in West's legal office. Raised wise to the fragility of marriage and family, she recognized in West a man who would remain a loyal and steady provider. When they married on November 22, 1933, in Fredericton, Kay was eighteen years younger than her husband. Children came quickly. Mary, the eldest, was born in 1935 and Barbara in 1937. Another daughter,

Sally, born in 1936, died shortly after birth, a tragedy that was never spoken of in the family.

As his young bride had hoped, Bill West dedicated his private life to creating a secure, sheltered home for his girls; Kay was treated almost as another daughter by her older, take-charge spouse. He built a new house at 126 Waterloo Row, a wide street following the Saint John River where it runs through Fredericton. Based on a plan for *Good Housekeeping* magazine's 1937 "House of the Year," the Georgian Revival–style four-bedroom house substituted locally quarried grey fieldstone for the simple red brick of the original design. Bright red—Kay's favourite colour—was reserved for the carpets and front window shutters, in lieu of the prescribed "raisin" colour. However, nothing in the impressive house so revealed West's desire to build a dream home for his wife as the kitchen: Kay was left-handed, so West ordered the entire room built in reverse.

Although the house was large enough to accommodate his mother-in-law, Edna, she did not live with them. Bill paid her rent to live down the street at 14 Waterloo Row in a rooming house, sharing a bathroom with the other tenants. She had a bedroom and a front room with a hot plate, and used one of her dresser drawers to store her groceries. Mary and her sister Barbara were no strangers to their grandmother's rooms, often joining Edna during their school lunch break for boiled eggs and toast.

Edna took on the job of teaching her two granddaughters the skills of housewifery. She emphasized that when ironing their husbands' shirts, it was necessary to iron over the seams in order that he never felt any roughness on his skin. Both Edna and Kay taught the girls to bake and cook. Throughout her adult life, Mary whipped up the most gorgeous cakes and prepared jams and jellies

without any appearance of angst or doubt of a perfect outcome.

Although she never lived with her daughter's family, Edna held her weekly bridge parties at the house, joined them every Sunday morning in the same pew at Wilmot United Church and never missed Sunday dinner. Though the house offered the luxury of an informal breakfast room, Sunday dinners were always eaten at the dining room table. In her own writings, Mary remembers those meals as "plain cooking" neatly served, with each plate having "a small row of carrot pennies, a small mound of mashed potatoes, a tiny pile of peas, a slice of roast beef, a spoonful of gravy, smooth as velvet, no separating fat, rich and dark."[4] Kay dreaded any dissension at the table, particularly between her husband and mother, and was known in the family as the "queen of the non sequitur" for her efforts to derail arguments by changing topic.

Both Bill West and his mother-in-law were strong-willed and opinionated, and so arguments often put a strain on such family gatherings. However, as long as everyone kept up appearances, conflicts were ignored. Already, at an early age, Mary was learning from the example of her mother to simply banish unpleasant events from her mind.

Whatever conflict simmered between the adults, the curly-haired West girls were doted on by their grandmother and both parents, and wore hand-smocked dresses made by their Auntie Tom (who earned money making smocked dresses for Ogilvy's department store in Montreal). Decades later, a Toronto journalist would memorably capture the effect of this constant doting on Mary and Barbara, describing them as "plump little Fredericton fruit protected from even occasional bruising."[5]

A polio scare persuaded the Wests to keep their daughters from the city's playgrounds. Bill built swings, a teeter-totter and a

sandbox in their backyard. All the Waterloo Row children were welcome to join in, and he added a large playhouse. As the girls grew older, the entire block of houses on Waterloo Row became their playground, with the youngsters running freely among the unfenced back gardens. Envious schoolmates, looking on from streets of lesser affluence, called Waterloo Row "Snob Alley." In winter, the West girls and their neighbours slid down the banks of the frozen Saint John River to skate on the ice. Barbara was the more active sister. Mary suffered from juvenile arthritis, which caused her hips to ache and kept her out of most sports. She was happier hidden away in her bedroom cupboard, doing what she already loved most: painting.

.

BEFORE NEWFOUNDLAND JOINED the Canadian Confederation in 1949, almost every aspect of life on the island was influenced by a family's social standing. The well-established families of the merchant class had ruled over the island's fishermen and lumber workers for centuries. Christopher Pratt's mother was a Dawe, whose ancestors had arrived in Newfoundland in 1595. Eventually settling in Bay Roberts, the Dawe family, who were invested in lumbering and sawmills (their company supplied most of the island with butter tubs, barrels and berry boxes), lived a life of comfort, able to import clothes and specialty foods from London or New York.

Christopher's father, Jack Kerr Pratt, was descended from the Pratt dynasty, which had begun much later than the Dawes, when Methodist minister John Pratt settled in Newfoundland in the 1870s. He had married Fanny Knight, the daughter of William

Knight, a well-known sealing skipper and coastal trader. John and Fanny had eight children. Christopher's paternal grandfather, James Charles Spurgeon (J.C.) Pratt, named after the famous British preacher at the London Tabernacle, was called "little Spurgie" throughout his childhood. Although John Pratt had hoped that his second son would become a Methodist minister, J.C. chose business instead, and prospered. He married Marion Kerr in 1918, and they had five children. He proved to be multi-talented, playing the organ and, after retirement, turning his attention to painting.

The third son was Edwin John, "Ned," later known as E.J. Pratt, the distinguished poet. Newfoundlanders took special pride in their native poet, memorizing verses that captured the essence of the province, such as "Erosion" (1931), which recognizes the toll of the sea's unpredictable fierceness on the wives of Newfoundland fishermen:

> It took the sea a thousand years,
> A thousand years to trace
> The granite features of this cliff,
> In crag and scarp and base.
>
> It took the sea an hour one night,
> An hour of storm to place
> The sculpture of these granite seams
> Upon a woman's face.

Students across the country read his 1952 long narrative poem *Towards the Last Spike*, about the construction of Canada's first transcontinental railway. Until the appearance of Joey Smallwood

as the first premier of Newfoundland, E.J. Pratt had been the best-known Newfoundlander in Canada.

Shortly after Newfoundland entered Confederation, another of Christopher's great-uncles, Calvert Coates Pratt, who held the award Officer of the Most Excellent Order of the British Empire (OBE) for his work in the Second World War, became one of Newfoundland's first federal senators in Ottawa.

Christopher's father, Jack, left high school before graduating to help his father, J.C., with his successful wholesale hardware business. Jack, a big, handsome, outdoorsy man, was dominated by his father. Although a competent businessman and inheritor of the family enterprise, Jack had to work hard to provide well for his family.

As a student, Christopher's mother, Christine Dawe, had boarded in St. John's at the Protestant Bishop Spencer School for Girls, where, before Confederation, the school's uniform of tunic, blouses and blazer came from Harrods department store in London. Under British-born headmistress Violet Cherrington, the girls learned the feminine attributes of virtue and good manners, while their studies included domestic sciences, art and secretarial skills. After finishing school at the Halifax Ladies' College, Christine took an unexpected turn west, to nursing school at Montreal's Royal Victoria Hospital. Daughters of the St. John's establishment routinely came home after finishing school to make good marriages; the ladies of the merchant class would shudder to think one of their own might become a common nurse.

While training in Montreal, Christine became engaged to a British doctor. However, after returning from a visit to her fiancé in England, she ended the relationship. Mary Pratt, who later became Christine's daughter-in-law, wondered if, when Christine caught sight of Newfoundland's rocky coastline from her ship,

she realized that Newfoundland was home and couldn't bear the thought of living anywhere else. Mary would certainly encounter that abiding sense of home in Christine's eldest son.

In October 1934, Christine married the handsome Jack Pratt. The newlyweds moved into a first-floor apartment of a large three-storey house on LeMarchant Road owned by the Dawe family. Christine's only sister, Myrt (her formal name was Myrtis, an ancient Greek name), would live with them for her entire life, sharing household chores and paying rent. Five years older than her sister, Myrt never married, travelled alone and drove her own car. Nicknamed "The Duchess" by the family, she also joined them on their holidays, picnics and fishing trips. In those days it was not unusual for spinsters to live with a relative, but it meant that Jack never lived alone with his wife.

Christopher was born in St. John's on December 9, 1935. He spent the first ten years of his life as an only child, although with abundant cousins to play with. The house on LeMarchant Road was actually a compound for three Dawe families: Christine and Jack's, along with those of two of her brothers, Chester and Max. A skylight brightened the building through a small inner shaft, and the cousins communicated by dangling baskets up and down its length, from the upper floors, where Chester's and Max's families lived, to the ground and basement floors, belonging to Jack and Christine. At the bottom, Florrie, the servant girl, kept a small bedroom.

As a little boy, Christopher pronounced his name *Tiff-to-fer*, and his family, and later his wives, referred to him as Tiff. One photo from LeMarchant Road shows Christopher around six years of age, sitting in a living room chair in blazer and short pants, his dangling legs clad in knee-high woollen socks and lace-up

shoes. His hands are clasped together and his sticking-out ears, which he inherited from the Pratt side of the family, are prominent. He has a nervous, tentative look on his unsmiling face. In contrast with this formal photograph, a much happier Christopher can be seen in a 1940s snapshot posed in front of his father's Studebaker with a fishing rod in one hand. Tiff was always happy when outdoors, especially if fishing with his dad.

Just uphill from the St. John's harbour, a back window in Jack and Christine's first-storey flat offered their son a bird's-eye view of the impact the Second World War was having on Newfoundland. During the Battle of the Atlantic, damaged ships often limped into the harbour to off-load rescued and wounded sailors. The city became a garrison for huge numbers of servicemen. Military vehicles roared past on the unpaved or cobblestoned streets of the capital. (Until then only the wealthy owned cars, while horse-drawn carriages delivered groceries, coal and—in summer—blocks of ice to keep food cool.) The city's hilly, uneven streets had few sidewalks and became treacherous after dark, when the mandatory use of blackout curtains and covered headlights made it impossible to see, especially on moonless nights. Sailors and civilians both lived with a constant fear of German U-boats sending torpedoes through The Narrows into the harbour, which they did more than once. Several disasters brought home to Christopher and all the other youngsters in St. John's that they were a country at war. The German sinking of the passenger ferry the *Caribou*, en route from Port aux Basques in southwest Newfoundland to North Sydney, Nova Scotia, in October 1942, led to the death of 136 people, including ten St. John's children.

In 1944, Christine and her two brothers moved their families en masse to Waterford Bridge Road and three newly built houses

all in a row—Jack and Christine at 93, Uncle Max at 95 and Uncle Ches Dawe at 97. Jack had needed to borrow money for the house from another Dawe relative, further indenturing himself to the Dawe family while working, at the insistence of his own father, in the Pratt family hardware business.

The arrival of baby Philip in February 1946, shortly after the move to Waterford Bridge Road, completed Jack and Christine's family. With more than ten years between them, Christopher loved his little brother in an avuncular way. Philip jokes that, with this older brother and Auntie Myrt, he grew up with two mothers and two fathers.

Christopher (and later Philip) attended Holloway School and then Methodist Prince of Wales College on LeMarchant Road. His first notable public achievement occurred in 1940, when a local newspaper reported that the kindergarten children at the Prince of Wales auditorium had presented a concert titled "Britannia and Her Colonies" in which Christopher, together with two other little boys dressed in sailor suits, represented England.

His report cards reveal that he excelled in maths and sciences; in particular, he whizzed through geometry, receiving a 97 percent in eighth grade. He didn't enjoy or do as well in literature, languages and religious studies. Never much of an athlete—Christopher says he inherited thin legs from his mother—he played a little hockey at school. Reminiscing on his years at Holloway, he said that all the boys played marbles with rules dictated by the loudest boy, nicknamed Hawk. After losing constantly to Hawk, Christopher practised for hours to perfect his style. After he had won back all his marbles, Hawk complained, "That's not fair—you done your best."

Christopher retains an exceptional memory of his public and secondary school years. He has attended, without fail, every school

reunion. He loves to reminisce about friends such as Itch (Bill Edgecombe), Bum (Bill Goobie) and Tubby (Robert Sparks). Toward the end of his high school years, Christopher wrote a song, "Alma Mater: Prince of Wales College," with lines such as "Through life's triumphs and life's gales, / We'll remember Prince of Wales."

With little Philip now in tow, Christopher and his parents spent summers in a rented cabin in the nearby cottage community of Top Sail on Conception Bay. But Jack sometimes took just his elder son on fishing trips along the southern shore of the Avalon Peninsula. Christopher remembers one such expedition to the Southeast River when he was about twelve. He proudly announced to his father that he had just caught a "Great Eastern Brook Trout," the name he had recently read in an outdoors magazine. Jack looked at his son and the fish, saying, "'S that so, now, Christopher? Looks like a mud trout to me."[6]

Even in Christopher's eighties, memories of these happy childhood outings with his father bring with them the smell of capelin fish drying on spruce boughs and of musty bogs, and the taste of scalded milk and cold water drawn from deep wells.

As Christopher entered his teens, he spent as much of his weekends and summers as he could outdoors with his friends. He was one of the "b'ys" proficient in hunting, fishing and all the other manly Newfoundland activities taught by fathers and uncles. Occasionally his poetic side overtook him. One June day out fly-fishing with his pals, Christopher began to muse aloud about the landscape around him—the sand dunes capped with bright grasses, the bogs as organic as the sand was crystalline. He was snapped back to reality by one of his friends: "Jesus, listen to him, will you—thinks he's a fucking poet."

There is one summer vacation about which Christopher's usually acute memory fails him. He and Philip travelled across the province by train with his mother to a country resort called Dhoon Lodge. Neither Christopher nor his brother can recall much about that holiday, but Christopher later wondered about the situation at 93 Waterford Bridge Road that caused his mother to leave Jack behind.

Christopher met his first real love in high school. Janet Ann Lake, known as Tannie, was two years younger and so a couple of grades below him. Her father, Spencer Lake, was a partner in the family business, Lake Group of Companies, which included importing and exporting fish. Fortune smiled on Christopher, since Tannie's parents were often away at their weekend cabin, leaving their young maid to chaperone. The maid took advantage of the freedom to spend Saturday nights at the bar of the American air force base, Fort Pepperrell, hoping to find a husband to take her away from life in domestic service. Christopher and Tannie were left alone.

As was the custom with the Newfoundland merchant class, after graduating from high school in 1954, Tannie was sent away to a finishing school, King's Hall, Compton, a girls' boarding school in Quebec's Eastern Townships, where she learned secretarial skills, including shorthand.

Christopher will only hint about their relationship. However, speaking to a reporter, he said that, when visiting St. John's Mount Pleasant Cemetery to pay his respects to his parents buried there, he would also take the time to visit Tannie's grave, "where the first real girlfriend, if you know what I mean, is resting, and thank her."[7] Commenting on Tannie on another occasion, Christopher talks about her "teenage instincts" and whether it is "appropriate or fair

to reveal things concerning privacies; to expose shared adventures past that others would guard themselves."[8] The innuendo makes it obvious that the teenagers were sexually intimate. But in time, Christopher says, Tannie grew to hate him and refused to speak to him ever again. She died as a very young woman in December 1963, slightly over a decade after the time she had been Christopher's girlfriend. Her premature death deeply affected him.

A guilt about Tannie that Christopher has never explained has hung over him his entire life. In 1996 he made a series of collages, and photos of Tannie featured in many, such as *Me and Others* and *Self-Portrait with Ghosts*. Whatever the whole story, Christopher's first love interest was, and remains, fraught with angst.

.

MARY INSISTED THAT she grew up in a happy sort of Eden, nurtured by parents who gave her only praise and support. In a talk given in 1999 to Wilmot United Church, long her family's church in Fredericton, she recalled her childhood in a similar spirit to the journalist from Toronto: "My life in Fredericton was as light and bright as the soap bubbles my sister and I used to blow from those small white bubble pipes found in Woolworth's fifty years ago."[9]

Her parents' companionable marriage had made good on Kay's determination to end the line of broken vows from which she'd descended on her mother's side. Both she and Bill were readers and art lovers. Classical music floated pleasantly through their riverside home. They patiently cultivated a back flower garden along with a kitchen garden that supplied them with fruits and vegetables, many of which Kay pickled and canned. A photograph taken in the late 1940s shows the Wests indulging a playful moment in

their garden, parodying Grant Wood's famous painting *American Gothic*, with Bill sternly holding a pitchfork and Kay looking the spitting image of Mary when she reached the same age.

Mary was a typical 1950s teenage girl, loving the dreamy music of Johnny Mathis and Perry Como. Girlfriends came to Waterloo Row for sleepovers. She went with friends to Saturday afternoon movies, one of her favourites being the 1947 *Golden Earrings*, a sultry love story with Ray Milland and Marlene Dietrich. She and her younger sister, Barbara, squabbled like many sisters close in age, but they were expected to work together to do household chores. A photo captures the two of them doing the supper dishes, with Mary in a matronly plaid skirt and sweater while Barbara, with an impish grin, is dressed in tartan slacks and a Fair Isle sweater. They often listened to Don Messer and His Islanders' old-time country music on CBC radio as they scrubbed and dried. Mary worked in the summers as an instructor of city-run day camps, earning $7.50 a week.

As a teenager, Mary felt awkward because she was taller than her mother and sister, and she always admitted to a poor self-image. Myopic, she had to wear glasses from about the sensitive age of twelve. She wore her dark, curly hair cut short. In her plaid skirts and twin sets, Mary West presented a rather serious, bookish appearance, though she contradicted that impression with her distinctive giggle and dimpled smile.

Despite her self-consciousness, Mary found a steady boyfriend, Lawrence Garvey, a surprising choice because he had two strikes against him: he came from the wrong side of the tracks and, worse still, he was a Catholic. The Wests evidently weren't keeping count, because they quite liked him (he went on to become

a lawyer and a provincial MPP). Barbara thought that Lawrence Garvey had a high opinion of himself and suggested this was a pattern in the men whom Mary chose.[10] When Garvey, who was older than Mary, moved on to the University of New Brunswick, their romance faded away.

All was not perfect in Mary's childhood paradise, however. In her later teens, she began to push back at her—as she saw it—conventional mother and overprotective father. When they discovered that she had hitchhiked home quite late one night, Bill asked her, "How would you like to go to your room?" Mary retorted, "How would you like to go to hell?"

.

WHILE THE WESTS were lifelong teetotallers, the Pratts were drinkers. As part of the St. John's social set, they frequented house parties in grand Victorian homes, with canapés and cocktails delivered by uniformed maids in rooms hazy with cigarette smoke and noisy chatter. When the Pratts entertained at their Waterford Bridge home, Christopher can recall lying in bed listening to his parents and their friends as they grew louder and more raucous with every round served. If Jack had been drinking before he came home from work, Christopher always knew it. His parents' personalities changed when they had been drinking, and he confesses to taking advantage, asking for money while their guard was down so he could buy himself treats. While it was socially acceptable in the 1940s for men to drink until they slurred their words, an inebriated woman was not tolerated; yet, behind the right doors, these rules didn't seem to apply to the Pratts and their circle.

Christopher's memories of visits to his Dawe relatives in Bay Roberts are more disturbing. They too were drinkers. He remembers loud voices, dark rooms, tensions and jealousies; and he remembers witnessing the intimacies of adults who had lost their inhibitions with the help of several drinks too many. In fact, St. John's gossip suggested that Jack Pratt's overindulgence had been caused by his association with the Dawes, such was their reputation for hard drinking, and Jack's own reputation as a kind man too easily overwhelmed by the stronger wills of others. Christopher pledged to himself while still in his teens that he would never drink alcohol. "I knew early on that alcohol wasn't something I was going to try. I've smoked four cigarettes in my entire life and just didn't like it."[11]

As adults, both Christopher and Philip are reluctant to discuss their parents', and especially their mother's, relationship to alcohol. There is no doubt in their recollections that Jack and Christine both loved and supported their sons, but neither is there any doubt that their heavy drinking and chaotic way of life took its toll on the brothers—as boys and as men.

I Is a Newfoundlander

"HE WAS STANDING by the window in the library waiting to register, and the light was shining right on him. He was wearing a bright blue sweater, and the bit of hair he did have was like a little halo around his head. I couldn't stop looking at him. I knew right away this was the good, and the true, and the beautiful."[1] Mary was wont to embellish and romanticize to make a story better. Likely tipped off by her uncle, vice-president of the university, Mary West was aware that poet E.J. Pratt's great-nephew would be attending his first year at Mount Allison.

Smitten as she may have been, Mary the diligent student had little time to pursue Christopher Pratt. She was thrown into her own first year of study, including thirty-five hours a week of rigorous studio training. Ted Pulford taught Basic Drawing, Design and Still Life Painting. He had served in the war, came to Mount Allison as a mature student and, after graduating in 1949, was hired as an art instructor. His 1948 diploma piece, the obligatory self-portrait, hung in the first-year drawing studio as an example of academic excellence. He put Mary and her classmates through

endless drawing sessions, using plaster-cast models. For that first term, he allowed them to work only in black and white. Mary's art classes in Fredericton had given her a head start on many of her fellow first-year students, and she found Pulford's class tedious; but she realized that every classically trained painter—even Rembrandt—had had to learn to draw. Nonetheless, Pulford's intense course of study made less of an impression on her than did the backaches caused from hours of intense concentration while perched high on a stool.

Distinguished cultural experts came to the campus to lecture. One was Alan Jarvis, director of the National Gallery of Canada (NGC). Since his appointment in 1955, Jarvis had been touring the country provoking controversy over what exactly constituted art. The international art world had worked its way through a multitude of modern and now postmodern "isms," and by the early 1950s abstract expressionism had become the dominant style among North American painters.

During a lecture attended by Mary, Jarvis dismissed what he called the "chocolate box" concept of pretty pictures and asserted that art should be gritty and provoking. Undeterred by Jarvis's stature in the national art establishment or the presence of so many peers and professors, she rose and challenged him. She argued that pleasant experiences can be equally as arousing, and asked if she was expected to intentionally seek out the ugly in order to be a contemporary artist. Jarvis shot back with the put-down, "Oh well, if you want to join the Mommy-Bunny school."[2] The innate confidence that allowed Mary to speak her mind throughout her life was already evident in the twenty-year-old student. Jarvis had convinced her of nothing.

Christopher and Mary were classmates in first-year English. In

November, the professor, a man named George Thomson, called upon Christopher during a grammar lesson to explain what a pronoun was. The professor and Christopher were friendly, having bonded while listening to the 1953 World Series together on the radio and lamenting the demise of their favoured Brooklyn Dodgers at the hands of the New York Yankees. Thomson asked, "Pratt, what is 'you'?" Christopher paused briefly, then replied, "I is a Newfoundlander, sir."

For all Christopher's wit and charm, Mary's first Mount Allison boyfriend was another Newfoundlander, Fred Woolridge, a fun-loving fast talker who was putting himself through university by working as a radio and television announcer. Fred and Christopher knew each other, as their families were part of the same social circles in St. John's. But in the end it was the young Pratt who made the stronger impression on Mary West.

In Mary's eyes, Christopher the student was a lonely and somewhat tortured soul. Later, a fellow student, journalist Harry Bruce, would describe his memory of Christopher as that "of a brooder, a youth inside whose head some argument raged forever."[3] However, the teetotalling but tall, witty and flirtatious Newfoundlander had more than his fair share of dates. Throughout his first two years at Mount Allison he went to proms, square dances and sports events with different girls on his arm.

His artistic talent was recognized as well. His date for the February 1954 coed formal, Libby Davis from Bermuda, following the tradition of the girls giving corsages to the boys, made him an arrangement with a miniature palette, two paintbrushes and eight pipe cleaners representing different paint colours.

During the winter term of 1955, Mary and Christopher began dating. In January, Christopher wrote to his parents, boasting,

"I was out with Mary West—the one I was always saying went out with Fred [Woolridge]—well she doesn't anymore."

Fred's wrongdoing had been to get drunk at the junior prom. On the way home, Mary demanded that he stop the car. She got out onto the side of the road, dressed in a red velvet, strapless gown with silver shoes, and stomped back to the girls' residence in the rain. Thus ended that romance.[4]

Though Christopher was still dating Libby, and a few others, during that winter term, the fact that he had been mentioning Mary to his parents while she was still Fred Woolridge's girlfriend makes it clear he'd had his eye on her for a while. He called her "Mae" and flirtatiously expressed his surprise that he was the first to note the similarity of her name to that of Mae West, the saucy Hollywood actress with the famous quip, "When I'm good, I'm very, very good, but when I'm bad, I'm better."

Christopher's letters to his parents emphasized that Mary was the pursuer, although he was not a reluctant catch. In late January, he wrote that going out with Mae was getting to be a habit. "She asked me to the Formal next week. I'm afraid it looks as if I'm cornered."

On more than one occasion, Mary invited Christopher to come home with her to Fredericton. In particular, she urged him to spend March break with her family. He turned her down. However, he deigned to let her take him out for dinner, later explaining to his parents that Mary's father was the Auditor General of New Brunswick (actually, he was the Attorney General) and so she could afford it.

It took a formative moment in their early life together to move Christopher to return the gesture. On a cold February day, they went for a walk on the Tantramar Marshes (a vast expanse of former salt marshes outside Sackville) and Mary commented on

the beauty of the scenery. In Mary's recollection, Christopher then disparaged her romanticism and marched off ahead of her. Running to catch up with him and trying to salvage the situation, she asked him what it was like in Newfoundland on a wintry day. His mood turned, and as he waxed eloquently about the grass on the barrens full of frost, he put his arm around Mary and invited her out for dinner.

Mary described herself as scrabbling that day for a way to get back into his good graces, because she already knew she wanted to be with him for the rest of her life. Her diary entry of February 1, 1955, stated, "I despised myself for being so groveling and conniving. But to lose him would be to lose access to a mind I found essential to my life."[5]

Many years later, in 1992, Christopher offered another version of the same incident. He described the scene:

A mixed-up, angry young man—moody, manipulative, selfish and jealous—and an attractive, intelligent and passionate young woman. He knows that he is the dependent one, that he will wait for her where the foundry track branches off the main CN line. Perhaps she is crying as he stomps on ahead of her, not wanting her to know that she could destroy him by not following, by just turning to walk the other way.[6]

Writing this, Christopher had clearly come to recognize how much he had needed Mary at the beginning of his career. He also reveals the subtle emotional game that would play out between them for the rest of their lives.

REUNITING IN SEPTEMBER 1955 for their third year, Christopher and Mary spent nearly all that autumn working on decorations for the upcoming prom. The theme was *Brigadoon,* and the couple threw themselves into creating the best decorations Mount Allison had ever seen. Sourcing huge sheets of paper from the Sackville Paper Box Company, they laid them out on the expansive floor of the campus boiler room. Christopher drew up scenes of a vast landscape surrounding a Scottish castle. They draped yards of blue-dyed cheesecloth across the ceiling to mimic a misty sky.

Utterly consumed by the project, Christopher came to two realizations. First, he most certainly would fail his term, as he had rarely gone to class (he'd failed first-year German for much the same reason). Second, he didn't want to waste any more time in university, feigning an interest in medicine to please his mother. He wanted to be a painter.

In a series of letters, Christopher announced to his parents that he was abandoning his pre-med studies at Mount Allison and would return to St. John's at Christmas to follow his dream of becoming a professional artist. He asked if he could stay at home and devote himself entirely to practising basic art theory on his own. He assured them that he had thought about his decision carefully and had no doubts.

In a November 1955 letter, he reported that Lawren Harris had fully backed his decision, telling him, "I wouldn't want to lead you astray and I wouldn't encourage you to do this unless I had complete faith you could do it." Harris had no problem with Christopher dropping out of university, as he himself had only one year of training, at Boston's Museum School of Fine Arts.

While Lawren Harris and Mary West may have been convinced of Christopher's determination to become a professional

artist, privately he suffered anxiety and misgivings. He needed the moral support and security that his parents could offer while launching his career, a choice that brought with it very few guarantees, even of his own suitability for the life on which he was embarking. Shortly before leaving Mount Allison, he wrote his parents, saying, "I won't be a brand new son. I'll still seem just as lazy at times, I know this. But I can't do it by myself, dad, I need your help to push me on."[7]

Christopher was well aware of what his withdrawal from Mount Allison would mean for his relationship with Mary. Whatever exactly the relationship meant to him, he wasn't about to change course: "I know it involves leaving all that but [studying art] means more than all those things to me."

Jack and Christine had paid for Christopher to spend three and a half years at two universities, and now he was returning without a degree. Not only did their elder son want to live at home painting pictures without any income, he had rejected the family business. Nonetheless, they accepted their son's decision without reproach. Philip remembers that winter when his brother quit university and came home. He recalls their parents being fully supportive, although he imagines there had been eye rolling from family friends: "Young Christopher wants to be *what*?" he mimics. "An artist!"

But once Christopher declared his intention to become a professional artist, Jack Pratt never let his son down. Nor did Mary. For Christopher's birthday in December, shortly before he left Mount Allison, Mary gave him the book *The Artist at Work* to encourage his bold decision.[8] Mary might have wondered whether the Pratts felt some hostility toward her for urging their son to drop his academic studies. Nonetheless, she would not be easily

left behind: she joined Christopher in St. John's to spend New Year's Eve at his family's Waterford Bridge Road home, returning late to Mount Allison because of typically bad Newfoundland weather.

With Mary gone, Christopher transformed his childhood bedroom into a studio with a makeshift drafting table. He refused to rent space to create a studio, possessed by the idea that it might make people think he had turned into some sort of free-spirited bohemian pursuing a dissipated lifestyle.

During the cold, wintry days, Chris painted watercolours exploring the distinct feel of St. John's, works such as *View of St. John's Harbour* (1955) and *Battery Road* (1956). He reread *Water Color Painting* by Adolf Dehn,[9] the book his grandfather had given him in the summer of 1952, and another, *Watercolor Methods* by Norman Kent,[10] an extremely useful book that gave step-by step instructions on how to construct a watercolour painting. He experimented with oils, beginning a painting of the Batteries, a small neighbourhood of colourful wooden houses near the bottom of Signal Hill at The Narrows, the entrance of St. John's harbour. (Although never finished, the painting first hung in his parents' home and now is on the wall of his brother Philip's home in Brigus, Newfoundland.)

In the spring of 1956, Aunt Myrt treated her nephew to a trip to New York City, where they stayed with a relative in Brooklyn. They visited all the important art galleries—the Whitney, Metropolitan Museum of Art, Museum of Modern Art and Museum of Natural History. Despite his own career coinciding with the pinnacle of New York's prominence in the global art world, this would be the one and only time in Christopher's life that he explored the city's art scene.

While he did see works of European Impressionists and American abstract expressionists such as Jackson Pollock, the works he related to were those of the American realist painters, particularly Winslow Homer and Edward Hopper. Homer shared Christopher's fascination with the sea, while Hopper inspired him with his clearly defined lines and emphasis on light. Eager to pursue formal art training, Christopher checked out the Art Students League of New York, but was disappointed by its informal attitude.

From New York they went on to Toronto, staying at the Royal York Hotel and visiting with his distinguished great-uncle, the poet E.J. Pratt, and his aunt Vi. He also explored the Ontario College of Art. Myrt then returned to St. John's, while Christopher took a detour to Sackville for a brief visit with Mary.

As spring returned to St. John's, so too did Mary. Her third year at Mount Allison complete, she took a job at St. John's General Hospital as an occupational therapist, using art as a means of therapy for children. The university had asked her to delay her fourth year because she would have been the art programme's sole student. In a year's time, the talented Nova Scotian painter Tom Forrestall would have finished his third year and be ready to join Mary for their final fourth day. Mary was no more prepared to spend a year idling in New Brunswick than she was willing to spend that long away from Christopher.

The Wests were horrified that their daughter appeared to be chasing her boyfriend. While her father told her "not to expect a cent" to sustain her during the coming year, he didn't forbid his headstrong daughter from going.

In St. John's, Christine Pratt found Mary a respectable boarding house, where the aptly named Mrs. Cooke provided oversized

meals that resulted in Mary packing on weight. Every Sunday, Mary joined the Pratts at Waterford Bridge Road for dinner.

That year Mary got the flavour of life in Newfoundland. In contrast to the hills and valleys of New Brunswick, Newfoundland was a stony landscape of scruffy trees and bogs, difficult to traverse with the Trans-Canada Highway still under construction. The province's sole university, Memorial, had become a degree-granting institution only in 1950. Fine dining in the capital was available only at the Newfoundland Hotel or the Old Colony Club; bustling Water Street offered lunch counters. Five cinemas showing the latest Hollywood films provided Mary with welcome entertainment. The steep streets and sidewalks remained un-plowed through winter, making them treacherous to walk. Mary didn't find St. John's an appealing city. But Christopher loved it, and Mary loved him.

Dressed in a uniform similar to that of a nurse, Mary occupied her weekdays with sick and injured children, helping them recover movement in their limbs by teaching them to manipulate pencils and brushes in simple art projects. Weekends she spent with Christopher, often hiking. She went to South Placentia to watch Jack, Christopher and Philip build a family cabin. Christopher's frequent outings with his male relatives and buddies to fish and hunt should have been taken as a forewarning.

During that winter and spring, Christopher continued paint-ing. He received a few commissions. A family friend, Bill Tiller, commissioned him to paint a picture of his boat, *The Gypsy on the Narrows*. As other friends and relatives bought works, his par-ents were slightly aghast at the prices Christopher was asking—decidedly non-amateur fees of $30 to $50. Some of these works from the 1950s are now popping up in auctions as their original

buyers disperse their collections or the paintings are inherited by uninterested relations. *The Gypsy on the Narrows* sold in 2015 for C$8,260.

By the spring of 1957, Christopher had built up a portfolio of works to submit with his application to art schools. He had discussed his options with Mary and his parents before applying to several excellent colleges in the UK, including Liverpool, Cardiff, Sheffield, and London's the Slade and Saint Martin's, all of which offered very rigorous, traditional training. Submission would be a nervous effort, as he had to send a selection of his best pieces rolled up in a cardboard tube with no guarantee of their safe delivery, nor even of their return. His parents had once again agreed to support him financially. Accepted at Scotland's prestigious Glasgow School of Art, Christopher would start in the fall of that year.

Having endured winter in the St. John's boarding house, and with Christopher now looking ahead to Scotland, Mary rightly demanded to know his intentions: either they got married or she would return to Mount Allison to finish her degree with Tom Forrestall. Christopher found himself at Silver's Jewelers on Water Street. Still under the wing of his parents, he was reluctant to take responsibility for himself, let alone a wife. However, he also realized that he would need Mary's support in Scotland.

Mary returned to Fredericton wearing a modest diamond ring and excited to prepare for a late summer wedding. Shortly after arriving, she underwent an operation to remove her tonsils, which resulted in her losing all the weight she had gained at Mrs. Cooke's boarding house.

By no means was Mary unusual in wishing to hitch her wagon to a star—or a potential one. Artist Joyce Wieland had chased after her man, fellow artist Michael Snow. A photo taken at a social

occasion in Toronto in 1955 shows a detached, somewhat dissipated Snow with the petite, dark-haired Wieland, arm firmly wrapped around his shoulder and with a chin-jutting look of sheer possessiveness: *This is my man.* The photo bears an uncanny resemblance to one of Christopher and Mary taken at their *Brigadoon*-themed prom; she clings to his arm with that same defiant look, as if to warn, *Hands off!* In the 1950s, a married woman was expected to visibly support her husband's career, a team effort for the success of the entire family. Like Mary, Wieland thought she would be the perfect helpmate in advancing and supporting her husband's career. And to similar detriment, Wieland ignored the fact that her ardent attention and dedication were not as strongly returned.

Mary freely admits that she had been scheming. She sincerely loved Christopher Pratt, but she also saw marrying her prodigiously talented former classmate as an escape. Options for women artists were limited in this era. Mary could have chosen to dedicate herself entirely to her art career and forget about Christopher, or about marrying any man for that matter. Several Canadian artists —Emily Carr, Prudence Heward, Rae Perlin—might have served as role models. Or Mary could have married a conventional professional man and dedicated herself to providing him with children and a well-run home. Russian-born Paraskeva Clark in Toronto took that route by marrying a Rosedale accountant, and nearly went mad trying to reconcile her artistic ambitions with the stuffy bourgeois establishment surrounding her. (She relieved some of her claustrophobia by having an affair with the noted Communist doctor Norman Bethune.) By marrying a promising artist, Mary thought she could have both—a family and a creative environment in which she could continue to paint.

The engaged couple agreed to earn as much money as they could that summer. Mary returned to Fredericton, as she had every summer during school, to work as a camp counsellor, while also preparing for their wedding. Christopher stayed behind and earned excellent money as a construction surveyor on the American naval base in Argentia. The job allowed him to spend evenings happily alone through the week at the newly built cabin in southeast Placentia, and then to welcome his family's company on weekends.

Mary wrote to her fiancé every week. He didn't always reply. Mary appeared to turn a blind eye to his inattentiveness and continued to write regularly and faithfully. Christopher knew he didn't reply as often as he should, but he allowed himself the excuse that after a long day working outdoors he was just too tired. After receiving his final paycheque, rather than heading straight to New Brunswick for the final wedding preparations, he spent Labour Day weekend trout fishing with friends on the west coast of Newfoundland. His late arrival in Fredericton meant that Mary had to secure the marriage licence with her father rather than her fiancé. Christine had sensed trepidation in her son's approach to marriage, and bluntly reminded him that he could back out of the commitment to Mary West; he could simply board the ship to England in St. John's without her. Whether she said so merely to be helpful and supportive, or was offering advice, is hard to say.

Conversely, Kay West and Mary had spent the entire summer planning for New Brunswick's biggest and most socially significant wedding of the season. Among the many showers given by the Wests' friends was one courtesy of Mrs. Hugh Flemming, wife of the premier. Just about anyone in New Brunswick who mattered had been invited to the wedding ceremony and reception, including Maritime arts royalty in Alex and Rhoda Colville.

The church rehearsal was the first meeting between the West and Pratt parents. They had little in common. With classical music playing on the gramophone, the house on Waterloo Row exuded a sense of quiet, calm refinement. Original artwork hung on the walls, and books occupied shelves and tabletops everywhere. By contrast, the Pratt house on Waterford Bridge Road smelled of cigarette smoke and shook with the booming voices of Jack, Christopher and Philip, as they argued with numerous Dawe uncles about fishing and hunting. Over bottles of whiskey, relatives and guests still ranted about Newfoundland's lost independence and dined on Auntie Myrt's seal flipper pie. Little of the gathering in Fredericton suggested the two couples would have more than a perfunctory connection in the years ahead.

On the morning of the wedding, Mary's two bridesmaids— Margaret Jean Clogg, a second cousin, and Mary's recently married friend Muriel (described in the newspaper as Mrs. Donald McGowan)—along with Barbara West as maid of honour, dressed upstairs at the West home in a state of giggling agitation while preparations for the reception went on below. The ceremony took place at Wilmot United Church on the afternoon of Thursday, September 12. Mary entered the church wearing a floor-length, white taffeta, princess-style gown with long lace sleeves tapering to points over her hands. A cascade bouquet of roses and ivy spilled over her anxious grip. Her sister wore a full-length dusty-rose velvet gown, while the two bridesmaids appeared in turquoise velvet.

Across the aisle, their counterparts looked decidedly out of place. Christopher and his best man were waiting in blue blazers and grey flannels rather than the expected tuxedoes. Roland Thornhill, nicknamed Toenail, who had been Christopher's friend since seventh grade, was filling the role of best man solely because

he was living in the Maritimes; Christopher's buddies from St. John's stayed home. It was almost as if Christopher had parachuted in to play the role of groom in the West family's wedding extravaganza.

The reception followed at Waterloo Row. In the Wests' living room, massive cuttings of gladioli and phlox surrounded the fireplace. Guests strolled through the garden, which appeared at its best in the gentle September sunshine. On the dining room table, white tapers glowed in silver candle holders alongside posies of sweetpeas. The silver tea set shone and the teacups were neatly piled, awaiting Mary's grandmother to do the honours of pouring. Guests were served dainty sandwiches, wedding cake and, of course, fruit punch. The Pratts and Aunt Myrt were bewildered by the complete absence of liquor.

Christopher would never be at ease at his in-laws' home. He'd grown up in a privileged environment too, but the cultured atmosphere of the Wests' residence—the talk of music, art and literature, as well as their close connections to the heights of Maritime society—left him feeling inferior in their company. However, he would come to like and respect his father-in-law. Reflecting on the stark contrasts between the two families, Christopher wrote decades later, "Perhaps the difference is that the Wests were into hands-on farming whereas the Dawes were into, albeit hands-on, management." He quipped that while Bill West had been a sergeant in the Canadian army in the First World War, the Dawes had preferred to stay behind in Newfoundland and fight amongst themselves.[11]

Both families had reason to feel intimidated on their children's wedding day. The unreserved style of Christopher's parents daunted the conservatively mannered Kay West: Jack, so tall and rugged; Christine, so chic in her beige satin-and-lace afternoon

dress. Her wide feather-trimmed hat, high heels and fur stole announced her presence at a volume that Kay's brown, patterned sheath dress, small, gold-coloured cloche-style hat, white gloves and sensible shoes could never achieve. The Pratts, however daunting their presence, found themselves mingling with some of the most powerful people in the Maritimes. A future deputy premier, Bill West had already served as New Brunswick's Attorney General, and the wedding guests included nearly all the provincial Cabinet ministers and their wives.

The newlyweds kept to a tight schedule. Before the reception was over, they sped off in Bill West's car to spend the first night of their honeymoon in a cabin in Fundy National Park. Departing in a grey suit with a black velvet collar, a white hat with long feathers and a charcoal muskrat jacket, Mary was dressed for a night in something finer than the rustic cabin that awaited, but the couple had no time for a proper honeymoon. The next morning they drove on to Moncton, where they left the car for Bill to collect later and took a train to Halifax to board the RMS *Nova Scotia*, bound first for St. John's and then across the Atlantic to Liverpool.

Glasgow and Mount Allison

CHRISTOPHER'S GREAT-UNCLE Arthur Pratt (1886–1961) and great-aunt Maud were waiting at the pier in Liverpool to welcome the young couple and take them for a brief stay at their home. Art, younger than his two brothers, J.C. and E.J., had remained in England after being wounded at the July 1916 battle of Beaumont-Hamel, in which nearly the entire Royal Newfoundland Regiment had been wiped out. After demobilization, Arthur Pratt opted to remain in England and worked as a broker in the export trade business on the Liverpool docks. He married an English woman, Maud, in 1924 when he was close to forty years old. They quickly began a family, having five children between 1925 and 1934, and so the youngest, Margaret, was the same age as Christopher. Art opened his home to any Pratt relatives visiting England, including his poet brother E.J. and sister Floss, both of whom arrived in Liverpool in the summer of 1924.[1]

Once on board the train to Glasgow, Christopher and Mary were completely on their own. Neither had any experience of big-city life. At that time, Glasgow, a gritty industrial centre with

a bustling dockyard, was the third-largest city in Britain. Years of coal burning had left its inner-city buildings blackened with soot. Many of the tenement slums were being torn down and replaced with blocks of high-rise towers.

They found a ground-floor flat on Grosvenor Crescent in a residential area close to the centre of Glasgow. It was a step up from most student accommodation. In a letter home, Christopher described its bed-sitting room, dining room, kitchen and private bathroom. Mary's recollection differs. She remembers an uncomfortable bedsit with two single beds at one end and a bathroom in the hallway. A pebbled glass door allowed other residents walking by to see her sitting on the toilet. Above them lived a nurse, while the third floor was occupied first by a writer and later by a Canadian naval architect, Flight Commander William Ogle, and his family.

The honeymoon voyage across the ocean in close quarters had been a reality check for Mary. Christopher expected her to wash his underwear and shirts. Once settled in Scotland, Mary began setting up their home while Christopher made his way to register at the Glasgow School of Art, a magnificent Arts and Crafts–style building designed by Charles Rennie Mackintosh. The tram ride took ten minutes; when he walked, as he most often did, it took him twenty.

Christopher had enrolled in a two-year general art course with the option to take further years. Perhaps he had been so excited to be accepted that he'd failed to read the syllabus carefully. He was disappointed to discover that the curriculum did not include life drawing and oil painting until the second year. He wrote home in November, lamenting that "the main reason I came was to learn figures and oil."[2]

First-year courses included the history of architecture, commercial and graphic design, modelling and craft. The lino-cutting course gave Christopher his first experience of printmaking methods. For half a term he resigned himself to a weaving class, which he hated, likely considering it either craft or woman's work. Somewhat more to Christopher's liking were twelve hours a week of drawing. At the end of each month, he handed in a composition on a subject assigned by the professor. His and all the other students' works were pinned up and individually criticized in front of the entire class.

Their first assignment was to portray "a view from a window." In a letter home Christopher remarks that this might prove difficult because of the acrid clouds of yellow smoke from coal fires and fog that often obscured anything outside his own window. He painted a watercolour of an entire Glaswegian apartment building with a cobblestone roadway in evocative winter-rain shades of grey, light brown and taupe, with wispy plumes of greyish smoke puffing out of chimney pots, stark, leafless trees, and a solitary man trudging along in overcoat, fedora and scarf. Many of the windows were lit up, with partially closed drapes tempting the viewer to imagine the people inside and what they were doing. Art historian Joyce Zemans would later discuss how quickly Christopher absorbed his lessons. "*Grosvenor Crescent*," she wrote, "was an exercise in a new approach to watercolour painting. Meticulously detailed, it lovingly caresses the cobblestones with a warm light. . . . the street scene is portrayed parallel to the picture frame and instead of his earlier expressionist handling, the watercolour medium is carefully controlled."[3]

From this very first assignment, Christopher Pratt stood out from his classmates. The principal, Douglas Percy Bliss, cited it for

excellence and hung it in the school gallery. Today this exceptional watercolour hangs in Christopher's dining room in Salmonier, Newfoundland.

Christopher's work also met with criticism. He remembers some in the university calling it "too American." Aside from their smug sense of European cultural superiority and refusal to acknowledge the new-found primacy of America, and especially New York, in the visual art world, Christopher's detractors no doubt held his choices of subject matter in low esteem. He had been influenced by American painters such as Winslow Homer and Thomas Eakins, but most particularly Edward Hopper, who had tried to give the United States an art of its own by choosing new-world subjects such as hotel bedrooms, gas pumps, building facades, automats and bars. The Glasgow School stressed naturalism, *plein air* painting and a sense of movement. Christopher gave them the polluted reality of Glasgow's soot-stained streets.

He threw himself into his studies, even fundamental lettering. He found it a tedious course, but it proved useful when words were necessary in a painting, as in the "Dawe's Coal and Salt" printed on the shed door of his 1970 ink-and-watercolour drawing titled *Coal and Salt*. Christopher dove into colour theory, learning the complex Ostwald system of colour harmony. Ostwald contended that certain colour combinations are harmonious while others are unpleasant to the eye. Critics would applaud both Christopher and Mary for their exceptional talent in capturing light and colour. Christopher often evokes in words his sensory awareness of colour, as in his description of Parson's Pond, just north of Gros Morne National Park on Newfoundland's Northern Peninsula. "The sky is grey at the horizon, then yellow with a

memory of orange, then green, finally blue, interrupted by a pale Payne's grey and warmer clouds, all over the soft grey sea. The horizon is the darkest line."[4]

Jessie Alexandra Dick, then nearing the end of her long career (1921–59) of teaching foundation year at Glasgow, had a profound influence on Christopher. She stressed the development of acute observational skills that required students to concentrate on drawing an object, whether it be an apple or a carrot, until they had completely absorbed its shades and contours. Chris readily took to the concept: "First drawing geometric forms; then applying these forms as guides to the portrayal of the object, the artist drew from life."[5] (In 1960, Mary and Christopher would consider naming their first daughter Jessie in honour of this influential teacher.)

Another lesson Christopher quickly grasped was the idea that art emerged from one's inner being and not simply from observation. In a letter to his parents during his first year, he tried to express how his mind was evolving. He was beginning to define himself as a painter. He wrote to his parents:

> Supposing you and I were to go out to Witless Bay and I decided to paint it. We might select some aspect of Witless Bay—some houses, some boats and stages that were pictorially correct—to make a painting. But this would only be an *illustration* of Witless Bay. What would make a piece of art would be the presentation of a scene which would show the artist's experience of Witless Bay as much as that is possible; that would show the warmth or coldness of the place; its simplicities or complications, its weight, its character, its relationship to the people who live there and to the whole world of human existence.[6]

Although thousands of miles from home and separated by the Atlantic Ocean, Christopher still brought his formal art studies to bear—even just in his thoughts—on the landscape of his beloved Newfoundland.

.

THE NEWLYWEDS RARELY fraternized with the other Glasgow students. The young Scots had adopted the beatnik look of black clothes and beards, affectations that clashed with Christopher's conventional sense of order. He described the Christmas dance, one of the few school social events the Pratts attended, as a "wild nightmare."[7] The students' bohemian sensibility was the very thing Christopher had tried to eschew when he'd refused to rent studio space in St. John's. Instead, he and Mary socialized with their Grosvenor Crescent neighbours, older couples who were outside the art world, or Glaswegians to whom Mary had been given letters of introduction from her parents' friends.

Mary and Christopher occasionally abandoned weekend chores to see a movie, but mainly spent their free days working together on Christopher's overwhelming load of assignments. Mary often did preliminary research for her husband. He also diligently filled a weekly blue aerogram form with news for his parents. Since they provided a hefty chunk of the couple's financial support, he included a careful report on their modest expenditures. Their economizing at home was soon to become more difficult.

Mary had her suspicions confirmed in early January 1958: she was pregnant. The timing was typical for young brides in the days before the pill. She had always intended to have children, but this was a surprise. Starting a family so soon worked for Mary, but less

so for Christopher. He was clearly ill at ease when breaking the news to his parents in a mid-January aerogram, announcing "the most important thing this week is that I am afraid you are going to be grandparents." He worried how his parents would take this news since they were partially financing his studies. Perhaps fearing that he sounded melodramatic, he ended his letter in a much more optimistic tone: "I hope I can be as good a parent to mine as you have been to me. That is the greatest gift a person can ever have."[8]

At the end of the school year, Mary and Christopher returned to Newfoundland. Good money awaited Christopher at the naval base in Argentia. Taking it for granted that they would live in his parents' Placentia cabin, which was over a hundred kilometres of poor roads away from St. John's, they expected Mary could have the baby at the local cottage hospital. Neither of them had yet grasped the realities of becoming parents.

Near the expected date of the birth, Mary moved into St. John's, where the baby, named William John after Mary's father, was born on July 30, 1958. Mary has frequently told the story of baby John's first bath in the Pratt home. Her mother-in-law, Christine, a qualified nurse, re-created a traditional hospital procedure for bathing a newborn, complete with thoroughly heated bathroom, washing one half of John and then swaddling him in heated towels and bathing the other half. When Mary took the baby back to Fredericton for the rest of the summer, Kay West bathed John in the kitchen sink. In Mary's mind, this bath episode typified the difference between the two grandmothers: Christine fussed while her own mother nurtured.

Christopher stayed behind in the Placentia cabin to work. For weeks, he had been dithering over whether to return to Glasgow for his second year. With an infant, it would certainly have been

easier to attend an art school in North America. Eventually, they opted to return to Scotland so that Christopher—who had yet to complete any of the post-secondary programmes he'd enrolled in —could at least finish the two-year general course.

Back in Glasgow, they first bunked in with a Canadian family, the Ogles, who had been neighbours at Grosvenor Crescent before moving to a newly built house in the suburb of Netherlee. From there, the Pratts found a well-furnished four-room cottage, with a modern kitchen and bathroom. They converted the dining room into a studio, cozy with a small coal fireplace. Chris's second year proved even more arduous than his first, with classes until four thirty every afternoon. The long bus ride—the commute took nearly forty minutes—in the dark of late fall and winter meant that he didn't arrive home until close to six o'clock, having left Mary alone the entire day with the baby. South of the city now, they had hoped to avoid Glasgow's smog, but that winter the yellow haze settled thick over the city. Even in Netherlee, Christopher could taste the sulphur vapours in his mouth and was often sick. He missed Newfoundland desperately; when they had guests, his idea of entertainment was a slide show of Newfoundland scenery.

Mary was proving an extremely well-organized housewife, to the benefit of her own art. With the baby asleep in the early evening, she could join Christopher in their studio to paint. She learned second-hand everything her husband was being taught, although she already had a strong technical foundation from her own years at art school. Energized at day's end by the promise of time at the easel, she had no intention of giving up her artistic ambitions.

That second Christmas, they took the train to Liverpool to share the holidays with Art and Maud Pratt. Returning to Glasgow for New Year's Day, they spent the day with Bill and Tessa Ogle.

While Christopher went off to a Ranger–Celtic football match with Bill, Mary and Tessa stayed behind with the children to prepare dinner.

Mary worried that Christopher was jealous of John. Naturally, the baby was taking up a great deal of her time. In letters home, though, Christopher appears proud of his son's benchmarks and evident cleverness. He reports that his first-born had an aversion to pureed prunes, whacking the spoon and spattering the purple paste over the floor as well as his father. Discovering the baby's first tooth, Christopher sternly told him to "brush his tooth" before bed. But, despite the good humour, there is no doubt that the additional responsibility and distraction of a baby in the house made it harder for Christopher to concentrate on his studies.

During the Pratts' entire stay in Scotland, only one family member paid a visit. Aunt Myrt arrived during the Easter holidays of 1959 and took the three of them to London, where Mary spent most of the trip in the hotel with John while Christopher and Myrt visited art galleries. As much as, or perhaps more than, the works of art in the National Gallery, Christopher was impressed by a man who had arranged his own modest paintings against a wall outside it, with a sign that read *All my own work*.

Having completed the two-year Foundation Course in May 1959, Christopher was accepted into the three-year specialized course in drawing and painting. The thought of spending three more years away from Newfoundland, and particularly in the noxious air of Glasgow, overwhelmed him. They packed their bags and sailed home. It had not been an easy decision to turn down a three-year degree from one of the world's foremost art schools. He later wrote, "I often ask myself why I quit the meat and muscle, the challenges of the Glasgow School of Art. There seemed to be good

reasons at the time, but perhaps it was a matter of immaturity, of insecurity. Or that the obvious benefits of being at Mount Allison in the late '50s outweighed that."[9]

Lawren P. Harris had made Christopher a promise: were he to return to the little university in New Brunswick, he would not have to attend formal classes and would have access to all the facilities and a studio. The benefit of taking Harris up on his offer extended to Mary as well; she could at last finish her degree over the two-year period. Furthermore, Mount Allison was close to Mary's parents and most certainly closer to Newfoundland.

They arrived in Sackville in autumn 1959 and, after a short stay with Mary's uncle, rented a picturesque house from the university. It had a large glass-enclosed veranda and located them only five minutes from the campus. Christopher took figure composition, landscape, graphics and portrait. Mary took mural painting and landscape, and had to go to the studio only once every couple of months. The arrangement served her well, because she was soon pregnant again. Christopher commented in a letter to his parents that since a self-portrait was a degree requirement, Mary's condition "should provide an interesting variation on the general theme." She chose to portray herself in the kitchen, pouring liquid from a light-brown pitcher into a luminescent green bowl. Predominantly in other shades of green, the watercolour features a curly-haired Mary gazing out at the viewer through her round-rimmed glasses, dressed in a white blouse and wrapped in a yellow apron.

He described his own *Self-Portrait* (1961), which depicted him as a dour-looking man with arms crossed defensively, his eyes unfathomable, as his "Eichmann portrait," because he was painting it in the spring of 1961 while listening to broadcasts of the war crimes trial of Nazi SS officer Adolf Eichmann. Mary recalled

that, while the university kept Christopher's self-portrait for the Owens Art Gallery, the Fine Arts Department sent her portrait back to her parents' home in Fredericton. Angry at the rejection and jealous of Christopher's acceptance, she instructed her father to destroy the work.

At the end of the 1960 spring term, Christopher went back to the family cabin in Newfoundland to paint, leaving Mary and John to be picked up in Sackville by Bill West and driven to Fredericton to await the birth of the second baby. It appears that Christopher did sense that parking his family with his in-laws could be construed as shirking responsibility, or at least as being insensitive to Mary's needs. He felt it necessary in letters home to repeatedly assure his parents, "She'll be in good hands."

Christopher was thus absent for the birth of his first daughter, Anne, on May 23, 1960. As soon as she was able, Mary, impeccably dressed in a white summer frock, boarded a plane with newborn Anne and the distraught toddler John, whose security blanket had been forgotten at his grandparents', and travelled to St. John's to join her husband.

Christopher's summers working as a surveyor in Argentia were behind him now (though in some of his most memorable works he would return to capture the sight of Argentia's abandoned buildings after the Americans had departed). In that summer of 1960, he began the preliminary work for a major oil painting, *Demolitions on the South Side* (1960). Art historian Joyce Zemans explains that *Demolitions* "was an important step in Pratt's resolution of the relationship between form and content and the resulting 'constructed' art work was crucial to his artistic development."[10] The St. John's street scene, empty of life, is viewed frontally, parallel to the picture plane. His unique style was taking

form. (*Demolitions* took second prize at the first Atlantic Awards Exhibition at Dalhousie University, netting Christopher a cheque for $500.)

He took time away from his otherwise intensive focus on painting that summer to teach a painting course at the Nova Scotia Arts Festival. Borrowing his father's car, he drove to Tatamagouche on the Northumberland Strait. His fourteen-year-old brother came along for the adventure. They camped for ten days while Christopher taught and Philip took a leather-craft course. Mary remained in St. John's, caring for the two babies.

They returned to the rental house in Sackville for the 1960 fall term. Along with painting, Christopher took a philosophy course, while Mary took a modern novels course with heavy reading and essay components. They hired a girl from the university to come in for nine hours a week to give Mary a short respite from looking after the children. That Christmas was spent with the West family, but on Boxing Day Christopher left his wife and children to spend a week in St. John's with his parents.

Upon his return to Sackville, Christopher appears to have had a sudden epiphany about Mary's crushing workload as both a student and the mother of two very young children. In a letter of January 5, 1961, he wrote to his parents: "I have arranged a few things to make matters a little easier for Mary. For instance, I'm going to insist that she send out all but the children's things to the laundry (up to now she has done *everything* herself, diapers to blankets)." He continued, "I feel I owe it to Mary to let her spend as much time as possible on her work, and to make things as favourable for her as I reasonably can."[11] Did he come to this awareness himself? Or could it have been that either the Wests or the Pratts, or perhaps both, commented on Mary's onerous workload?

Lawren P. Harris told Mary that if two artists are married, only one of them can be a success. He went on to say that in her case, obviously, it would be Christopher. Undaunted, she had set herself the goal of being an artist but accepted that for the time being a career would be secondary to marriage and motherhood. Christopher realized that, as soon as they graduated, he would need to financially support his family. Prizes in amateur competitions were lovely, but at a much more serious, professional level, success had become his imperative.

Townie and Bayman

AFTER THE YEARS spent in Scotland and New Brunswick, Christopher Pratt simply could not bear to be away from his native island any longer. His parents understood that their elder son intended to return to Newfoundland, and they had encouraged him to follow his desire. In a March 1959 letter to Christopher shortly before the end of his first year back at Mount Allison, Jack wrote, "I have always had a wish that some day you would be able to do something in your chosen field which would be expressive of life and conditions in Newfoundland, and I believe that basically, this is what you want to do."[1] For Mary, as comfortable as she'd been in Sackville, so close to her parents and sister, this meant that eventually settling in Newfoundland was non-negotiable.

The Pratts' high standing in St. John's society assured the aspiring artist of a good job, were he to return. In fact, in 1961 the recently established Memorial University (MUN) offered Christopher two positions. He accepted the dual roles of teaching art and serving as the inaugural curator of the MUN Art Gallery, then under construction in the university's new yellow-brick library. Upon opening, it would be the only art gallery in the province. When

Christopher assumed his positions at MUN, the university president said to Mary, "Well, young lady, it will be your job to keep his feet on the ground." She retorted, "I don't think so. It will be my job to keep his head in the clouds."[2] Mary accepted this dutiful life she was leading so that she might one day be married to a great artist, not the curator of a small university art gallery.

In anticipation of the MUN gallery's opening show, Christopher travelled to Ottawa and called on Russell J. Harper, curator of Canadian art at the NGC, to borrow a selection of works. Bemused by the visit from this brash young Newfoundlander with the celebrated last name Pratt, Harper agreed to the loan.

Besides his curatorial responsibilities, Christopher had been hired to teach studio classes and the history of art with the newly formed university extension service—an innovative programme of community economic development being delivered primarily to rural Newfoundland. In a letter to his parents, Christopher described the troublesome issue of selecting visual examples for his art history courses. He suggested that almost all Western art would prove offensive to one group of Newfoundlanders or another. Art from AD 500 to 1500 abounding with Virgin Marys and other Catholic symbolism would deeply offend Protestants. Regardless of religious persuasion, all would be offended by nudes. And as for showing abstract art, Chris wrote, "I will then be known simply as a nut."[3]

Christopher and Mary put the down payment on a small postwar government-subsidized bungalow near the university, at that time on the outskirts of St. John's. Beyond their backyard stretched farmland. Mary found the little house—brand new with modern appliances, including a washing machine—perfect. Christopher, referring to the newly built university buildings and

their bungalow, felt "trapped in a maze of concrete blocks." In a 1973 feature article about him in *Maclean's* magazine, Christopher said of their house that so suited his wife's needs, "I can't even bear to think of the place. It's all I can do even to drive up that road now."

Mary's earlier rebuttal to the university president was proving correct. Her husband's employment was leaving him little time to paint, although he received ample recognition for almost any work he shared publicly. His silkscreen *Boat in Sand* (1961), created at Mount Allison, was chosen for the 4th Biennial Exhibition at the National Gallery of Canada, and his *House and Barn* (1962) for inclusion in the 5th Biennial Exhibition. This painting, though, was the only one he managed to complete during his years of employment at the university.

As part of the university's extension services, both Mary and Christopher taught evening art classes in St. John's, mainly to housewives. Student Kathleen Knowling, who would later become an artist in her own right, remembers Mary as warm while Christopher struck her as self-absorbed and oblique with his instructions. Reflecting on those years, he admitted that he had been a terrible teacher, describing himself as "dogmatic" and "unsympathetic." He asked one woman why she came to his Thursday evening art class, and she replied that that was the night her husband went curling. When he later reread the vitriol and frustration in his diaries from this period, he destroyed them.[4]

By the spring of 1963, Christopher was juggling several roles: he was a husband, a father of now three preschoolers—a second daughter, Barby, had been born on February 16, 1963—a homeowner with all the attendant chores, and the curator of the university's art gallery, as well as a teacher working extra hours in the

evenings. The salary was comfortable, but he was accomplishing little of the work that really mattered to him. When Alex Colville decided to retire from Mount Allison and move to his wife's family home in Wolfville, Nova Scotia, to devote himself entirely to painting, Christopher was given the opportunity to replace him, but he turned down that attractive offer. It would have meant leaving Newfoundland, for one, but also rededicating himself to academic life instead of painting.

Under the strain of all these pressures, Christopher complained to his doctor frequently of stomach problems. Mary awoke in the night to his panic attacks and vomiting. Always slim, he became gaunt and shed more of his already thinning hair, a loss that greatly troubled him.

To add to his mounting distress, the Pratt cabin in southeast Placentia Bay had burned down in the winter of 1961. The cause of the fire was never determined. With his bolthole destroyed, Christopher was left with no escape from St. John's. However, Jack and Christine relieved their son's despair somewhat when they rented a cottage on the south coast of the Avalon Peninsula near the small village of St. Catherines on the Salmonier Line. And Christopher bought himself a thirty-four-foot trap skiff called *Walrus*, which he sailed with his father on summer weekends in the nearby St. Mary's Bay. In the summer of 1962, the Pratt seniors purchased the cottage.

To the local community, the "Murray place" had always been associated with wealth and social standing. The property had originally belonged to the Andrew Murray family, one of Newfoundland's oldest and most prosperous merchant dynasties. The Pratts bought it from the Murrays' daughter Gerta and her husband, Bill Crosbie. The cottage had been used as a seasonal fishing lodge.

Protestant townies, their cars loaded with fishing gear, tennis rackets and exotic groceries, appeared in this Catholic rural community at the end of each winter. Locals were hired to provide housekeeping services and help care for the tennis court and grounds, including the formal flower gardens. A visitor had once recounted how she and other guests sat in the living room with a great blazing fire in the long-hooded stone fireplace and gazed out the wide windows at the property's pond, "a wide quiet pool of the bluest water" where three muskrats were playing in the reeds with a beaver dam close by.[5] At the end of every season, the Murrays had closed the cottage down and drained the water pipes to ensure their unwinterized summer retreat would survive the coming deep freeze undamaged.

Jack and Christine, aware of their son's worsening emotional fragility, offered Christopher and his young family use of the cottage. This was a generous offer, since they had bought the retreat with the idea of spending more of their own time there. Christopher instantly resigned from his university job, and in mid-May 1963 he moved his family to the furnished cottage. The Pratt grandparents and Aunt Myrt helped him, transporting baby equipment, provisions, linens and, of course, art supplies. The move was little more than a blur to Mary, who was coping with two preschoolers and an infant, as well as new distance between her and whatever social connections she had developed in St. John's, let alone her family in New Brunswick.

Christopher had explained the move to Mary and his parents as an experiment to see if he could get his legs under him and support his family as a professional artist. They were all under the impression that this would be just a one-year adventure. Their little house in St. John's had been rented out with their furniture

still in it. Mary's silver and chinaware, along with other wedding gifts, had been put in storage, awaiting the family's return. He had assured his wife and both sets of grandparents that John, now school-aged, would attend only one year in a rural Catholic school.

At the crack of dawn on their first morning there, Christopher went outside and, through the mist on the pond, saw a flock of eider ducks flying up the river. He took that as a sign and confirmation that he would enjoy artistic success while living in Salmonier. As he listened to the rustling of the trees, he thought to himself that no one would ever convince him to leave. "I said so to myself. I really did know that."[6]

Christopher began to make himself a studio. The two-bedroom cottage was reasonably spacious but simple. It had a bathroom, a large living room with its huge windows (the family called them "shop windows") and a very basic kitchen with a pass-through to a large back-room space with a portion used as a dining room. A covered passageway led to a second dwelling, known as "Gert's cottage," originally built when the Murrays' daughter was a teenager so she could have friends for weekend sleepovers. This smaller building had a bathroom, bedroom and living area with a wood-burning stove. When Christopher took in this room, he saw a perfectly adequate studio space. Jack sent a skylight to give his son more natural light in his new workspace.

Mary's sister Barbara came to help that first summer. She had been alarmed at how hard Mary was working to look after three small children while keeping up with the laundry, ironing and housekeeping—and even baking the family's bread. The sisters pushed Barby in an old-fashioned black stroller along the gravel road, with the newly acquired family dog, a border collie called Rob, ambling along beside them. Barbara recalls her astonishment, too,

at Christine Pratt appearing every weekend, often with guests, and presuming her daughter-in-law would wait on them hand and foot.

Many years later, Christine acknowledged the thoughtlessness of these constant visits: "Now I feel bad about it but at the time it was just natural. It was our summer place so every weekend my husband and my sister Myrt and one or two other guests would go down. We would bring the food but Mary did the cooking."[7]

Once autumn arrived and the first frost meant partridgeberries were ready for picking, any visitors other than the Pratt in-laws stopped coming. While seasonal residents were boarding up windows and leaving for home, Christopher and Mary began dealing with frozen water pipes, dragging buckets of water up from the pond. In a building without insulation, it was difficult to keep the children warm. That first winter, Jack paid for the furnace oil.

He, Christine and Myrt still showed up on weekends, bringing groceries. They arrived on Friday evenings and left after elaborate Sunday lunches of roasted chicken or beef with a full complement of vegetables and assorted pies and cakes, all prepared by Mary. The Pratt children were happy to see their grandparents, "Daddy Jack" and "Nanny Peek"—and of course "Aunt Myrtie," who routinely provided Mary some small relief by cooking porterhouse steaks for Saturday dinner. Mary kept her feelings to herself, but it would have been impossible not to resent the constant impositions.

Just before their first Christmas in Salmonier, Christopher received a terrible shock while scanning a newspaper he was about to crumple and toss in the fireplace. A brief notice in the *Evening Telegram* announced that Janet (Tannie) Lake Wilson had died at Grace Hospital on December 19, 1963. Christopher's first girlfriend had married William "Spike" Wilson and had three children, who

were still very young. Oddly, the death notice did not include her husband's name, and the funeral procession left from the Lake family home on Hamilton Avenue in St. John's. Her parents dealt in noticeable haste with their daughter's burial, placing the death notice in the newspaper on Friday followed by her interment on Saturday afternoon. There was no mention of a church service. Being so close to Christmas Day, perhaps the family opted for a quick burial for the sake of the three children. It was whispered that Tannie had died of anorexia nervosa, although it would not have been a widely recognized condition in the early 1960s. Christopher had not spoken to Tannie in years, but her premature death came nonetheless as a shock.

CHRISTOPHER WAS NEVER leaving Salmonier. He never directly addressed his intentions; he simply sold the St. John's house and cashed in his $500 of pension funds from MUN. His parents never questioned the fact that their son had adopted their summer house as his own; instead, Jack Pratt was concerned for Mary. He and Christine realized that Christopher needed Mary in order to stay focused himself.[8] When Christopher received his first honorary degree, Jack sent a congratulatory telegram, stressing the vital role of Mary: "may you and Mary, who has played such a major part in your success story, enjoy many years of continuing progress."[9]

By 1964, they had become a family of six. Edwyn (Ned, August 15), named after his famous relative E.J. Pratt, was Mary's fourth baby in six years. No matter where Mary Pratt had been living, her time would have been utterly consumed with taking care of so

many youngsters. But in the isolation of Salmonier, especially during winter, she had the added burden of feeding a family without even a grocery store nearby.

Despite the limited amenities of the Salmonier cottage, Mary tried to maintain the strict domestic standards of her childhood home, having finally brought her wedding china and crystal out of storage. Christopher, on the other hand, says:

> I have an instinct for "cabin living," coming and going with the freedom of a cat, curling up to sleep as the mood overtakes me, in my bed or on the couch in the corner of my studio, not wanting primped pillows or sheets or furniture that needs dusting every day, and where the door to the outside world is just a door to another room.[10]

This unspoken clash of values drove a wedge between the couple. It revolved around Mary's belief in the correctness of her family's code of quiet order and grace in contrast to the Pratt/Dawe clan's rambunctious camaraderie. At the beginning of their marriage, she confronted this clash of decorum—what she called "the war of which way is the right way." She explained in her memoir, "I escaped the Eden of my childhood and ran with blind determination into a chaos so full of massed flowers, casseroles, exotic clothes and stylish Christmas trees that I almost drowned in the confusion."[11]

Understandably, Mary's parents were unhappy with the primitive conditions, social isolation and limited cultural opportunities of their daughter and grandchildren; there were no libraries, cinemas or theatres nearby to enrich their understanding of the world. There was not even a Protestant church near St. Catherines.

Christopher, by contrast, felt no need for cultural stimulation. In Salmonier, he had found a sanctuary where he felt in control of his life—and where he could face the pressure to make a living as a professional artist. His Mount Allison professor, Alex Colville, worried about the Pratts' isolated existence, warned in a letter: "You must continue to believe that the making of good art *is* important, even though perhaps living where no one even knows that art exists."[12] But nature, and particularly the Newfoundland landscape, gave Christopher all the imperative and inspiration he needed.

Though tempering her ambitions until her children were school-aged and more independent, Mary had not forsaken her own dream of becoming a professional artist. She captured fleeting hours each week to work on small watercolours, which didn't require the extensive preparation of her husband's oil paintings. She would play the helpmate while he cast himself as a successful and increasingly famous artist. As long as their roles were mutually compatible, life in Salmonier was good.

Life in a Bubble

MORNINGS CAME EARLY in the Pratt household. Christopher and Mary rose around six and ate breakfast together before the children descended upon them. By seven Christopher was in his studio, from which he returned to the kitchen only at ten for a cup of tea and again at lunchtime for a meal prepared by Mary. After an early family dinner and a catch-up with the CBC evening news, Christopher went back to his studio until around nine thirty. The Pratt children were aware that their father needed calm and quiet to work.

Christopher worked formidably hard during his first years in Salmonier. He signed his first work completed there, a drawing, *Window by the Sea*, on June 28, 1963. That summer, although busily setting up his studio, he found time to work nearby on St. Joseph's beach, and one result was the watercolour *Sheds on St. Joseph's Beach* (1963). He called these sheds folk architecture at its best. The original price he charged for the painting is unknown, but it was likely no more than $100; nearly four decades later, a private collector from Ottawa sold this work at a Sotheby's art auction for $11,000.[1]

Christopher's meticulous approach to the canvas meant he produced new works slowly, leaving him in need of a more immediate plan to support his family. So he borrowed a page from Alex Colville, who every year created several limited edition silkscreens, and began to make prints—serigraphs at first, and later lithographs. Referring to these works as his own "cottage industry," Christopher produced at least one silkscreen limited edition print a year. He worked directly on the silk, using a water brush or a ruling pen to apply glue or lacquer to fill in all the parts of the screen that he wanted ink not to pass through. His complex prints used ten to sixteen screens. He calls his serigraphs "multiple paintings" rather than the usual term for such mechanically constructed images. In the printing process, he began with a hundred printing boards (a necessarily firmer surface than the canvas he'd use for painting), but it was rare that more than half of them met with his approval as acceptable commercial prints.

Hand printing is an arduous and messy process that Christopher, with his proclivity for neatness, did not enjoy. But it did present the Pratts with a rare opportunity for teamwork in the studio. Clothed in a protective shirt and face mask, he placed a screen on the printing board and with considerable strength used a squeegee to pull the paint along the entire length of the screen to force the colour through. The work had to be done quickly, as the paint tended to dry on the screen. At this point, Mary stepped in to remove the printing board and place it on the drying rack while Christopher started in on the next one. When the children came home from school, they found prints drying all over the house, even on their beds. The nasty reek from the paint, mineral spirits, lacquer and acetone used in the process lingered for days.

Printmaking remained a crucial part of Christopher's artistic output. Influenced by his boyhood hobby of stamp collecting and his family's anti-Confederation stand, he produced a series of large serigraph prints between the years 1968 and 1974 based on pre-1949 Newfoundland stamps. These were very different themes from those Christopher usually explored. In another thematic departure, some of his prints included wildlife. The somewhat menacing wildcat in *The Lynx* (1965) appears to be oversized until one realizes that it was created from a rabbit's-eye view. "Its last view, I imagine," Christopher mused.

Along with the silkscreens, he was producing works in pen, ink and watercolour, all of which helped pay the family's bills. His greatest focus, however, remained on oils, with which he rarely completed more than two or three paintings a year. Oil is a slow medium and many artists prepare at length for a major work, but Christopher's painting process is particularly laborious. He makes numerous studies or sketches that may change radically until he is satisfied that the composition will translate into a painting. This is common practice. However, once he's decided on a composition, Christopher produces a rough drawing and then disciplines it using what he calls "engineering drawings." This grid system of his own design is based on the geometric construction known as the golden section or ratio, which is itself a mathematical order of proportions based on the rectangle. Basing images on these proportions helps to direct the viewer's visual path, creating a picture pleasing to the eye. Discovered by the ancient Greeks, the golden ratio, or golden mean, has been used by many artists, from Leonardo da Vinci and Michelangelo to Salvador Dali. Mount Allison instructor Ted Pulford taught the golden section as a method of structuring a composition. Alex Colville used the golden section and other

geometric ratios to mark out space in preliminary studies when he drafted. The end result of Christopher's engineering drawings are works that strike their viewers as depicting a moment somewhere on the line between reality and abstraction.

.

ALTHOUGH THE IDEA of artists struggling in poverty, their children shivering as they sleep in unheated garrets, makes for a much more dramatic story, Christopher and Mary Pratt never truly suffered for their art. Their parents had helped pay for their art education and travels to Scotland. They had been given a home and studio in Salmonier. At this early stage of their careers, relatives and family friends became patrons, buying their works. The unwinterized cottage could indeed be uncomfortable, but the family never experienced real misery like that of contemporary Newfoundland artist Gerry Squires, whose wife and two daughters endured years of living in an isolated and freezing lighthouse in Ferryland, on the Avalon shore. The Pratts, conventional in appearance, with four well-behaved children packed into a family sedan, mostly lived like a typical bourgeois 1960s family.

Mary had never learned to drive and so relied on local produce, which meant mainly potatoes and other root vegetables. Christopher regularly drove her into St. John's, and she sometimes took Gordon Penney's communal taxi. Those who were not used to cars and became motion sick were moved to the front seat, where Mr. Penney provided a plastic bucket if passengers had to throw up. Mary, a "come-from-away," always felt a disconnect with the locals. She was embarrassed and awkward, and admits that she didn't "have the common touch." Neighbours deferred to the people

living in the "Murray place" and always called them Mr. and Mrs. Pratt. For all the modesty of Mary and Christopher's living arrangements, vestiges remained of the old Newfoundland pecking order of merchants and outport folks.

The four Pratt children have mostly positive memories of their upbringing in rural Newfoundland. They all attended Our Lady of Mount Carmel School from grades one to eleven. The village's traditional one-room schoolhouse had recently been replaced on a rise of land overlooking the inner waters of St. Mary's Bay, referred to as the Arm or Salmonier Arm. Relying heavily on whatever choice of lumber was available from a nearby mill, the school had birch board floors, birch plywood walls and birchwood desks. Classroom doors faced each other the length of the single long hallway; along the walls hung fire extinguishers with inspection labels printed *J.C. Pratt*, the name of the family hardware business.

The children made friends at school, although Barby, somewhat shy and delicate as a child, felt more comfortable going into St. John's to play with her Dawe cousins or, later, children from the sailing club. They played with the six children of their next-door neighbours, Jim and Elsie Power. Together, the Pratt and Power children learned to skate on the frozen pond in winter and swam in it during the summer. Elsie sometimes helped the Pratts out with domestic work and became a friend to Mary.

Every morning the children all piled into Jerett Walsh's school bus to bounce the four miles down a narrow gravel road. Mary sent them away with lunchboxes full of what she called "inventive" goodies, including carrot sticks and homemade soup kept hot in Thermoses. Like children everywhere, they were really hoping for something simple, like peanut butter sandwiches. John Pratt remembers one memorable swap in which he got a schoolmate's

sandwich made from huge slices of white bread slathered in margarine and stuffed with whale meat.[2]

Lunch at the school lasted an hour and a half, time enough for many children to go home for a midday meal, or "scoff" in the local slang. Those who remained had even more time, which often resulted in mischief. John recalls many adventures, one of which could have ended tragically. During the winter months, the Arm froze over, although the tides created loose pans of ice known as "clampets." John and his buddies would sneak down to the shallow inlet and, with the aid of wooden poles, ride around the shallows on the ice pans. Only the intervention of some older boys saved John one day when his pan began to drift toward open water. Needless to say, he kept this adventure to himself (until years later, when his parents were horrified to read his detailed account of the incident published in *Newfoundland Quarterly* magazine).[3]

With their parents working from home, the Pratt children received quality attention from both Christopher and Mary. For one thing, living in the home of two artists provided ready access to art supplies for crafts. Christopher built his two daughters a wooden dollhouse, painted white with a blue roof, with stairs to a second floor and large windows cut out on the sides. Although he was a typical 1960s husband who never helped with cooking or housework, Christopher took an active role with his family. He drove his eldest son and friends to play floor hockey at the school gymnasium in nearby St. Catherines. He spent a great deal of time to-ing and fro-ing between Salmonier and St. John's, driving children to appointments and running errands. In winter he often broke away from painting to clear snow off a portion of the frozen pond and play hockey with John and his friends. In the warm months, pucks gave way to baseballs as Christopher joined his sons for many a

game of catch in the yard. So invested had Christopher become in the community, he served for several years as a member of the Mount Carmel town council.

It is strange that in their isolated location Mary did not learn to drive. Perhaps she recognized that the family's dependence forced Chris to make himself available to shepherd his wife and children to all their appointments. She made up for his time behind the wheel with time in the kitchen, though. The welcoming smell of fresh baking greeted the children when they piled off the bus at the end of each school day.

Salmonier could seem a lonely place. Mary certainly found it so, and she wanted the children to look forward to coming home. Holidays were particularly memorable. At Easter, she baked hot cross buns and breads flavoured with cardamom, anise, cloves and cinnamon, and frosted them with white butter icing. One Easter, unable to keep her artistic spirit out of the Salmonier kitchen, she made a great round, rich, sweet bread with red-dyed boiled eggs nested on the top.[4]

Christmas celebrations highlighted the great gaps between the Pratt and West family values. Mary's childhood holidays had been quiet and understated, but with an impeccable dinner table complete with glistening homemade red jelly in a cut-glass bowl. Like every meal in the Wests' Fredericton home, Christmas dinner was served without wine. By contrast, the extended Dawe family celebrated loudly on Waterford Bridge Road, fuelled with ample libations. Christine Pratt went all out, planning a different colour-themed Christmas tree and table settings every year. Lavish gifts awaited the grandchildren. John Pratt remembers one year when "Daddy Jack" gave him a large Lego kit and he flung his arms around his grandfather. Tears came into John's eyes when he recounted

this episode, realizing that his own father in those early years didn't have the money to buy such extravagant presents.[5]

During their first Christmas at the Salmonier cottage, the electricity, which had been installed locally only a few years earlier, went out from December 18 to 24. Feeling rather glum in the cold and dark, Christopher and Mary decided to open one present on Christmas Eve. Choosing the parcel from Christopher's English relatives, Uncle Art and Aunt Maud, they unwrapped a set of angel chimes, which they immediately set up on the windowsill. As the heat from six little red candles below made the angels rotate, their light reflected magically against the windowpanes. In a darkness that only such isolation as theirs could provide, these smallest of lights enchanted the couple. Mary described this as "a perfect moment."

.

WHILE THE PRATTS thrived, the economy of Newfoundland continued to sink. Since joining Confederation in 1949, the province's first premier, Joey Smallwood, had valiantly attempted to improve the lives of impoverished outport folks. He encouraged foreign investors to bankroll Newfoundland factories, running the gamut from a cement plant to a leather tannery to a manufacturer of rubber boots and clothes. Alas, the boots leaked due to the factory's shoddy second-hand machinery. Most of these enterprises "failed up," as Newfoundlanders describe it, within five years.

With the decline of the cod stocks in the mid-sixties, Smallwood attempted to resettle non-viable fishing villages from remote bays and islands, where they were without any services or amenities. During a five-year period (1965–70), 119 communities were

resettled. Entire villages of houses, stages (wooden elevated sheds used to process the fishermen's catch of cod), shops and churches were abandoned. Although they gained access to education and medical facilities, electricity and sanitation, resettled families lost their traditional self-sufficiency attained through growing their own food, tending to livestock and fishing. Young people from across the province with no hope of finding local employment— including many from St. Catherines, Mount Carmel and St. Mary's Bay—began to drift into St. John's or across to the Mainland. Many who stayed in the outports scrambled to find enough hours working in fish-packing plants or on road crews to collect the stamps needed to apply for a few months of unemployment insurance.

Amidst this turmoil, Mary was managing to create an idyllic domestic life in Salmonier that defied the family's surroundings and echoed the protective bubble of her own childhood. She and Christopher worked in harmony. Powered in no small part by his wife's determination and sacrifice, his star rose even as the island around them descended into decades of frustration.

You Can't Pretend Beach Rocks Are Potatoes

IT IS NOT easy to determine why Christopher Pratt, isolated in rural Newfoundland at a time when it was a "have-not" province that provoked Newfie jokes across the country, rose so quickly to prominence. He painted in a realistic style in the midst of Canada's focus on abstract expressionism. When asked, he attributed his quick success to luck, but added, in his way, that talent might have something to do with it: "You can't pretend beach rocks are potatoes. You have to have something to work with."[1]

Christopher's marked artistic talent had been acknowledged early. When he was still a student, his first silkscreen, *Haystacks in December* (1960), was selected for an exhibit at the London Public Library and Art Gallery in London, Ontario. That led to an invitation the following year for Christopher to serve as a judge in another London exhibition. A university town and headquarters to staid insurance companies, London was an unlikely hub of artistic activity. However, in the 1960s it was home to three renowned painters: native sons Jack Chambers and Greg Curnoe along with Tony Urquhart, artist-in-residence at the University of Western Ontario. Montreal-born Paterson Ewen moved to London in

1969 and began teaching drawing and painting at Western in 1972.

Although labelled an Atlantic realist, along with Alex Colville and Tom Forrestall, Christopher never associated himself with a group or school of painters. Toronto was home to the abstract expressionist group Painters Eleven. Saskatchewan was the site of the famous Emma Lake Artists' workshops, in which established artists were invited to teach other professional artists, who honed their skills with two-week study sessions; the workshops spawned the Regina Five group of abstract painters. But in rural Newfoundland, Christopher kept to himself. Mary was his only sounding board, though it would be some time yet before she was recognized as his peer.

Without realizing it, Christopher had absorbed the noblesse oblige attitude of entitlement that comes with being a member of Newfoundland's merchant class. This high-caste status is part of Christopher's persona. While he is genuinely unpretentious, he is also very confident and slightly aloof. He knows he's a Pratt. And this remoteness results in his not being fully embraced by his fellow Newfoundlanders. While he is highly respected and admired, there are several other artists in the province, the late Gerry Squires for one, who are genuinely loved by the people.

·

DAVID SILCOX SAYS he first discovered Christopher Pratt's work in 1964, but he can't recall where. Most likely he had come across *Woman at a Dresser* at the 6th Biennial Exhibition at the National Gallery of Canada. The exhibition had subsequently travelled to the Commonwealth Institute in London, England. Silcox had reviewed in *Canadian Art* magazine the reaction of the British press,

which had been uniformly negative. Christopher commented in his diary that the reviewer for the venerable international art magazine *Apollo* had observed: "the sprinkling of what could be called 'traditional' paintings is so bad as to be embarrassing."[2] Christopher wryly noted that his *Woman at a Dresser* was likely the most traditional in the whole show. What the reviewer had failed to recognize was that the painting had been selected by William Townsend, the vice-president of one of Great Britain's most prestigious art schools, the Slade. Christopher had encountered the smug, prejudicial attitude of the British critics while a student at the Glasgow School of Art. But the art world had moved on from Europe, and it was finding stars in America. Christopher Pratt, were he to pursue the opportunity, had a chance to be one of them.

Silcox, an ambitious man with a keen interest in art history, would become one of Canada's most influential visual arts bureaucrats. He graduated from the University of Toronto and began his career organizing art events, such as the 1961 Conference of the Arts and the first Toronto Outdoor Art Exhibition, which garnered him the honour of being named the *Globe and Mail*'s 1962 "Man of the Year in Arts." Silcox had made a good marriage with Mimi Fullerton, the daughter of Douglas Fullerton, who coincidentally had been born in St. John's and rose to become a top economist in Ottawa.

By 1965, Silcox had been appointed the first Senior Arts Official of the decade-old Canada Council. He became a "kingmaker" with his power to provide artists with government financial support. Using a system of peer jurors, Silcox travelled across the country each year to visit artists and decide who would receive a bursary to support their work. In 1969, Silcox invited Christopher to join Quebec painter and sculptor Ulysse Comtois and Dorothy

Cameron, one of Toronto's cutting-edge commercial art gallery owners, on his travelling jury. Overcoming his dislike of flying and hotels, Christopher seized the opportunity to take a crash course in the work of his contemporaries. Among the dozens of studios they visited were those of multidisciplinarian Charles Gagnon, abstract expressionist Yves Gaucher, London regionalist artist Greg Curnoe, pioneering abstractionist Tony Urquhart and conceptualist Iain Baxter. Christopher described it as "a who's who of my own generation."[3] With the exception of juror Dorothy Cameron, the group was male-dominated. The Canadian art scene at the end of the 1960s was still mainly a boys' club, which didn't bode well for women seeking entry in the decades to come.[4]

Christopher found it difficult to see the merit in some of the art forms he'd come across while traversing the country, such as glazed ceramics. He wouldn't have been alone in calling these craft rather than art. "If you can piss in it, it's craft," he said. "If you can piss on it, it's art."[5]

David Silcox appears to have been fascinated with Christopher and his Newfoundlander's way of life. He was pleased to be invited as one of the "b'ys" to join Christopher's uncle Ches, father Jack and brother Philip to sail, or in Newfoundland vernacular "go down on the Labrador." Silcox got along with this group of hearty kinsmen who loved fishing and being out on the water on the motor launch *Hemmer Jane*. Recognizing that David was a bit of an egghead who read a lot, Uncle Ches told him, "I read a book once."

Silcox returned to Newfoundland for a number of summers in the 1970s to fish, sail and accompany Christopher on his road trips. The friendship would endure for decades. Silcox worked with Christopher on a couple of coffee-table books. The first was *Christopher Pratt*, published in 1982 with texts by Meriké Weiler and

Christopher himself.[6] In 1995, Silcox collaborated with Christopher again to produce *Christopher Pratt: Personal Reflections on a Life in Art*. In his introduction, Silcox called himself a close friend for over thirty years. He wrote this about his comrade: "He is one of the funniest and wittiest men I know, an inveterate ham, a captivating story-teller, kindly to those he satires, and not above pointing out a moral. But when the inner man is revealed, one wonders if he will immobilize himself with the gravity of his own thoughts."[7] These are shrewd insights.

Another influential person in Canada's burgeoning art world had spotted Christopher Pratt's rising star, and she soon became instrumental in propelling him into the limelight. It had been during his Canada Council jaunt that he first met Mira Godard, a petite, dark-haired, elegantly dressed European-born intellect and art lover. Her wealthy, cultured family had fled Romania in the late 1940s, and she had studied in Paris before immigrating to Canada. Her studies culminated with an MBA from McGill. Combining her artistic sophistication with her business acumen, in 1962 she bought the Agnès Lefort Gallery in Montreal (renaming it the Godard–Lefort Gallery), and inherited such renowned Quebec artists as Jean Paul Lemieux and Paul-Émile Borduas, leading members of the rebellious Automatistes movement that embraced automatic painting expressing the subconscious.

In late 1969, Godard flew to St. John's, where Christopher picked her up for the drive to Salmonier. As they turned off the Trans-Canada Highway and bumped along the narrow Salmonier Line dirt road, Godard must have wondered what she had got herself into. Arriving at the Pratt home, they met Mary in the kitchen and then went right into Christopher's studio. After studying his canvases, she said, "We'll have a show." Before the harrowing drive

back to St. John's, they returned to the main house for a meal. Mary had managed to prepare a soufflé and served it on her wedding china. Whispering to Christopher "not to ask for ketchup," she had presented a meal as stylish as her guest, despite the limited ingredients available. The meal didn't do much to warm the two women to one another; they would never like each other. Mary believed Mira was "enthralled" with her husband.

Godard featured Christopher's work twice in 1970 in her Godard–Lefort Montreal gallery. Anticipating the potential economic upheaval that would follow if the separatist Parti Québécois came to power, Godard, like so many other Montreal business people, decided to hedge her bets by planting one foot in Toronto. She opened a second gallery, in Toronto's trendy Yorkville neighbourhood, established in a fifty/fifty partnership with Frank Lloyd of Marlborough Galleries, an international art dealer with galleries in New York, Rome and Zurich.

When the Marlborough–Godard Gallery opened on March 4, 1972, works by thirty-seven artists hung on the walls. Christopher Pratt's paintings joined others by Canadians such as Paul-Émile Borduas, Jean Paul Lemieux and Takao Tanabe, along with England's Francis Bacon and Henry Moore, and Americans Jackson Pollock and Mark Rothko. This was heady company for the Newfoundlander.

While still a laggard in cultural affairs, Canada in the 1960s and '70s experienced the emergence of new commercial galleries in Montreal and Toronto, and later in Vancouver and Calgary. In Toronto, Avrom Isaacs, Dorothy Cameron, Carmen Lamanna and David Mirvish shook up the stuffy Toronto art establishment. The new Marlborough–Godard would display its artists' work in the formal European style, hosting a vernissage (private

showing) with the artist in attendance, drawing Christopher out of Newfoundland on many occasions to come.[8]

Once he was represented by Mira Godard, Christopher Pratt became one of the very few professional artists in Canada throughout the 1970s and '80s and beyond to make a living entirely from the sale of his works (another being Alex Colville). Indeed, corporations and wealthy art collectors joined the queue to snap up oil paintings by this latest find of Mira Godard. Other noted Canadian artists, including Tony Urquhart, Paterson Ewen and Bruno Bobak, still found it necessary to supplement their incomes by teaching.

Jack and Christine Pratt had taught their two boys by word and example that it was a duty to work hard and earn a living. Speaking to a class of Mount Allison fine arts students late in his career, Christopher considered their request for a good piece of advice for young artists. Ever the pragmatist, Christopher reminded them that they were making a "product." Recognizing the shock this opinion aroused, he cited Anthony Van Dyck, the Flemish Baroque artist, who painted portraits on commission, and added, "This may sound like sacrilege, but we are part of the world. We function in the world, we depend on the world. I don't think it is safe to have as our audience exclusively other artists."[9]

·

ALONG WITH PROFESSIONAL success, Christopher Pratt was gaining a degree of celebrity. Long before Newfoundland was a tourist mecca, people were beating a path to the Pratts' door. Since there were no nearby accommodations, visitors often stayed overnight, leaving Mary to cater to them. She provided clean sheets and three meals a day.

Canadian media personalities such as TV host Adrienne Clarkson, later Canada's Governor General, and writers Richard and Sandra Gwyn paid calls, and became lifelong friends as well as promoters of both Pratts' careers. Governor General Jules Léger and his wife, Gaby, came down to see the couple at home after officially closing the 1977 Canada Games in St. John's.

Reporters and television crews with vast amounts of equipment arrived at the Pratts' door. A three-quarter-page article in the Canadian edition of *Time* magazine in 1966, accompanied by two reproductions of recent works and a photo of Christopher standing on a beach, introduced Canadian readers to this new Atlantic Canadian artist. In 1971, CBC TV's *Telescope* introduced Canadians to the Pratt family in a half-hour documentary. Harry Bruce, a fellow student from Mount Allison, wrote national magazine profiles of both Christopher and Mary. Bruce described them as being "in a private rhythm of peace, a life and place as close to a Canadian paradise on earth as most of us are ever likely to find."[10]

Edythe Goodridge, a St. John's art maven and art director at MUN's gallery, persuaded Mainland artists and critics to visit the outport studios of Newfoundlanders such as Gerry Squires, the artists at St. Michael's Printshop and Christopher Pratt. But the Pratts were quite capable of drawing a crowd on their own. St. John's townies were delighted to receive invitations to Salmonier. Christopher and Mary became renowned for throwing great parties, such as their twenty-fourth of May get-together. Boiled lobsters covered the table, in the company of Mary's salads and baked goods. While the couple were teetotallers themselves, they never insisted relatives and friends observe any such restraint.

Christopher's droll humour and seductive charm coupled with Mary's giggles and witty asides, along with the delectable spread

of homemade food, made Salmonier a destination. In those last years of the 1960s, as far as the art was concerned, visitors came to see Christopher Pratt. Most were unaware that there were two artists in Salmonier. That would soon change.

Who Didn't Eat Their Hotdog?

AS BUSY AS Mary had been, supporting her artist husband and taking care of their four small children, she was somehow managing to paint. That she found the time and energy revealed her utmost determination. Extremely well-organized, Mary frequently squeezed in a half-hour of painting time when the children were in their cots for their afternoon naps. Eventually she was able to hire local girls to do some of the household chores. In such an isolated environment, with no library to tempt her away from her easel or a social clique of women for luncheons, Mary had few distractions, and her free time was devoted to her art.

She celebrated her thirty-second birthday by presenting her first solo show, *Paintings by Mary Pratt—Mostly Sketches*, at Memorial University's art gallery. For that March 15, 1967, opening she had assembled nearly sixty works done in watercolour, oils and pencil. In her artist's statement, she stressed that, due to her responsibilities as a wife and mother, she could only work in "small packages of time." She succinctly summed up her circumstances:

If one allows one's ambitions as a painter to soar beyond the reality of one's responsibilities as a mother, one must be frustrated with the resulting work. If, on the other hand, one surrenders to the housework and the household, there is an emptiness, a frustration which is no less real. As in all things—what is needed is balance—an equilibrium.

The works in that show, mostly small, included images of still lifes, flower arrangements, outdoor scenes captured through the windows of Salmonier and figure studies of her children. The magic she captured in mundane subjects, for which she would later become famous, was already emerging in such pieces as *Herring and Potatoes* and *The Back Porch*. The *Evening Telegram* art critic, Rae Perlin, wrote a generally positive review that presaged the value of this quotidian quality in the future direction of Mary's work, acknowledging the "amazing strength in a plate of red apples."[1] Mary told journalist Robin Laurence that she considered her style at that time to be Impressionistic.[2]

Priced modestly, none of the works over $50, every one of them sold. Some of these early works have appeared in auctions. In 2004, *Vase with Silk Flowers*, a large (34 by 44 inches) watercolour and pastel signed and dated 1960, sold for $27,000, while an oil painting, *Preparations for a Pudding* (1966), owned by a private collector in Mexico, sold in spring 2017 for $10,625.

It is open to question whether Mary Pratt would have merited a solo show at MUN's art gallery at that time if she hadn't been married to Christopher Pratt. According to the custom of the time, the literature described her as the wife of Christopher Pratt and daughter of the Honourable W.J. West. Not only did the occasion

of Mary's first solo show identify her in relation to the two well-known men closest to her in life, it created significant tension between her husband and father.

Mary's parents had come to Salmonier for the weekend to attend the show, briefly, and then to babysit their grandchildren while Mary and Christopher continued with the exhibition in St. John's. The weather was turbulent, as a snowstorm was blanketing the entire Atlantic coast. Left alone at the cottage with their four young grandchildren—and one, Barby, sick with a cold—the Wests experienced first-hand the isolation and loneliness that their daughter endured. Although there is no record of what they said or implied to their son-in-law, at some point Christopher lashed out in response. He wrote in his diary that he felt badly about the way he'd acted. He admitted to having "a short fuse" at hearing any disparagement of Newfoundland in general and his Salmonier home in particular. Perhaps the Wests had commented on the lack of a proper workspace for their daughter, as Christopher now suggested to Mary that they could create a studio for her in the corner room. She demurred at the suggestion. Christopher wrote that, despite being fresh from the triumph of her very successful first solo show, Mary remained hesitant to commit herself to her work.

French feminist Simone de Beauvoir had coined the expression "the second sex" to describe "the other" in a marriage, nearly always the wife who has put her family's needs ahead of her own. If a woman could not transcend her standing as wife and mother, de Beauvoir maintained, she could not create incandescent works of art. Mary proved her wrong. While she did put her family's needs first, she always found a way to paint. And that very word

incandescent is frequently used to describe Mary's lauded talent for capturing light in her work.

By no means is Mary Pratt the only female artist who painted while raising a family. The Bloomsbury painter Vanessa Bell, who had three children and lived in an unorthodox country home with guests coming and going, painted around them, using subjects close at hand, such as her sister Virginia Woolf. The St. Ives sculptor Barbara Hepworth, married to artist Ben Nicholson, managed to persist in her career even after the arrival in 1934 of triplets.

The German-born artist Christiane Pflug, who moved to Toronto in the 1950s with her doctor husband and two daughters, worked mainly within the confines of her midtown apartment. Unlike Mary, whose paintings celebrated the beauty and magic of everyday domestic objects, Pflug portrayed a claustrophobic atmosphere with her predominant use of windows, cages, and small toys and animals as symbols. With works such as *Over the Kitchen Sink, The Kitchen Door with Ursula* and *Kitchen Door in Winter II*, the label "kitchen artist" aptly describes Pflug.[3]

Mary had taken a considerable risk in that 1967 show by exposing her art to the public eye. Her work could have easily been held in ungenerous contrast to that of her successful husband. Peter Bell, an Englishman who had replaced Christopher as director at MUN's art gallery, played an instrumental role in promoting Mary Pratt, and curated that first solo show in the original gallery on the MUN campus. (In late 1967, the gallery changed location, moving into the newly built Arts and Culture Centre, Newfoundland's major 1967 Centennial culture project.) He recognized that the isolation in Newfoundland made it difficult for the island's few professional artists to create a coherent style or philosophy. He

acknowledged that the province's artists were indeed distinguished but independent and unique.[4] This certainly held true for the very distinctive and individual styles of the two Pratts, whose isolation existed within the same house.

.

MARY PINPOINTS AS the start of what she considers her professional painting career an event that occurred two years after that first MUN show. One early evening in the autumn of 1969, the family had just finished supper and had excused themselves from the table. As Mary sat savouring a quiet moment to finish her cup of tea, she was seized by a desire to capture this messy scene amongst the remnants of a meal, which she described as "jumbled and untidy in its pool of autumn light, indicative of us."[5] On the table, a single uneaten hotdog sat on a blue-and-white plate surrounded by relish, mustard and ketchup bottles and unfinished glasses of milk. The table had been set with sturdy blue-and-white Staffordshire Chef Ware plates, while Mary sipped from a delicate porcelain teacup.

She began to make preliminary sketches of the table, but Christopher realized the light would soon fade and snapped some pictures for her. Mary protested that she would never work from photographs. However, when Christopher brought her the developed slides several weeks later, she saw that they had perfectly captured the light. Mary describes *Supper Table* (1969), one of her most iconic works, as the painting that began her obsession with light and her acceptance of working with the objects that surrounded her in isolated Salmonier.

Not long after Mary had begun working with the aid of slides, she abruptly stopped painting altogether. A thoughtless, offhand remark from one of her parents that she was cheating by using photographs deeply shamed her. She was in the midst of *Eviscerated Chickens* in the fall of 1970 when she packed away her paints and brushes.

Neither Mary's parents nor Mary herself realized that as a painter working in photorealism (sometimes referred to as hyper-realism, new realism, super-realism) she had joined artists in the United States and Europe who were using this technique. Canadian artist Jack Chambers (1931–78) called his realist works aided by photographs "perceptual realism," since he used the photograph more as reference material and changed some of the details in his actual painting.[6]

According to Pratt family lore, under the Christmas tree in 1970 Christopher left his wife a gift of two slides. One was the photo of the two plucked chickens sitting on waxed paper atop a large carton. Accompanying it was a note suggesting that if she did not get back to her *Eviscerated Chickens* painting, he would be visiting her at the Waterford (St. John's psychiatric hospital, known locally as "the Mental") every week. She got the message and finished the painting—a mesmerizing image of two plucked, goose-pimpled, plump, uncooked chickens sitting on a red Coca-Cola carton.

It had taken Christopher's cajoling and encouragement to convince Mary to disregard her parent's disparagement and get back to painting. Mary believed that Christopher was the greater artist, a point he did not dispute. She told Sandra Gwyn, "As an artist, I'm not really at his level. My intellect isn't powerful enough, nor

profound enough for me to be there."[7] Gwyn herself concurred, declaring Christopher "a genius" while calling Mary "a talent of the highest order." As long as both spouses agreed to this hierarchy, harmony remained in their marriage.

After Mary had accepted photorealism as her method, she would select a subject and take a number of photographs of the scene. Studying these slides, she would select the one that gave her a distinct jolt. She said that in the early days this shudder felt erotic, but later it became more of a shiver. Mary describes her painting *Roast Beef* (1977), featuring a charred roast with crispy fat covering the top, resting in a roasting pan, as "quite a sexy thing, with that sort of drool coming out of it."[8]

Mary often talked of having near-orgasmic reactions to ordinary objects she saw. She repeats the story of walking down the windowless hallway of the Salmonier cottage and opening their bedroom door. Sunlight was reflecting from the pond and drenching their twin-size four-poster bed; the red chenille bedspread was hanging down onto the floor, along with the pink woollen blanket and the masses of white-and-cream-coloured sheets, and two pillows were scrunched together. "As soon as I had that gut reaction, I knew that it had to be a sensuous thing, an erotic thing with me."[9]

To hell with making that bed, she thought. Mary gathered an easel and prepared canvas from Christopher, and began to paint. This was before she used photography, so Mary and Christopher were forced to sleep on their living room sofa for a few nights in order not to disturb the scene. Perhaps it was this episode that prompted Christopher to suggest that a slide would be useful for the supper table painting, fearing that the family would be dining from plates balanced on their knees for days to come.

Mary invented a unique method for her photorealist paintings. After laboriously preparing a Masonite board, she projected the slide and, using a pencil, drew outlines of the image on the canvas, like a map of its various surfaces, writing in codes for colour and light. Beginning to paint in the top-left corner of the canvas, using very thin oil paint and the kind of tiny sable brushes usually used for watercolours, she worked her way across the image. Then she began the process again, but this time finishing one of those outlined parts of the painting before moving on to the next. Her brush style was based on small cross-hatched strokes that blended together to create an impression of utter smoothness. Standing in front of a Mary Pratt oil painting, one is awed to think that it was created by a human hand. Mary's lush, warm colour palette, which favours pale yellow, orange, red and rose, is similar to that of Matisse. She decided early on if the painting would be a green, red or blue picture and then, knowing the complementary colours, she would begin to build up the work. If she ever used black, it did not come out of a paint tube. She would mix red, green and blue to create a dark, deep tone resembling the shade of black she wanted.

No one has ever offered a better defence and appreciation of Mary's photorealist technique than her husband. After attending a retrospective of her work in 1983 at a public art gallery in Oshawa, Ontario, Christopher noted in his diary,

In her work, the 35 mm slide is brought together with the techniques of Chardin [eighteenth-century French master of still-life paintings]; a Renaissance concern with what looks real, brought together with a highly literate, post-Freudian awareness of what

is real. Hers is a truly original departure; its uniqueness is so subtle it can easily be overlooked.[10]

Likely the first time Mary's works were shown together with Christopher's was at the Memorial University Art Gallery in a 1971 group show of Newfoundland artists organized by Peter Bell (in collaboration with the Toronto Picture Loan Society). Mary had two oil paintings from 1969, *Cake, Apples and Potatoes* and *Caplin*, while Christopher had two prints. So much of Christopher's available work was touring in another exhibition put together by Bell that the MUN gallery director was left with only a couple of Christopher's works to put in the St. John's show.

When the exhibition moved from Newfoundland to Toronto, critics recognized and wrote about the talent evident in Mary's works. In fact, both the *Toronto Star* and the *Globe and Mail* chose a Mary Pratt image as the illustration accompanying their reviews. Better still, a comment by Peter Wilson, the *Toronto Star*'s art critic, validated her use of slides, writing, "It came close to the new avant-garde photographic realism being done right now, mostly in the United States."[11] If Mary was cheating, as her parents had implied, then in the eyes of Canada's foremost critics she was doing so in esteemed company.

Dorothy Cameron, the lone woman among Christopher's fellow jurors on the 1969 Canada Council cross-country junket, sent a copy of one of these reviews to Mary with a note reading, "Who's the artist in this family anyway?" Cameron's friendly compliment was a harbinger of the emerging competition between the two artists named Pratt.

Early in the 1970s, Mary began to acknowledge that she had moved from the role of artist's wife to rightful artist herself, and

she finally allowed herself to have a studio of her own. An old garden greenhouse at Salmonier was converted into a small A-frame building with light coming from two windows plus a small window in the door. Although a tiny space, her easel, slide projector, desk and sound system, together with a number of wicker chairs, all fit tidily in. Good lighting from a large overhead fixture and white sheer curtains made the studio bright and cheerful. The children were always welcome. In late afternoon, when Mary returned to the house to start dinner, Anne would invite her teenaged school friends into the studio to listen to records.

Mary Pratt's next major solo show, in 1973, again curated by Peter Bell, was one of a series of touring solo exhibitions featuring the works of emerging and mid-career Canadian artists, including Christopher, the British Columbian Toni Onley and Winnipegger Tony Tascona. Titled *Mary Pratt—A Partial Retrospective*, the show included such works as *Baked Apples on Tinfoil* (1969), *Eviscerated Chickens* (1971), *Bags, Caplin and Salt Fish Drying* (1971), *Jack Power's Rooster* (1971), *John and Anne on Sofa* (1971) and *Red Currant Jelly* (1972). After it had toured to six Maritime art galleries, David Blackwood, a Newfoundland artist who had moved to Ontario, brought Mary's show to a gallery at the University of Toronto's Erindale College. If there had been grumblings that Mary Pratt warranted exhibitions only because of her famous artist husband, she had laid them to rest. Although perhaps unaware of it herself, Mary Pratt was on the cusp of a major breakthrough. But it wouldn't come easily.

ON JANUARY 2, 1975, Mary found herself in an ambulance rushing from Salmonier to St. John's with the local doctor attending to her en route. She was hemorrhaging badly. Eleven years after the birth of her last child, Ned, forty-year-old Mary was pregnant again. Understandably ambivalent about the impending arrival of a fifth child, Mary had been handling her condition in a casual manner. After all, she knew the ropes of motherhood. And living an hour's drive from St. John's obstetricians, at a time when prenatal checkups and ultrasounds weren't yet standard practice, she was accustomed to handling pregnancy on her own. This ambulance ride to the capital was unnervingly beyond her experience.

On arrival at St. Clare's hospital, the doctors realized that Mary had been carrying twins. One had likely been dead for several weeks, but the other was born alive. Weighing about a pound and a half, the premature boy lived only a few hours. In order to have the baby baptized, they needed to name him, and so he was David Philip. Christopher arranged to have a small gravestone engraved with "David Pratt, infant child of Mary and Christopher Pratt, born and died, January 2, 1975." Even today, with medical advances in neonatal care, a premature baby under twenty-four weeks has only a small chance of survival. Christopher was as heartbroken as Mary. The children mourned the loss of little siblings. Mary remembered Ned remarking that things like that just didn't happen to the Pratt family.

After the death of the twins, Mary painted *Eggs in an Egg Crate* (1975), a sombre depiction of half a dozen cracked and empty eggshells lying in their cardboard carton, coloured in shades of ochre and yellow. She had been making one of her elaborate family birthday cakes that included several eggs in the recipe when her attention had been arrested by the scene on the kitchen counter, the

slippery interiors of the empty shells and the light sinking into the porous paper egg carton. Showing the finished work to a friend who commented on the emptiness of the eggshells, Mary only then recognized the poignant autobiographical message of fertility and loss, and how deeply it had affected her. It is not surprising that the deaths of her twins brought Mary to her knees. Her skin broke out in hives, and six months after the births she was readmitted to the Grace Hospital, likely suffering from depression. She had noted in her diary on April 20 that this had been the due date. She wondered what life would have been like with two more children. She had been trying not to obsess over the deaths, and surmised that eventually they would "seem like a floating dream of something that never was."

.

IN THE MIDST of Mary's grief, her career took a great step forward. She was chosen as one of seven contemporary artists in an exhibition at the National Gallery of Canada titled *Some Canadian Women Artists*. Galleries across Canada were mounting exhibitions of women painters and sculptors in 1975, which had been designated International Women's Year by the United Nations. This exhibition was an attempt to acknowledge that in the past women artists had been neglected or underrated by the curators of Canada's national art gallery.

The NGC artists included only anglophone women: ceramist and painter Gathie Falk; Colette Whiten, a recent Ontario College of Art (OCA) teacher who most famously cast long-suffering friends in plaster of Paris to create the series *September*; Leslie Reid, who had studied at London's Chelsea School of Art; Shirley

Wiitasalo, trained at OCA and self-identified as a feminist, who explored the aesthetic and philosophical effects of media, urban environments and contemporary culture on society; along with An Whitlock and Sherry Grauer. And Mary Pratt.

As supportive as Mary had always been of her husband's career, she had been coming to resent her own lack of national recognition. Frustration about her conflicting roles of angel of the house and professional artist began to rise to the surface. Shortly before the invitation to participate in the NGC show, she suffered through an unbearable week with a journalist couple who had come to Salmonier with their children to write a profile on Christopher. Taking advantage of the Pratts' hospitality, they had overstayed their welcome. While enjoying Mary's cooking, they had focused entirely on interviewing Christopher. Mary told an *Atlantic Insight* journalist that after the couple left, she retreated to take a hot soak in the tub and sobbed her heart out. "Then the phone rang. I remember wrapping myself in the biggest towel I could find and staggering to the phone."[12] It was someone from the NGC telling her that she had been included as one of the seven Canadian women artists.

Mary informed Tom Smart, who later wrote the book *The Art of Mary Pratt: The Substance of Light,* that it had only been through a fortunate accident that two curators from the National Gallery had discovered she was an artist. According to Mary, Pierre Théberge (later director of the NGC) and Mayo Graham had been visiting Christopher's studio, and only by chance had Graham noticed Mary's painting *Cod Fillets on Tin Foil* (1974) in a side bedroom.

Mayo Graham's recollection is quite different. She had admired the painting *Red Currant Jelly* in Mary's 1973 touring solo show. So,

either at one of the Maritime galleries or at Toronto's Erindale College, Mayo had attended the show *Mary Pratt—A Partial Retrospective* and had been impressed with the painter's photorealist style. Mayo had added Mary Pratt's name to the list of potential Atlantic women painters for the upcoming National Gallery show.[13]

In one version, Mary is an undiscovered artist's wife with her work pushed off into a side bedroom, while in the other, Mary Pratt the painter is boldly putting her work before the public eye. Both versions contain truths. Mary had begun married life in 1957 and came from the most conventional of families. And then, in the 1960s, women's expectations began to change. A focal point of second-wave feminism, Betty Friedan's book *The Feminine Mystique* had challenged the idealized role of the middle-class housewife and suggested that women should find personal fulfillment outside the home. Friedan wrote, "It is easier to live through someone else than to complete yourself."[14] To some extent, this had been Mary Pratt's dilemma. She and everyone around her—husband, children, parents and in-laws—had viewed Mary as her husband's helpmate and the excellent and loving mother of four children. Yes, she was a talented painter, admired and supported by all. But to suggest in 1975 that she actively promote her work and thereby compete with Christopher was really not acceptable —especially not to Mary herself. And yet she could not refuse the siren song of recognition.

Along with Christopher, Mary's mother-in-law, mother and sister accompanied her to the November 20 opening in Ottawa. Mary wore a new rusty-red dress made by her sister Barbara, who had developed a small business as an excellent seamstress.

Among Mary's works on display that evening were *Herring on Salt Bag* (1969), *Eviscerated Chickens* (1971) (the infamous painting

that she had stopped working on during a period of self-doubt) and *Salmon on Saran* (1974). While Mary's work was clearly the most traditional of the seven artists', the critics liked what they saw. Robert Fulford in the *Toronto Star* described Mary as "a first class craftsman and the possessor of a personal vision" and found her work "the most memorable in the show."[15]

During her whirlwind visit to Canada's capital, Mary gave interviews and stocked up on books from the National Gallery bookstore. On November 21, Christopher had dashed down to Toronto for one day to see Mira Godard. When he returned to the Ottawa hotel that evening, Christopher and Mary ordered peach melbas and milkshakes to be sent up to their room. A silly, delicious episode in a year that had been so turbulent and sad.

Coinciding with Mary's work being shown in Canada's most important art gallery, the weekly magazine the *Canadian* ran a three-page article titled "The Fine Art of Familiarity: Mary Pratt Paints as She Lives—Close to Her Kitchen Sink."[16] Accompanying the article was a full-page picture of her taken by the well-known photographer John Reeves. The journalist, Harry Bruce, cast Christopher in the most unbecoming light, as a thoroughgoing chauvinist. Midway through his detailed account of the Pratts' situation, he wrote, "Now surely, if ever there was a woman who sacrificed her artistic soul to the cause of keeping husband and children happy, she is Mary Pratt." Her witty quip that "all Newfoundland men have this strange inability to bend at the waist. They never pick up their socks" only endorsed Christopher's portrayal. Bruce ends the piece depicting Mary and Christopher as mutual admirers and helpmates, but the facts did nothing to convince feminists of Christopher's enlightenment. Mary noted in

her diary that the article had been "just nutty and very cruel to Tiff." She added, "the Reeves picture is good though."

After the National Gallery show, the balance of recognition as artists had become more equally weighted between the Pratts. Mary began to speak about how her role had changed. In a 1978 interview with art critic Gary Michael Dault, she said: "In recent years I've been a lot less help to Chris than when I wasn't painting seriously myself. I used to be able to really understand what he was doing. Now, I'm impatient to be on about my own work—and I feel guilty about it."

But Mary, as increasingly consumed as she was with her own painting, understood very well what Christopher had been doing.

Familiarity Breeds Consent

CHRISTOPHER'S INTENT NEVER to leave Salmonier was only one resolution he was keeping from Mary. He had two others when he moved to the country, and he acted on both of them: he wanted to sail big boats and he wanted to paint nudes. After leaving the Glasgow School of Art, Christopher regretted that he had had little to no opportunity to draw from life, which he feels is essential to being an artist. He decided to begin again where he had left off in Scotland.[1]

Christopher quickly found a ready supply of models among the teenaged girls in nearby Mount Carmel and St. Catherines. Over the years, he hired half a dozen or more local girls, and he occasionally titled his works with their names: *Sheila Asleep* (1979), *Donna Now* (1980), *Me and Bride* (1977–80), *Marion* (1980), *Blue Diane* (1984/96). Often the girls came first to help Mary in the house, then became comfortable in Christopher's presence. In time, they'd agree to model for him. Mary cleverly described their willingness to pose as "familiarity breeds consent."[2]

Most of these models were between the ages of seventeen and twenty, and Christopher found them almost Grecian in their

attributes. Their rounded, firm, unblemished bodies reminded him of the plaster cast models he had copied daily at the Glasgow School of Art.

One of his first models was Bernadette Powers, featured in *Young Girl with Sea Shells* (1965), a painting that had morphed from his original idea of a young boy and girl stealing apples in an orchard into one of a girl standing just inside a doorway in school uniform holding seashells in her uplifted skirt. Other works —*Woman and Stove* (1965), *Young Woman Dressing* (1966), *Young Woman with a Slip* (1967) and *Nude Lying Down* (1967)—bear witness to the fact that as Bernadette became more comfortable as a model, she posed in a semi-dressed state and finally undressed. These early female figurative paintings are what art historian Joyce Zemans calls "idealized neo-platonic abstractions."[3] They bore a similarity to Alex Colville's 1950s works such as *Nude and Dummy* (1950) or *Coastal Figure* (1951). These pale women, created by geometric precision rather than freestyle drawing, look more like marble statues—abstractions—than real women.

When Christopher tried to use more mature women, he rarely found inspiration. Besides, by their early twenties they were likely married and had been through pregnancies. On a couple of occasions he hired professional models from St. John's, but again the results were unsatisfactory. He admitted in his diary that he enjoyed that sense of frisson working with inexperienced young girls "who found some excitement in the studio and had a sense of adventure and participation, of doing something unexpected, just off-centre."[4]

It appears the girls' parents raised no objections to a middle-aged man picking up their daughters in the early evening and driving them back to his rural studio, where they took off their clothes.

Quite possibly, the fact that these girls were being collected by Christopher Pratt made it acceptable. Locals would read stories in the newspapers about the famous artist living in their midst. Besides, he was taking them to his family home, where his wife and four children were present. That the girls were earning money proved to be another incentive for parental approval.

Christopher made sure the studio was warm enough, with extra heaters running on cold or rainy nights. To put the girls at their ease, he played records—sometimes contemporary music like the Beatles, the Rolling Stones or the Band, sometimes jazz, such as Billie Holiday, but most often classical music. Other times he just turned the radio on to a rock station that the girls liked and tried to ignore the noise. He was aware of the double standard: in the house he would often tell his own kids to "turn that stuff off."

Christopher rationalized his figurative drawings as the touch-stone by which he could measure his skills. Drawing models free-hand challenged his reliance on mathematics-based drawings.[5] And yet he rarely used the woman closest to him as his model. He joked that drawing and painting Mary wouldn't be as much fun, but added more seriously that she had her own work to do. Either way, when these young women were in Christopher's studio, Mary was not.

Many artists used their wives as models, of course. Canadian contemporaries of Pratt, including Alex Colville and Bruno Bobak, even joined their wives in the occasional composition, making the relationship of the couple the image's deeper subject. Colville's *Refrigerator* (1977) portrays the naked couple grouped around the refrigerator, with Alex frontal, drinking a glass of milk, while Rhoda with her back to the viewer stares into the open fridge as the family cats mill around her legs. Rather than evoking tension

and anxiety, which is often the case in a Colville figurative work, *Refrigerator*'s midnight raid suggests intimacy and companionship. Both Colville and Bobak presented their spouses tenderly but honestly as their bodies aged.

Years later, when Christopher was asked whether he thought Mary and the children had been affected by his practice of sketching nude teenagers in a studio next to the family's kitchen, he admitted that he had been aware Mary felt excluded and that perhaps his then-teenaged son, John, might have been unsettled. His children were teased at school about their father having naked ladies in his studio. Christopher blamed his family's close proximity as one cause for his difficulty with figurative drawings. He felt that self-imposed censorship inhibited him from doing his best work.

Mary never directly confronted her husband about his use of these girls as nude models, but she made snide remarks to him that she noticed he always shaved and changed his shirt before going out to collect them.[6]

·

OWNING A RACING boat fulfilled a wish of Christopher's stronger even than becoming an artist. At the height of his racing addiction, his artmaking took second place. He agreed with Mary that the abstract and competitive aspects of racing took away from the energy he should have been applying to his art.[7]

Christopher came by his passion for boats and sailing from his ancestors. His paternal great-great-grandfather, sea captain William Knight, had taken American landscape painter Frederick Church (1826–1900) on an 1858 expedition to Newfoundland and

Labrador. The Dawe side of Christopher's family included genera-
tions of owners of seafaring merchant ships.

Christopher bought his first racing boat in 1972, less than a
decade after moving to Salmonier. He mastered sailing on his
C&C (Cuthbertson and Cassian) thirty-foot fibreglass boat, which
he called *Walrus Too*. Accompanied by his teenaged son, John, and
David Silcox, he sailed round Cape Race at the southeast corner of
the Avalon peninsula. (The Cape Race lighthouse is one of the
most important marine landfall markers in North America.)

In 1973 Christopher, his brother, Philip, and father, Jack, bought
a thirty-five-foot C&C sloop, which they called *Lynx*. After learn-
ing to handle it and cruising along the east coast of Newfoundland,
Philip took possession of the boat and sailed it across the Atlantic
and around the Caribbean. So Christopher in 1974 went to Ontario
to buy his own vessel, a larger, thirty-nine-foot C&C, which he
then sailed down the St. Lawrence River, through the Gulf of St.
Lawrence and home to Newfoundland. He called it *Proud Mary*,
the title of a then-popular song by the American rock band
Creedence Clearwater Revival, in which the lyrics celebrate quit-
ting a day job for freedom. Of course, there was another Mary in
his life, one who increasingly had much to be proud of, but she
wasn't on the trip.

Boats became his singular focus, and his competitive streak led
him to buy bigger and faster vessels. He moved up to a forty-three-
foot C&C named *Dry Fly*, which needed up to nine crew members
for racing. Frequently, Christopher's two sons and Philip accom-
panied him. The elder son, John, remembers that it was sometimes
difficult to find sailors, partly due to Christopher's precise mathe-
matical navigational procedures, but mostly because of his refusal
to allow alcohol on board. When the Pratt family finished a race,

recalls John, they went home while other crews piled into the yacht club bar for beers and a rehash of the day's sail.

Owning and sailing a boat has a certain cachet. The Pratts belonged to the Royal Newfoundland Yacht Club at Long Pond on Conception Bay, where Christopher became the Commodore in 1980. The Pratt dynasty's standing in St. John's and the fact that his uncle, Calvert Pratt, had been an earlier Commodore made Christopher an obvious choice for top position in the yacht club hierarchy. All four of the Pratt children sailed with their father, and on occasion even Mary joined to go cruising for a day sail or over-nighting. While Mary was never much of a sailor, the RNYC hosted special event dinners, barbecues and dances, which opened some much-needed social opportunities for her. The Pratts became friends with fellow club members Dr. Bill and Mary Green, and for years the two couples celebrated New Year's Eve together at the club.

Despite the yacht club's active social calendar, Christopher's sailing largely meant even more isolation for Mary, minding the children at Salmonier. From the days when men spent long periods away fishing and sealing in season and then inland to cut wood during the winter, life was changing in Newfoundland. But Christopher had grown up going "in on the country" to hunt rabbits, ptarmigan and ducks, as well as going salmon and trout fishing. While clearly not a working-class man who ventured out on the land or water to earn a living, Christopher thought little about leaving his family behind. His appointment (1975–81) to the board of the Canada Council for the Arts added at least four trips a year to his regular absences. His productivity in the studio, never great at the best of times, suffered even more.

As some wise Newfoundland women called their men, Christopher Pratt was every bit the "married bachelor."

DURING HIS 1956–57 return to St. John's to explore a full-time career in painting, ahead of his studies in Glasgow, Christopher had received numerous commissions from family friends and patrons to produce watercolours of their yachts. He'd produced his very first boat print in 1961, while still a student at Mount Allison. *Boat in Sand* remains a seminal Christopher Pratt print. He took four months searching for the technique to produce the image of a wooden cod-fishing boat abandoned on a beach. He wanted to make a deliberate statement about the erosion of the traditional Newfoundland way of life. Besides its inclusion in the National Gallery of Canada's 4th Biennial Exhibition, his teachers and fellow students snapped up the limited edition of twenty-five prints. Lawren P. Harris bought one for $30, while Ted Pulford traded one of his own watercolours for a print.[8] Christopher's love of sailing, he realized, could prove lucrative for a painter from Newfoundland.

He began to use his own boats as the subject matter for a series of limited edition prints. Among the first was *New Boat* (1975). Christopher said that the work was less about sailing and more about the boat itself. "It has to do with its newness, that instant of possession when something you have waited for becomes a part of you, and the process of its inevitable weaning starts." Art critic Jay Scott described *New Boat*, its unblemished vessel hanging in slings above the water, as "an image of a clean, shiny and very nude projectile, an ithyphallic [erect penis] male offspring in shades of baby blue."[9]

After sailing *Dry Fly* back from Ontario, Christopher created several prints inspired by the trip, including *Above Montreal* and *Light Northeast* (1979) and *Gaspé Peninsula* (1981). *Yacht Wintering*

(1984), again with the boat out of the water, standing in its cradle wrapped in a tarpaulin, reminded Mary of a human body laid out under a shroud. Joyce Zemans compared his earlier print, *New Boat*, which she described as "pure in hope and promise," with *Yacht Wintering*, which, she says, is "about death and about unrealized ends."[10]

Christopher's boat prints served a dual purpose. They provided him with appealing subject matter that sold prints quickly, and, with some creative accounting, he was able to deduct some of the considerable costs of his hobby as business expenses on his income tax.

He reached the top of his sailing game with *Dry Fly* in Nova Scotia during the summer of 1978, taking two first-place finishes at the Royal Nova Scotia Yacht Squadron Regatta. He went on to win Visitor's Cup for best performance overall for four days of races at Chester Race Week. After he had proven to himself that he had mastered sailboat racing with a shelf full of trophies, his enthusiasm waned. He began to downsize, first with a forty-one-foot C&C called *Greyling* and finally with a thirty-seven-foot C&C, *Dora Maar*, the name of one of Pablo Picasso's mistreated lovers.

It seems reasonable that once the family had achieved sufficient financial stability to support Christopher's sailing endeavours, Mary and the children could expect a few creature comforts around the home. As a reliable and wonderful cook, Mary might warrant a modernized kitchen, and perhaps private school could have opened up academic opportunities for the children. But Mary had never complained to Christopher, and so he left what seemed well enough alone.

Mary and Christopher had never even discussed how much money he spent on his boats. She never asked. He has publicly

commented, "Everyone has heard the adage that ocean racing is like standing in a shower tearing up ten dollar bills. That's only halfway there; it's standing in a frigid and gyrating shower watching salt-water sodden hundred dollar bills go down the drain."[11] In a 1977 newspaper article, he said, "We don't go to great restaurants and drink fine wines. So, committing such an extraordinary amount of my resources to acquiring one single object is an act of bravado and vitality for me."[12] In other words, Christopher did not spend his money on taking Mary out for fine dining—he spent it on himself.

He acknowledges that boating had brought out the best and the worst in him. He admitted to "loving the feel of the boat, its looks and its lines and those euphoric evenings, hating the frustration and responsibility and always the expense."[13] And he wondered how his father felt, seeing Christopher "sporting around in a 39' yacht" while living for free in a house that Jack had worked hard to buy.

Reflecting back in old age, he recognizes he had put himself ahead of Mary and the children. He wrote: "It was the boats—and not the sailing—that influenced my work (the sailing preoccupation cost me a lot of time, money and was a limiting experience) ..." He continues with a comment that captures the essence of the remaining years of his marriage to Mary: "... just as it was the models (girls) and not the work I did of them that I found energizing."[14]

This Is Donna

IN 1969, MARY AGREED to select the Valentine Queen at Our Lady of Mount Carmel School's February sock hop. This was the time when American pop culture had seeped into rural Newfoundland from television and the nearby American naval base in Argentia. Students from the base high school had introduced local teenagers to the idea of dances and competitions. The radio played tunes from the Beatles and music to accompany dance crazes such as the twist, the loco-motion or the pony. A few years earlier, kids had gathered at the St. Catherines convenience store, Mr. Ted's, one Sunday night to watch the Beatles on *The Ed Sullivan Show*.[1]

Mary remembered that the sock hop winner "stood out like a light" with her bubbly personality and compact little body, her bobbed hair and very short dress, not to mention her dancing. "Her pleasure in dancing filled her body," recalled Mary, "and her eyes, though deep-set, crinkled in smiling intimacy with the beat." Donna Meaney walked off the gym stage wearing the Valentine Queen crown.

Impressed, Mary asked Donna if she would like to do some babysitting of the Pratt children. She did, and after graduating high school at the end of grade eleven, Donna became Mary's live-in helper. In no way did Donna command Mary's housewifery skills, but as an incurable chatterbox she kept Mary amused as they worked side by side. She helped Mary keep up with the constant pile of ironing; Christopher often changed his shirt more than once a day. And she was excellent with the children, who then ranged from five to twelve years of age. To them and to the two painters, she became an extended member of the Pratt family, with her own small bedroom between the kitchen and Christopher's studio. Donna, one of seven Meaney children, had two younger sisters, Mary and Bride, and two brothers (two other sisters had died in infancy). Missing their older sister and wanting to join in the fun with the Pratt children, the Meaney girls began to hang around at Salmonier. Their presence came as no surprise to Mary. It was the custom in rural Newfoundland for children to enter their neighbours' kitchens without knocking and sit or stand silently, watching and listening to the adults. Donna's sisters became an extension of the Pratt family.

Donna first posed nude for Christopher in April 1969, the month she turned sixteen. He quickly realized that she was an exceptional model. In her clothes she may have looked like any other outport girl, but her figure was exquisitely proportioned, almost classical. He noted in his diary, "She has no pretensions or preconceptions, an ordinary girl with enough self-confidence to get undressed."[2] He described her as a very private, self-contained, delicate youth. "She liked to pose but she instinctively turned away, sheltered herself. She sat there preoccupied with something else, as if being in the studio was like sitting on a hilltop on a warm, soft

day."[3] Donna was equally confident undressing inside the studio or outside in the open air, and became a willing participant in a photography project Christopher had agreed to do.

While touring with the Canada Council peer jury, he had met one of Canada's first conceptual artists, Iain Baxter. The two men had struck up a friendship, and Baxter visited Salmonier in late 1969. In 1970 he invited Canadian artists, including Ken Lochhead, Jack Chambers and Christopher, who all used photography, to participate in a project he called *North American Time Zone*. He assigned fourteen specific photographic topics, which each artist was to interpret in his time zone on October 19, 1970. The second topic was "nude," and Christopher between 12:30 and 12:45 p.m. photographed Donna standing nude against the open passenger door of his Volkswagen Karmann Ghia.[4] In his 1:00 p.m. photo with the assigned theme "still life," he captured Donna's bra and panties, as well as two chocolate bars, tossed onto the back seat of the car.

He had treated himself in 1969 to the brand new racy yellow Karmann Ghia sports car, perhaps with money earned as a juror for the Canada Council. Imagine an outport teenager's delight at being seen speeding through her village in the passenger seat of a sports car alongside a famous artist.[5]

The Pratts spent July 1971 in Sackville, where Christopher taught summer school at Mount Allison. Donna came along to help look after the children. Christopher never enjoyed being in the Maritimes; he was constantly complaining. Tension ruled the day. After visiting a cottage to which they were invited in nearby Shediac, he could express only disappointment with the beach and the cottage's musty, screened-in veranda.

In August, Mary and the children went to Fredericton to spend time with the Wests—Nanny West and Damp (Bill West had

acquired this name when first-born John could not say "Gramp"). With the grandparents now available to help with the children, Donna's services weren't needed, and she was free to do as she wished for the rest of the summer.

As always, Christopher felt constrained and uncomfortable in the company of his in-laws and far from his work. So he said his farewells and left for a three-week trip, driving up Newfoundland's Great Northern Peninsula to sketch and photograph. Unbeknownst to Mary, he had made arrangements for a companion to travel with him. In his maroon Volkswagen camper bus, which he had carefully fitted out for the trip, he drove first to Halifax, where he picked up Donna Meaney. The now nineteen-year-old girl was infatuated with the much older man, and she had become his preferred travel mate.

Christopher alludes to this lengthy road trip more than once in his published diaries. He refers to it as his "hippy summer in a VW bus." A clandestine tryst—yes—but hardly a freewheeling psychedelic adventure à la Ken Kesey and his Merry Pranksters. On the road, Christopher made sure to avoid calling attention to himself and Donna by never eating in restaurants. They slept in the bus and he cooked their food. Through the mostly warm days of August, they happily drove, hiked and made love.

That fall, Donna left Mount Carmel to take typing and shorthand at a trade school a few hours away in Conception Bay. Years later, in 2014, Mary, speaking at her major retrospective exhibition at McMichael Art Gallery near Toronto, candidly told the audience, which included Donna, that she had encouraged her to take the trade school course because she was always hanging around Christopher's studio and she wanted to get rid of her.

With Donna away from Salmonier, Christopher produced

several oil paintings based on his sketches and the many slides he had taken of her. *French Door* (1973), which he had begun in 1971 using another model, morphed into a tribute to his absent muse. Unlike his 1960s works, this is not a depiction of an archetypal female form; it is a painting of Donna. He captured her as a shadowy nude figure trapped behind the glass hallway door in the Pratt home. Discussing the work with Joyce Zemans, Christopher said, "I always felt that she was on the periphery, endangered, exposed to our ideas which were not viable for her. She was outside looking in. She wasn't part of our lives. But we were dominating hers—I saw that after she had left. I did the painting then."[6] While these comments were useful information for the catalogue, Christopher was being disingenuous. She was very much a part of his life, as his muse and mistress.

Over the years to follow, Donna drifted in and out of the Pratt household. In the spring of 1975 she came back to Mount Carmel and again posed for Christopher. Mary noted in her diary in April that Donna had hung around Salmonier until ten thirty in the evening, when Christopher had driven her home. Those modelling sessions inspired several oil paintings. *Summer Place* (1975/78), presenting a nude Donna standing behind a washbowl, came from sessions in an empty cottage to which Christopher had access, just off the Pratts' property.

Working from a sketch he called *Donna, Study for Apartment* (1975), Christopher created a diptych entitled *Apartment* (1976), in which a smaller panel contains a nude of Donna and the second, a study of the sea. Also based on studies done in 1975 is *Donna Last Summer* (1976). In this pencil drawing, Donna stands nude, her arms crossed in front and hands clasping her elbows, with a distant, pensive look on her face.

It was around this time that Christopher reconsidered his silk-screen method. Unhappy working with the toxic solvents required, he turned to lithography. His first lithograph was *Nude by the Night Window*, renamed *Fisher's Maid* (1978). He had originally imagined a figure standing backlit by a daylight window, and provisionally called it *Summer Place II*. Clearly this referred to the Donna painting *Summer Place* (1975/78). He reconsidered the medium, in this second case, believing the lithograph technique to be better suited to the rich, inky blacks he wanted to produce. Another change was needed as well: Donna was not available, so he posed then forty-three-year-old Mary, lit by a bedside lamp, which better exploited the technique's strength with dark colours. Describing the work in the catalogue *The Prints of Christopher Pratt 1958–91*, he called the model simply an "older woman." He held back six prints —one for himself and each of his immediate family members. (Both Christopher and Mary gave works to the children, creating a type of savings account for their futures.)

With Donna so rarely available now, Christopher began to try other models, including her younger sister, Bride. In 1974, he drew a nude that he titled *Girl with Small Breasts*. He explained that in drawing people, he felt it necessary to be accurate and respectful of their individual details and thus annoyed Bride with his pencilled description at the bottom of the sketch "girl with small breasts 4-12-1. Dec. 6/74."

His oil painting *Me and Bride* (1977/80) is a five-panelled work in which we see Bride wearing pink underpants, posing in the far-left panel, arms raised as if she's clasping her hands behind her head. She faces across two panels of an empty room to the fourth and fifth panels, which contain a self-portrait of the artist drawing his nude model. The scene appears as if witnessed through an

enormous window that runs the length of the room. The huge work, measuring 44½ inches wide and 107½ inches in length, was immediately bought by a patron for $65,000 and today is displayed in the dining room of a condominium in St. John's.

When Donna or her sister was unavailable to model, Christopher made use of another close connection. Friends and neighbours Jim and Elsie Power had several daughters, playmates to the Pratt children. One, Brenda, after completing high school in 1980, became a clerical assistant to Christopher on his flag and book projects. He noted in his diary, "I have asked Brenda—whose usual role is to get me out of otherwise irreversible commitments and run interference on awkward phone calls—to stand in for Bride."[7] Brenda stepped in to pose nude, and later remarked that it was a natural progression to model for him.

Brenda is the female in *Girl in a Spare Room* (1984), shown in full-frontal pose with her hands on her hips and face turned away rather than looking directly at the artist, as Donna and other models so often did. The head is cropped at nose level. Art critic Lawrence Sabbath describes this work as one of Christopher's more successful nudes, with a sense of warm flesh: "One has the impression that both model and artist have crossed thresholds and come to terms, as they should, with the situation and its sexual implications."[8]

Christopher still preferred to work with Donna when she was available. But the tone of his depictions changed. In contrast to the wistful, vulnerable female haunting the viewer from behind the glass in *French Doors*, the 1981 drawing *Madonna* presented Donna kneeling with her legs folded beneath her and knees spread in a sexually provocative pose. In *Girl Sitting on a Box* (1981), a naked Donna sits with her legs dangling as she stares directly at

Christopher. Donna is no longer a girl but a sexually mature woman. In these two drawings, she appears to be taunting Christopher, as if asking him to declare his intentions about their ongoing affair. No viewer of these erotic works could miss their sexual intimacy.

An intimate relationship between artist and muse is hardly unusual. Christopher Pratt and the American painter Andrew Wyeth are at times compared. (Ironically, Pratt says that he was never a fan of Wyeth, nearly twenty years his senior, finding his work too narrative.) With their preference for realism—even magic realism, some critics would say—both ran counter to contemporary trends, such as abstract expressionism. Both lived in a remote landscape with little desire to leave. Both lived in conventional family situations with a wife and children to support. And both men solicited the same curiosity from the public about their relationships with their nude models. Were they mistresses? If so, for how long? What did their wives really know? In Wyeth's case, his neighbour Helga Testorf, a buxom German with long blond hair, often in a thick braid, is celebrated in 240 drawings and paintings, often nude. Their fourteen-year relationship was apparently unknown to Wyeth's wife, Betsy. In Pratt's case, Donna Meaney remained his model on and off for well over a decade. Mary, meanwhile, was not at all in the dark about her husband's infidelity.

·

MARY NEVER ASKED her husband how much money he'd spent on boats, and she never directly challenged him about his affair with Donna. Instead, she responded in a way that few in her circumstances would have chosen: she started to paint Donna in the nude.

Painting nude women had traditionally been the exclusive

domain of male artists. In Western art, some of the greatest paint-
ers—Botticelli, Titian, Rubens, Ingres, Watteau, Fragonard—cel-
ebrated luscious, full-bodied, beautiful females in their paintings.
In the nineteenth century, Impressionist and Post-Impressionist
artists dropped mythological images for real, corporeal women,
such as the main figure in Manet's work *Le Déjeuner sur l'Herbe*, an
unabashedly naked woman picnicking along with two fully
dressed young men. The Pre-Raphaelites depicted half-clad, highly
stylized über-romantics. Cubist artists deconstructed the body
into bits and pieces in order to challenge idealized representations
of female beauty. All these masterpieces were painted by men and
mainly for men.

After second-wave feminism emerged in the late 1960s and
'70s, the academic concept of the "male gaze"—that is, the theory
that pictures of nude women reduce their subjects to objects for
male speculation, desire and consumption—caused a re-evaluation
and self-consciousness for many male painters. Challenged by
feminists, men suddenly had to justify their motivations in draw-
ing and painting nude women. And for the viewer, as Julian Barnes
writes in his recent essays on art, "we [men] have become more
self-conscious spectators: queasiness and correct thinking have
entered the equation."[9]

Until well into the twentieth century, art schools did not allow
female students to work from nude models. In 1913, British student
Laura Knight protested with her *Self-Portrait*, which captured her
with back to the viewer painting a naked model. Critics called it
vulgar and the Royal Academy refused to exhibit it. Today, this
portrait, owned by Britain's National Portrait Gallery, is described
as a key work in the story of female self-portraiture and a symbol
of female emancipation.

Canadian artists in the early twentieth century, mostly male, tended not to paint nudes, probably due to parochial prudishness and religious disapproval. The women among Montreal's Beaver Hall Group of painters in the 1920s and '30s challenged the taboo. Regina Seiden's *Nudes* (1925) features two naked women with Jazz Age bobbed haircuts. Lilias Torrance Newton's *Nude in the Studio* (1933) portrays a self-confident, well-toned, muscular woman wearing nothing but a pair of stylish green sandals. At the first Canadian Group of Painters (CGP) exhibition in November 1933 at the Art Gallery of Toronto, the gallery's trustees refused to include Newton's nude, fearing that the city might cut off their funding. The story has a happy ending, as future governor general Vincent Massey and his wife, philanthropist Alice Massey, bought the painting. Pegi Nicol MacLeod painted a series of naked self-portraits, including *A Descent of Lilies* (1935), which shows a defiant Pegi, back turned, torso nude but draped from the waist down in red fabric. Prudence Heward triumphed when her *Girl Under a Tree* (1931), which portrayed a nude white woman stretched out under a tree, was included in the Group of Seven Exhibition at the Art Gallery of Toronto in December 1931.[10]

Some of these female artists painted models. Some painted themselves. None of them painted their husband's mistress. When Christopher had first offered Mary that slide tray of nude shots of Donna, he had in effect thrown down the gauntlet.

Why did Christopher give these slides to his wife? Why did Mary accept his challenge and indeed go on to use the slides herself? She mostly dodged the question. Frequently, Mary cited her friend Adrienne Clarkson urging her to paint female nudes. Or perhaps Mary wanted to let the world know that she didn't care that Christopher and Donna were lovers. Or she may have thought

that using Donna as a model would quash rumours of the affair. Another possibility—one now impossible to prove—is that Mary wanted to show that she could paint the object of her husband's desire better than her husband could.

Mary described Donna in the first slide she selected to paint as a "little perfect person sitting in a wicker chair."[11] Naked, Donna has drawn up her legs slightly agape, covering her breasts but leaving a space between her ankles and calves. This small, dark opening is almost the direct centre of the picture's composition. Mary told art historian Tom Smart that she was attracted to the slide by the formal qualities of the image—the symmetrical balance of the pose, the quality of light raking across the model's body. She explained that she wanted to discover what it was about Donna's body that made her an erotic muse for her husband.

This painting *Girl in Wicker Chair* (1978) graced the cover of *Saturday Night* magazine in September 1978. Some readers objected to the painting of a nude girl on the cover of a Canadian national magazine and cancelled their subscriptions. Mary laughed uproariously when she learned of the response.

In the spring of 1980, Donna returned unexpectedly to Salmonier. She had been living in Halifax, but an affair that ended badly brought her home to Mount Carmel. As Mary recalled, "Donna was some upset." So Mary and Christopher asked her back to work.

Much has been written about Mary's 1981 oil painting *Girl in My Dressing Gown*, which captures Donna clad in white bra and briefs, and draped in a too-large, wrinkled negligee with ruffles running down the front. Mary had staged this particular photo shoot and Christopher took the pictures. Mary repeatedly explained that she had always wanted to paint Donna in a robe and that the only one available was a wrinkled one of hers that she

pulled out of a dresser drawer. She added that the wrinkles made it hard to paint.

There's the obvious and uncomfortable element of exploitation and passive-aggressive gamesmanship going on between Mary and Christopher. Why would Donna agree to strip down to her bra and panties in order to be photographed by her lover in his wife's dressing gown? At the time, it simply didn't occur to her that Mary had a hidden agenda behind this particular pose. More curious is why Christopher agreed to participate. Whatever the drama that went into the painting, it resulted in a most remarkable portrait.

Academics and art critics discussing *Girl in My Dressing Gown* write about "the triangular subtext" and that the "iconography of the work points clearly to female rivalry and an attempted usurpation of the wifely position."[12] David Livingstone described the work as disquieting, with "something primal and heavy about the slack and sullen young woman in panties and bra wearing a negligee that obviously belongs to someone of greater stature."[13] Livingstone suggested that the painting hints at some sort of archetypal female rivalry—between mother and daughter, wife and other woman.

Mary clearly had pierced her husband's equanimity. Christopher observed: "She just visually ravaged Donna. She makes Donna look wasted. Donna has on *her* dressing gown and Donna was *my* model."[14] His irritation was understandable; Mary's nude work was not just better than Christopher's, but truer to life. With her superior ability to capture the complications of human flesh in paint, Mary had picked up her husband's gauntlet. The artistic battlefield would be the body of the very woman who had usurped Mary in her husband's erotic imagination.

Once Mary realized how successful her Donna paintings were proving to be, she began to stage new poses for Donna in place of her husband's old slides. Sometimes she asked Christopher to take the photos; later she took them herself. For *Blue Bath Water* (1983), Christopher stood on a chair above the clawed bathtub while Donna sat in blue-tinted bathwater, her face turned away, as if in a private moment. The painting is a compelling study of the smooth textures and pale, luminous colours of the female body reflected against the hue of the azure bathwater.

Mary began to take the emphasis away from Donna displaying herself to Christopher, putting it instead on Donna alone, with no self-consciousness, taking pleasure in female rituals. A century earlier this same desire to portray women in intimate moments of self-pampering inspired the female French Impressionist Berthe Morisot to paint, famously, *Jeune femme se poudrant* (*Young Woman Powdering Herself*), which displayed a young girl at her dressing table.

In one of the first Donna photos taken by Mary, *Girl in Red Turban* (1983), the model was dressed in a deep-red velour dressing gown with a brighter-red towel wrapped around her hair; the image captures a young woman in the timeless gestures of fussing with her appearance. Another, *Cold Cream* (1983), shows Donna staring straight out of the canvas with her face covered in layers of cold cream—reminiscent of a deer caught in headlights. In *Donna with a Powder Puff* (1986), the model is self-absorbed in the pleasure of dusting her body with talc. Mary joked that Donna's contribution to this photo shoot was to go through Mary's entire box of Chanel No. 5 bath powder.

During one of his visits to Salmonier, celebrity photographer John Reeves took pictures of a robed Donna and Mary sharing a

congenial cup of tea, with the works *Blue Bath Water* (1983) and *Bowl'd Fruit* (1981) on easels in the background.

Mary considered painting to be an erotic rather than an intellectual exercise. She described Donna in *Blue Bath Water* as a "kind of pearly, lush, warm and sensual thing." Christopher has said that a session with a model was close to a sexual experience, and that he liked to think that the girls who posed for him wanted to be there. But Mary, clearly disagreeing with her husband's assessment of his own work, continued: "I don't think [Christopher's] nudes are the same. They're much more cerebral, they're distanced. . . . I think I dare to be sensuous because this is what I feel about women."[14]

The model was becoming what Mary called her "partner"[15] in the business of making images of the female figure. But she was also becoming a weapon in two artists' duel over their ability to portray women. The rivalry seemed to extend deeper, however, than just their skill at portraying female nudes.

·

AT SOME TIME IN THOSE first few years of modelling for Christopher, Donna entered a relationship with her employer the likes of which would not be tolerated today. In 2008, the Canadian criminal system raised the legal age of consent from 14 to 16. Donna had been of age, but an additional proviso to this recent change states that 16- and 17-year-olds cannot consent to sexual activity if their partner is in a position of trust or authority toward them. As the Pratts' live-in mother's helper, Donna certainly depended on Christopher for her livelihood. By today's standards, with the rise of the #MeToo movement, his sexual behaviour would be considered harassment rather than simply

inappropriate. This international protest against sexual harassment has exposed myriads of men in positions of power getting away with sexual abuse. In another era, Christopher's involvement with young women in his employ could have caused his rising star to fall very quickly.

This is not to deny that Donna was a willing partner. However, she has severed ties with Christopher, and though she has never publicly complained about his behaviour, she resents that Christopher has never apologized to her.[16]

What about Mary's responsibility in the affair? She opted for her usual ploy of avoiding confrontation by ignoring the situation. In doing this, she dodged her responsibility as a trusted adult who had brought this young girl into their household and had a mother-figure relationship with this unworldly teenager only a very few years older than her own daughters. Mary appears never to have held Donna responsible for the affair.

Donna achieved lasting recognition as the result of being recorded pictorially many times as the Pratts' nude model. But she has lived a conventional life since. One day, years after the last of Donna's modelling, Canadian book editor Phyllis Bruce and the late author Bonnie Burnard were lunching together at the University of Toronto's Hart House Gallery Grill and discussing Burnard's book *Casino and Other Stories*, which featured Christopher Pratt's evocative painting *Summer of the Karmann Ghia* on its cover. When their server, Donna Meaney, approached to take their order, she glanced down at the book and exclaimed, "Oh, that's me on that cover."

The House That Jack Built

BY THE BEGINNING of the 1980s, the Pratt family had lived in Salmonier for close to two decades. Mary and Christopher's years of parenting four children were almost over. John and Anne were independent, while Barby and Ned had gone off to the Mainland for school.

Jack Pratt had been in poor health and confined to a wheelchair for several years. He'd been suffering circulation problems that resulted in the amputation of both legs. In November 1980, Christopher's father died.

Christopher and Philip were left inheritances. Christopher and Mary used the bequest for what Mary described as "the house that Jack built." They hired Philip, an emerging architect, to design and build a home on a half lot at 161½ Waterford Bridge Road, the street where Christopher and Philip had lived while growing up in St. John's. Although the location was convenient and Christopher liked the leafy neighbourhood of Waterford Bridge Road, the new property came with a residue of childhood memories, flashes of living alongside his Dawe uncles and the alcohol-fuelled parties

that dominated his youth. Those memories never left Christopher, and Mary was well aware of their impact on him.

Imagine the reaction of Christine Pratt to reading a September 1981 *Maclean's* cover story and finding these words from her daughter-in-law: "The reason for Christopher's passion for order is the total chaos of his childhood, an absolute horror story. His parents were kind and generous but they were undisciplined."[1]

The article suggested that the move was necessary for Christopher to prove to himself that he could thrive in an urban environment, although 1980 St. John's was hardly a bustling metropolis. "I would call it an experiment," said Christopher carefully. "We want to wean ourselves from what is obviously a pleasant sanctuary, but which we fear is somehow a trap."[2] It would be hard to conceive of a less enthusiastic response to the idea of leaving Salmonier.

What began with the idea of a simple in-town *pied-à-terre* evolved into a narrow four-storey house featuring his and hers studios—his in the basement, hers on the top floor. Christopher insisted that Mary take the prize studio while he took the basement, a space he had abhorred since the days of his childhood subterranean bedroom on LeMarchant Road. Mary described this decision as "almost masochistic."[3] He may have been disingenuous rather than masochistic; surely Christopher recognized that he would be deluding both himself and Mary to think he could live full-time in St. John's.

Completed in late 1981, the tall, thin house is clad in cedar and painted black and red, and backs onto a long garden with a stream at its perimeter. The ceilings are high, and light floods in from the large windows facing the garden. Mary chose a lacquer-red kitchen sink with a matching range hood over the kitchen island.

She boasted to *Equinox* magazine that they liked "class" and could no more compromise in their house design than in their painting. A photograph accompanying this article shows an unsmiling Christopher tentatively perched on their new white sofa, his running-shoed foot resting on the winter-blue carpet. One can just imagine his other crossed leg jiggling up and down with impatience.

Behind him hangs his triptych of prints, *Labrador Current* (1973), *Strait of Belle Isle* (1972) and *Ice* (1972). Their muted tones of blue and white could have been chosen by an interior decorator for their stylish co-ordination with the furniture. Christopher, however, looks like a fish out of water; or, better, to use his own comparison, "a bayman" in a "townie" home. There is a false conceit at work in his choice of words: Christopher, born and raised in St. John's, was every bit a townie, but he liked to think of himself as rural, and his time at Salmonier fed into the myth he was developing about himself. He told the journalist he was having a very hard time adjusting to his new basement studio, as he had always experienced visceral reactions to environments in which he wasn't comfortable. Most telling of all, Christopher referred to the beautiful new edifice as "Mary's house."

On December 9, 1981, Christopher's birthday, they moved in. In late January, Mary had business in Hamilton, Ontario, and as usual Christopher drove her to the airport. The tension on the drive was palpable. Christopher had been short-tempered throughout the Christmas week, lashing out at the whole family. Mary wrote in her diary, "He hates everything and all of us—dissolving into a sort of mush when he's afraid that his fury has really damaged one of us—which it will eventually do—as I have no power and no energy."

Mary was herself in a state of deep irritation, annoyed even by the way her husband dressed. "I wish he could get some decent clothes—somehow cope with himself," she wrote in her diary. He preferred comfort to fashion, wearing elastic-waist pants and a shabby navy coat. After a couple of days alone in Hamilton, Mary had had time to reconsider her feelings about her husband and decided that her frustrations were about his current negative attitudes and not with his "soul or real being." She continued, "He is my only love. I only long to mean as much to him as he means to me. But then—as someone or other said—'Love is woman's whole existence.'"[4]

The French, who know a thing or two about love, have a proverb: "In every relationship, there is one who kisses and one who offers the cheek"—the lover and the beloved. This imbalance sometimes makes the relationship mutually satisfactory; the adored one basks in the attention of his or her mate. In other cases the more-loved one takes advantage of the partner, or the beloved may begin to feel trapped or burdened by smothering affection.

Mary would be the first to admit that from their earliest days she wanted and pursued Christopher. She championed him in every imaginable way and enabled the conflicted young man to choose the life of an artist over the conventional path his parents wished for him. She sacrificed comfort and a social life for the isolation of Salmonier, where her husband could paint without the burden of teaching. While never neglecting his duties as a family man, Christopher made few, if any, sacrifices for his family's sake. In one of his poems, "I Have More Evidence of You," he wrote, "My heart broke its promises to you before the words were dry upon my lips."

In January 1982, having lived in the new house for a matter of weeks, Christopher packed up his belongings and drove back to

Salmonier. He claimed a nervous breakdown. He had proved to be the hothouse flower, unable to face the constant interruptions and noises of urban life. Mary was faced with two options: continue to live in St. John's and accept separation, or move back to Salmonier. She chose to go where he went. The house in St. John's was rented out. Christopher would never again live on Waterford Bridge Road.

Personal troubles went on the back burner with the terrible Newfoundland catastrophe that took place in the early hours of February 15, 1982. The *Ocean Ranger*, a mobile offshore drilling rig working the Hibernia oil fields almost two hundred miles east-southeast of St. John's, capsized in a ferocious storm and sank. Everyone on board—eighty-four people—drowned. Like the ocean liner *Titanic*, which sank 370 miles off the southeast coast of Newfoundland in 1912, the *Ocean Ranger* had been deemed unsinkable. Although tragedies at sea are an integral part of Newfoundland's history, this modern disaster put the entire province into a state of mourning. Christopher, a proud and faithful Newfoundlander, was devastated. He wrote a poem titled "Ranger," depicting the horrific deaths of the crew leaping off the burning rig, and ended his elegy, "behold / the fires / the furnaces / the very flames of hell / were cold."[5]

ONCE LIFE HAD settled down again in Salmonier, Mary decided to replace her converted greenhouse studio with a purpose-built one. Their youngest son, Ned, who had briefly studied architecture at the University of British Columbia, designed the new six-hundred-square-foot white clapboard building to her specific

requests for space, light and storage. The plans called for a building with an entrance hall leading into a small lounge and a large studio, a four-piece bathroom, a greenhouse and a sundeck facing the pond. In the studio, with large windows providing light, Mary set up separate work stations for her oil paintings, watercolours and drawings. She brought in a stereo system and played classical and jazz records. Around the outside of the studio, she planted flower gardens, and she tended to other plants in her greenhouse. To get to her studio, she walked across a tiny bridge over a creek and so entered her own world.

Every day, the two Pratt artists spent long hours in their respective studios. They were living in the same house, but increasingly becoming two solitudes.

Poor Me

MARY'S RECOGNITION BY THE 1975 women's show at the National Gallery of Canada had been a game changer. In its wake, she began to exhibit her work in Toronto at a commercial gallery near the St. Lawrence Market on Front Street, run by a young married couple, Lynne Wynick and David Tuck. Aggregation Gallery, a loft-style space, featured the works of highly collectible rising-star Canadian artists. The gallery presented new works by Mary Pratt annually, either in solo shows or included in group exhibits. With their lush colours and compelling and curious choices of subject matter, including fish on plastic wrap and drooling roast beef, her paintings soared in value, from $2,000 at her earlier shows to $10,000 later in the decade. With a long list of eager clients awaiting her next offerings, Tuck predicted, the prices could only continue to climb.

Included in her spring 1978 solo show was *Service Station* (1978), a startling and violent painting of a moose carcass. Mary delighted in telling the story of how she acquired this image. Ed Williams, who owned the service station up the road from the Pratt house, had phoned Mary to tell her that he had shot a

moose and hung it up for curing. He had seen Mary's moose carcass painting *Dick Marrie's Moose* (1973), which portrayed an animal shot by his cousin quartered and hung on the outside of a white clapboard house. Perhaps she'd like to see another. Moose is a staple food for rural Newfoundlanders. People register annually in the moose-licence lottery ahead of the autumn hunting season. In the more rural areas, some hunters ignore that requirement. When Mary arrived to take photos of Ed's moose, he pushed open the garage door to reveal a skinned and gutted half carcass with its legs splayed open and tied to the winch of a beat-up wrecking trunk. Mary came close to being sick, but stoically shot a roll of film. After getting the slides developed, she stashed them away, as she had no desire ever to paint the grotesque scene.

Some time later, NGC curator Mayo Graham asked Mary if she had any slides that she didn't want to paint. Mary pulled out the slide of Ed's moose and explained that it raised thoughts she really didn't want to explore. Mary told art historian Joan Murray, "If I see something and I really like it, then I paint it. Then I hope other people will like it too. But I don't want to make that kind of comment." Clearly, she is referring to the violence of the image.[1] When she did finally paint the scene, it became one of the most powerful works in her entire oeuvre.

Unmistakably feminist and political, *Service Station* shocks the viewer with its brutality and implied sexuality. Although the image clearly signifies rape, Mary once remarked in an interview that "actually it was the other end of the moose." Before shipping the picture to Toronto, Mary invited Ed, the service station owner, to see the finished work. Staring silently at the painting for a few seconds, he finally commented, "There's my old truck."[2]

Service Station and two other 1978 paintings—*Preserves* and *Meringue*—have something in common: for the first and only time in her career, Mary had added her maiden name into her signature—Mary West Pratt. Several of her contemporaries had chosen to sign their works with their maiden names. Joyce Wieland and Dorothy Knowles, for instance, did so to distance themselves from their artist husbands, Michael Snow and William Perehudoff. Mary's use of her married name might have had more to do with her conventional ideas about marriage than an attempt to cash in on Christopher Pratt's fame.

Having gained confidence through the growing success of her work, Mary made up for lost time by aggressively seeking markets farther afield. Unlike Christopher, who relied solely on his dealer, Mira Godard, Mary took it upon herself to promote her work. In the spring of 1980, she left Christopher at home and, with her friend and fellow artist Kathleen Knowling (nicknamed Muffet), took a trip to England. This time she hired a taxi to drive them to the international airport at Gander. They visited Kathleen's sister in the English countryside and then stayed at the English-Speaking Union's Dartmouth House, a stately Georgian mansion in Mayfair. Kathleen came from the Ayres, one of the most prominent Newfoundland merchant families, and she and the elder daughter of Fredericton's Wests fit comfortably into the gracious surroundings.

Mary brought with her a slide portfolio of selected works as she visited the numerous commercial art galleries along London's famous Cork Street, which stretched just north of the Royal Academy of Arts. The combination of "Canadian" and "woman" militated against Mary receiving any welcome, and she failed to find an interested dealer. Only a very few Canadian artists at

that time had met with any success in cracking the international art market. Mary's attempt did nothing to distinguish her from the majority.

Mary was still in London when Christopher faced a mutiny in the provincial legislature at the unveiling of his design for a new provincial flag. As Newfoundland's most famous artist, he had been asked to design a flag to replace Britain's Union Jack, which had represented Newfoundland since 1932. Christopher had produced seven variations, and the jurors had come to Salmonier to view them. Mary had charmed them by serving coffee and homemade muffins, while outside, Christopher paced the property. The jurors chose a design of blue and white framed in red triangles and with a gold arrow. As would be expected, Christopher had spent a tremendous amount of time thinking about and producing his designs. He was confident the jury's choice would represent the interests of all Newfoundlanders.

He and his elder daughter, Anne, sat in the legislature gallery as the flag was unveiled. They expected cheers and kind words of praise. Instead, rather than unanimous approval, they received complaints from the Liberal opposition and a considerable number of Newfoundlanders. Former premier Joey Smallwood, whom Christopher had worked actively to defeat in the 1971 provincial election, called the design "the worst Newfie joke yet."[3] A CBC telephone poll of a thousand people showed public opinion to be two to one against the new flag. An editorial in the *Daily News* called for it to be burned or bound to rocks and dropped into the Atlantic Ocean. Christopher, who had taken on the task pro bono, was deeply hurt.

The flag was officially approved on May 26, 1980, by a vote of twenty-two to ten. The result did little to ease the sting felt by the

flag's creator, nor did it ease Christopher's resentment: Mary, busy with her own career in London, had not been by his side during his hour of need. Though ostensibly a working holiday, the trip had been Mary's first solo vacation during their entire marriage.

.

MARY'S FOCUS INCREASINGLY lay elsewhere. In 1981, the London Regional Art Gallery in Ontario—a hub of artistic influence at the time—curated a show featuring thirteen years of works by Mary Pratt. This show, called simply *Mary Pratt*, toured in 1981–82 across the country to ten regional public galleries, putting Mary on the map of Canadian art.[4]

Of the forty-seven pieces in that show, food featured as the subject matter in more than half. These mouth-watering paintings, which included *Supper Table, Preserves, Salmon on Saran, Baked Apples on Tinfoil, Roast Beef, Steamed Pudding, Three Gifts* and *Christmas Turkey*, caused one woman in attendance to wonder out loud what kind of cook Mary Pratt must be.

Suddenly the tables had turned and Christopher, as artist's spouse, accompanied Mary to the various openings across Canada. He championed Mary and noted in his diary that her work held up exceptionally well. "It is intellectually honest: apparent without being superficial, literate without being narrative and articulate without being glib."[5] Understandably, he had difficulty adjusting to his supporting role.

As Mary became more prominent and had proven herself to be an intelligent and articulate spokesperson with strong opinions, organizations began to court her to join their boards and committees. Elated to be recognized and eager to raise her profile, she

accepted everything, qualified for it or not. She joined a task force on provincial Newfoundland education and even sat briefly on the Fishing Industry Advisory Board. In 1980, she was appointed as one of four lay "Benchers" of the Law Society of Newfoundland and joined the board of directors of Grace Hospital in St. John's.

A position more appropriate to her expertise was membership in the Federal Cultural Policy Review Committee, more commonly referred to as the Applebaum–Hébert Committee. Mary championed the regions that had always suffered from the fact that funding most often went to large arts organizations in Central Canada. Reflecting back on her time with this committee, she appreciated that she had had the opportunity to travel widely across the country to attend hearings, but thought it had ultimately been a waste of her time. Visiting eighteen cities as well as attending monthly meetings in Ottawa meant the committee—together with her many other new commitments—kept her away from the studio for much of 1981.

While not prepared to retreat from her suddenly very public life, Mary realized that her burgeoning recognition and success were hard on Christopher's ego. She told *Maclean's* as much. "In fact," she added, "in the last year I was almost pleased if something bad happened to my work so I could say, 'Well, everything isn't coming up roses for *me*.'"[6]

·

IN THE MIDST of all Mary's triumphs, Christopher had suffered his first major setback as a painter. At his November 1984 Mira Godard Gallery solo show, several works, all figurative female nudes, failed to sell. Toronto art critics ignored or, worse still,

panned these nudes. The *Toronto Star* reviewer described them as "all rendered with a scalpel-like precision that wants to rob them of their humanity."[7]

Christopher had been forewarned when, in 1982, his show of twenty-one graphite drawings of female nudes at the Godard Gallery had closed a week ahead of schedule. The *Globe and Mail* critic, John Bentley Mays, had found them illuminating for their less laboured and more freely drawn style. "They narrated the planes and volumes of the nude figure with the same firm purpose we find in the paintings but without the characteristic great labor of execution."[8] Despite Mays's critical praise, the show failed to attract the usual interest from buyers, many of whom were corporations.

While the nudes at his November 1984 show sold poorly, all his big oil paintings found buyers. Titled *Interiors*, the show included *Pink Sink* (1984) and *Light from a Room Upstairs* (1984), based on recollections of visits to his relatives in Bay Roberts. *Whaling Station* (1983) featured monochromatic, stripped-down tiers of wooden bunk beds that could as easily have belonged to a concentration camp as a whaling station. When Christopher had returned to his Salmonier studio in 1982 after the thwarted attempt to move to St. John's, he had spent time alone sorting through his accumulation of notes and sketches. He came across a series of studies he had made a decade before at an abandoned whaling station at Hawke Harbour on the coast of Labrador. He had sketched the bunkhouse, whose graffitied walls evoked the lives of the men who had been stationed there.

Included in the *Interiors* show was his limited edition print *Yacht Wintering* (1984), depicting a boat on dry land wrapped in

tarpaulin and standing on a crib. In his artist statement in the accompanying catalogue, he wrote that his racing ambitions were no longer a driving force in his life. "It is analogous to someone in art school feeling that the day will come when it will be 'move over Picasso.' But when you get to be forty-eight years old you know that that's not the case." Christopher was in the midst of dealing with disillusionments and coming to grips with middle age.

When he uncrated the returned works, *Washstand*, *Attic* and *Model on a Mattress* (1983), they went straight into his burn barrel. One of the destroyed works, *Model on a Mattress*, which featured a local girl, Denise, lying on a mattress with her legs provocatively spread open, had been reproduced in Joyce Zemans's catalogue. *Washstand* can be seen in several John Reeves photos from a 1983 session with Donna. Writing about *Washstand* in the catalogue, Christopher seems to suggest that the model had a certain coarseness or sexual forthrightness that he chose not to capture, wanting rather to celebrate what was decent and delicate about her. "I guess by not bringing out those things in models which I see from time to time is rather the same as not showing glass broken in a window or paint peeling off clapboard."[9]

Art writer Tom Smart described the women in *Washstand* and *Attic* as being "objects of desire." Smart suggested that Christopher's idealized woman from his 1960s works became the temptress muse, the submissive model being replaced by a dominator role. Christopher's long affair with Donna made him feel less in control of the situation. Mary, writing in the privacy of her diary about the Denise works, including the oil painting *Model on a Mattress*, commented that she found them objectionable not because they explicitly exposed the model, but because Christopher

painted them without any real compassion or understanding. "His problem with figure paintings," she wrote, "is indicative of his fear of the human condition."

In a 1983 photography session at Salmonier, John Reeves had focused on Pratt's relationship with models. In one shot he posed Christopher standing in the background, with one hand high on an easel that holds the finished nude work *Washstand* while his other hand rests on the actual rustic washstand. In the foreground, Donna lies curled up in a blue dressing gown on a raised platform. Other photos from that session include one of Christopher posed with his arms crossed directly behind Donna, who is sitting on the platform reading a newspaper while an unfinished nude drawing with charcoal and erasers is in the foreground; another shows the two of them smiling at each other as they share a tea break. Donna was now in her early thirties, had had other lovers, and appeared self-possessed and comfortable in the presence of a professional photographer. That session could have been titled "Males Gazing." One middle-aged man was taking pictures of another middle-aged man looming over a younger model naked but for her thin blue robe.[10]

Christopher recognized that he had lost his way:

> How did I get so far from the meat and sinew of things? I have retreated from that hard edge of abstraction, but not far enough. What has killed the poetry and left me arranging lines and tone: is there nothing beneath the surface of the pond, behind the wall, through the window, in the room, or on the mind of a model.[11]

Depressed by the rejection of his nude works at the Godard exhibition, Christopher accompanied Mary in December 1984 to

Alberta to teach at the Banff School of Fine Arts. He refers to that occasion as "the Battle of Banff." His resentment at being invited to attend alongside his wife leaked out. "I don't want to be looked at as some sort of ma and pa cotton candy act—people who've been married for 100 years living an idyllic life and all that."[12] They refused a request to do a mutual interview for the publication *Banff Letters*, but instead each spoke privately to writer Marie Morgan. Photographer Kim Chan captured Christopher's sullen mood in a picture of the couple separated by several feet leaning against a bridge with a snowy forest background. No idyllic setting could warm the gap opening between them now.

.

FOR THE ENTIRE Pratt family, the early 1980s were eventful years. Christopher's aunt Myrt died after Jack Pratt, leaving his mother alone in her St. Philip's home. The beginning of a new generation of the family began with the birth of Mary and Christopher's first grandchild (daughter to John and his wife, Alix Howson). Baby Katherine, named after her maternal grandmother, became immortalized in one of Mary's favourites among her own paintings, *Child with Two Adults* (1983), which captured the vulnerable infant's first bath in a large bowl.

Then, in the spring and summer of 1984, both daughters, Anne and Barby, were married at home. In late March, Anne, who had been working as a chef in St. John's and attending Memorial University, married a local fellow named Bob Lamar. In July, Barby married journalist and author Russell Wangersky, whom she had met at boarding school in New Brunswick and then followed to Acadia University in Wolfville, Nova Scotia.

At these family events and in public, Mary and Christopher perpetuated the image of a happily married couple. One journalist proclaimed that any readers suspecting "marital discord, parental-child battlefield, jealousies or other deep dark secrets that could only be bestowed on two such well-known and talented people" were "morbidly curious muck-rakers." A 1984 issue of *Newfoundland Life Styles* included an article titled "Christopher and Mary Pratt: They're Quite Unique" and featured the Pratts on the cover. Mary, dressed in a preppy Fair Isle sweater and tweed skirt, is smiling broadly as she leans against Christopher, who has his hand on his hip while glaring straight into the camera.[13]

Mary admitted that she had that old-fashioned attitude of avoiding too much self-reflection and not making "a big deal out of bad things."[14] This she had learned from her mother, who feared confrontation. She had told art writer Joan Murray in 1979 that she and Christopher had experienced difficult times. "Somebody's up somebody's down. Marriage is not really easy; and with divorce so acceptable in so many eyes—and so fashionable—it isn't always the obvious thing to try to find happiness within a continuing relationship."[15]

Christopher felt abandoned by Mary, despite his adultery, his years being away sailing in races and spending vast sums of money on his boats, his unwillingness to compromise on leaving Salmonier for St. John's, where Mary might have had a more fulfilling social life. They took long Sunday drives during which, amid constant passive-aggressive tension, they rarely spoke.

He attempted to describe his sadness in the 1984 poem "You Came into My Studio," portraying a conversation with an unnamed person, most likely Mary, in which he voices his despondency

at life not meeting his expectations. His complaints do not engen-
der sympathy. The final verse ends, "You said, I thought sarcasti-
cally:/ 'Poor Me'?"[16]

You Look like a Grand Bank

CHRISTOPHER'S DEPRESSION LASTED through the winter months of 1985. When he closed his eyes or was half-asleep, he saw images of dark corridors or strange, unknown rooms. Mary watched helplessly as her husband stared silently into space and became even thinner. She had her own sadness. In February 1985 her beloved father, Bill West, died at the age of ninety-three. Christopher accompanied her to the funeral, driving them in the dark, early morning from Salmonier to St. John's, enduring a turbulent flight to Halifax and then driving to Fredericton in icy conditions. Mary insisted on going into the funeral home alone.

With three of their four children now married and Donna permanently in Toronto, Christopher had only Mary to snap at during breakfast. He expected her to join him promptly at 6:30 a.m. One April morning Mary puttered around washing her hair, changing the bed and feeding the cat before she sat down at the table. He snarled at her tardiness. She went out of her way to tempt him from his mood with meals such as the one described in her April 17 diary entry: pork chops in orange, honey and ginger sauce and an apple dessert with cinnamon biscuits. But gusting winds and

snow in mid-April only added to his despondency. Nothing lifted Christopher's gloom.

It would not have helped her husband's spirits when Mary showed him a letter written on April 18 by their mutual friend Jim Hansen, an American artist who had moved to Newfoundland in 1970. Hansen observes in the letter that Mary seemed more in control of her work than Christopher. He'd addressed it to both of them, so upon reading Hansen's opinion Mary shared it with her husband. Perhaps a more empathetic choice would have been to shield a depressed spouse by not passing this letter along. She noted in her diary that Christopher had been upset by the comments.

The eventual arrival of spring with its sunshine, sprouting of bulbs in the flower beds and honking of geese as they passed overhead cheered him slightly. His single silkscreen that year was *Spring at My Place* (1985). He had marvelled over the years at how the west-facing clapboard wall of the Salmonier house acted as a kind of screen onto which the sunlight projected images of the nearby trees. Though just shadows, really, these images and the ways in which they changed with the time of day and the seasons inspired him to capture their sharp forms in the screen, leading him to produce at least this one image in what had begun as a dismal year.[1]

·

A MAJOR CHRISTOPHER Pratt retrospective had been scheduled for November 1985 by the Vancouver Art Gallery (VAG). Although Christopher was one of very few Canadian artists with national recognition, it seemed an odd choice for a west coast gallery to feature the life work of a Newfoundlander. But the VAG's director, Luke Rombout, Dutch-born and trained in Amsterdam, had

come to Canada in 1954 and studied fine arts at the Pratts' alma mater, Mount Allison University, and then become director of the university's Owens Art Gallery (1968–71). He'd also worked with David Silcox at the Canada Council, where he'd have further championed Christopher's work.

Rombout's departure from the VAG a year before the show left Christopher's retrospective in the hands of a new curator and thus vulnerable to cancellation. Christopher fretted that Rombout's successor might prefer an artist more in keeping with the gallery's regional focus. If abstract art had been a test to figurative, realist painters—a description that applies to the work of either Pratt —the latest trends in visual arts presented a far greater challenge to Christopher. The very worth of "easel artists," people putting brush to canvas, was being challenged by the Canadian art estab-lishment in the light of new media—videos, performance art, in-stallations and conceptual works.

Continental Bank stepped in to rescue the Christopher Pratt retrospective with a direct grant of $30,000 and marketing ser-vices. Proving that his wit had not vanished, Pratt sent its presi-dent, David Lewis, a telegram that ended, "From where we sit on the Continental Shelf, you look like a Grand Bank."[2]

Christopher Pratt: A Retrospective opened as planned, featuring more than 150 paintings, watercolours, serigraphs and drawings. Nearly 90 percent of his output to date had been retrieved from national and provincial galleries and corporate art collections, as well as from Pratt family members and private owners. The show covered the breadth of his artistic career, beginning with his ama-teur watercolours such as *Rocks and Surf, St. Mary's Bay* (1952) and then examples of his student works from the Glasgow School of Art, *Grosvenor Crescent* (1957), and Mount Allison, *Demolitions*

on the South Side (1960). Visitors learned about his process of making preparatory drawings and sketches before beginning the final work. The guest curator, art historian Joyce Zemans, prepared a scholarly and detailed exhibition catalogue. The show moved on to Toronto's Art Gallery of Ontario, Memorial University's Art Gallery in St. John's and finally the Dalhousie Art Gallery in Halifax.

A party in Toronto given by Joyce and Fred Zemans after the opening at the Art Gallery of Ontario gave Christopher the opportunity to reconnect or meet for the first time with artists and dealers such as Ron Bloore, Tony Urquhart, Dorothy Cameron and Bruce Parsons. Earlier that day at Mira Godard's, Christopher had traded stories with Quebec artist Ulysse Comtois about their travels together as Canada Council jurors. They recalled biting their nails as David Silcox careened along the road from Toronto to London, driving them to the studios of Jack Chambers, Greg Curnoe and other notable Ontario painters.

The retrospective attracted a great deal of media attention. Amidst many laudatory reviews and complimentary profiles, a few critics took a harsher viewpoint. *Canadian Art* featured Christopher Pratt on the cover of its Winter 1985 issue, with a lengthy article written by art critic Gary Michael Dault. He argued that Pratt's paintings focus on radical contrasts and dichotomies, and gave the example of the oil painting *Federal Area* (1975), with a large wall on the left side with a handleless door and on the right a window view of a green meadow and peaceful blue sea and sky. Dault argued that by trying to depict both sides of an experience at the same time, Pratt ended up giving the viewer a frozen moment of contrasts or a sense of indecision. Dault called Christopher "the laureate of the middle way, the great sitter on the fence."[3]

Christopher directly addressed this "sitting on the fence issue" in a later interview with Kate Taylor. He explained that just as his work balances equally between abstraction and realism, life is composed of dualities. "So many things defy resolution. There are a great many things for which there are no answers."[4]

Globe and Mail art critic John Bentley Mays, in a review titled "This Is Not the Newfoundland of Getaway Fantasy," gave a lukewarm appraisal of the show. He wrote that Pratt's old-fashioned "unchanging stance towards his history, space and land" was understandable since Pratt was confronting and presenting images of Newfoundland's chronic economic plight. Mays allowed to stand as praise what some might have considered Pratt's parochial concentration on his home province: "He is widely admired as the quintessential Mr. Newfoundland—a proud and successful native son of the big island, a designer of postage stamps and flags, a family man and good citizen all round," he wrote.[5]

Despite these critical reviews, the retrospective only made collectors more keen to own a Christopher Pratt. He felt lucky to have what he called "a halftime break in 1985"[6] at the age of fifty to review the span of his professional career. He categorized his work in two stages: pre-Mira and after-Mira. Analyzing his progression many years later, he did realize that with success had come "the unconscious establishment of a product line,"[7] but that was an understanding that was yet to come. He had been following the encouragement of Mira Godard, who knew that individual and corporate collectors would continue to snap up works painted in Christopher's trademark style, and he newly determined to satisfy that demand.

By the time the VAG retrospective closed in Halifax at the end of August 1986, Christopher's depression had lifted. Newly

energized, he decided that the compositions of some of his prints and small drawings could work as large paintings, and he set his mind to painting them. As part of his fresh start, he felt the need for a larger studio, one that would offer him more room in which to work, and greater space between the making of his art and the family home.

The studio would take time to design and construct. His desire for distance between himself and home would find another outlet in the meantime.

This Is Jeanette

WITH CHRISTOPHER FEELING triumphant, their two daughters recently married, Donna living with her partner in Toronto, and Mary having achieved respect and fame as an artist in her own right, the Pratts might have seized this moment as a chance to reconcile and work and live together in harmony.

In 1984, Christopher employed a local nineteen-year-old to assist in his studio. Jeanette Meehan had never been inside an art studio and had no experience or knowledge of the world of art. She remembers that Christopher had been working on *Pink Sink* (1984) when she began there.[1]

Before being hired by Christopher, she had never heard of him and had little to no idea of what an artist did in a studio. Her jobs were simple ones: clean and tidy the studio, sharpen pencils, cut towelling for cleaning paintbrushes, and pack up in tinfoil the acrylic paints Christopher had mixed—useful jobs that required no knowledge of Christopher's trade but from which she could slowly learn to do more. In time, she moved on to priming canvas and preparing watercolour paper, jobs that Barby used to do.

Once the VAG retrospective had been confirmed, Christopher realized that he would be away from the studio for much of the next few months and so dismissed his "girl Friday." Jeanette went to work as an aide in an old-age home, which could have been her future. But Christopher had returned from the VAG retrospective with vigour and hired her back. She arrived wearing a white over-tunic, perhaps the same outfit she had worn as an elder-care worker.

Jeanette had begun to assist in the arduous printing process with the 1985 silkscreen *Spring at My Place*. Christopher observed in his diary that Jeanette had developed so much aptitude for the process that she might be able to take on even more involved tasks. He set up some exercises to test whether she could help with un-derpainting (traditionally, the process of first painting a blank canvas in monochrome). She did so well with the trial exercises that he trusted her to go beyond conventional underpainting. After he had drawn all the lines of a new work, Christopher would mix the paints and instruct her where to lay-in the colour tones. Not inclined to romanticize her contribution the way an awe-struck art student might, Jeanette thought of her work as painting a big colouring-book page.

The first work she underpainted was *Big Boat* (1986–87), a mas-sive canvas, 49 inches high and 115¼ inches long. She had studied how Christopher held his brush and held hers in exactly the same way. Working a regular eight-hour shift, five days a week in the studio, she could soon underpaint a work in three weeks to a month. This enabled Christopher to increase his typically slow output.

Jeanette came from nearby Point La Haye in St. Mary's Bay. Born in 1965, she was the youngest child of Gertrude (née Kielly) and Michael Meehan, Irish Catholics who had a large family of

seven girls and three boys. The Meehans were a poor but close-knit family, with Jeanette remaining home to help her parents. (Jeanette left school before graduating, but years later finished her high school diploma by correspondence.) When she began to work for Christopher, she was engaged to a man eleven years older than herself.

Though Jeanette declined ever to be one of Christopher's nude models, Mary sensed trouble the minute she laid eyes on her. Speaking about her in a documentary, Mary observed that the young girl was "ignorant, didn't know from nothing, but was perfect for Christopher."[2] He did not hide his infatuation with this blond, curly-haired girl, whom he called Jenny. Christopher often expressed repressed emotions by writing about them. In a 1986 poem titled "I Had Already Written Poetry for You," Christopher spoke of his pain at the thought of Jeanette in the arms of a lover.

I feared the silent evidence
The echo of a foreign substance on your lips,
A different rhythm on your breath[3]

He called the summer of 1986 his personal Indian summer, a time when he felt a temporary reprieve from growing old. He wrote in his diary that when he looked life in the face, he found it "unbelievably sweet and beautiful. I have seen it smiling back at me, restoring me and healing me, and I believe that I have never been so happy or known such warmth and lightness of being."

Christopher began to take Jeanette sailing, thereby exposing Mary to public humiliation. At Salmonier, Mary screamed at Christopher, tried to give him back her wedding ring and smashed

dishes. He remained cool and detached. Nothing would deter him, and he continued to take his underpainter out in public.

The Pratt children, all older than Jeanette, had to accept her presence if they wanted to sail with their father. Barby, in particular, had frequently been her father's sailing companion and felt usurped by this girl two years her junior. Friends of the Pratts thought Christopher was in the midst of an all-out mid-life crisis.

In the summer of 1987, Mary discovered a photograph of Jeanette displayed on Christopher's desk in his studio office and demanded that he get rid of it. When it appeared again, Mary realized that she had the fight of her life on her hands. This situation made his relationship with Donna seem trivial. Mary had come to terms with her husband's infatuation with Donna, writing in her diary that she had "long ago stopped agonizing over whatever relationship she and Tiff had."[4]

Donna, visiting home in the summer of 1987 and expecting a baby, was equally infuriated at Christopher's very public relationship with Jeanette. She offered to take it upon herself to confront Christopher. Mary wrote in her diary, "I wouldn't want Donna's relationship with Tiff to be as soured by that horrid girl as mine is —and as the children's becomes."[5] Whether or not the Pratt children ever had an inkling of their father's relationship with their au pair, they uniformly chose to ignore it and considered Donna a member of their family. To this day, in the minds of the Pratt children, Jeanette has always been the villain who snatched their father away from Mary.

Christopher readily admitted to being utterly smitten by this creamy-skinned young woman with her growing thirst for knowledge and bred-in-the-bone outport sensibility. While feisty, she

did not make him feel culturally inadequate as Mary and the West family did. She did not challenge him. Perhaps there was in their relationship a hint of George Bernard Shaw's *Pygmalion*, an older man educating a young woman eager to better her station in life.

Naively or in desperation, Mary thought she could wait it out. She continued to believe it was not necessary or even advisable to ditch a marriage. She had stood by her man throughout his earlier affair, and even befriended the younger woman since. And indeed Mary refused to relinquish her home and her husband. She believed that her art could be only as successful as her life, and remaining married was part of her idea of success. She could live with her anger, but as it turned out her art could not contain it.

Ménage à Trois

EVERY DAY, MARY escaped across the bridge to her studio. In the midst of emotional turmoil, her workspace, with its big south-facing windows, its view of the pond and the forest beyond it, together with the sounds of the nearby brook and river disrupted by the tides, brought some peace. She buried herself in work from early morning often until well after midnight. Life in Salmonier had again become a ménage à trois.

Her diary entry for August 8, 1986, tells of her sense of being trapped in the family home, feeling like a fly enmeshed in a spider's web. Continuing with the metaphor, Mary wrote, "I saw that it was beautiful, but I had no desire to touch it. I was forced into it against my will—against my better judgement—because I was weak."

She tried to understand why Christopher had betrayed her again. She had convinced herself that her love and grace would win out. She wrote:

But I soon discovered that the influence of evil is very strong and the love and grace I had hoped would gild my personal

relationships was too weak to overcome the cynicism that evil produces. . . . I found that the centre of my world—that other human upon whom I had bestowed everything I had to give— didn't really want any of the things I had given.

In a rare moment of truthful soul-searching, she acknowledged that in her youthful pursuit of Christopher, she had perhaps played a role in this agonizing dynamic. She concluded, "The web was my own—and instead of the fly—I was the spider."[1]

Mary's pent-up emotion went into her work. She painted some of her best Donna works as an outlet for her rage. Once again using the slides taken by Christopher of his previous lover, she created *Donna* in 1986. It is an extremely unsettling image, with Donna naked, sitting on the floor with her knees drawn up protectively and her back to a wall. Mary felt she had made Donna look like a threatened animal, capable of lashing out. Sock marks on Donna's shins add to the sense of vulnerability.

Mary followed with *This Is Donna* (1987), in which the model is dressed in white panties and bra, standing with her back to the wall, facing forward with a defiant look. This slide is part of the photo shoot from which Mary had painted *Girl in My Dressing Gown* in 1981. In that earlier painting, Donna has a more ambiguous or troubled expression, as if wondering what is going on. Mary called *This Is Donna* her most strident and confident painting of her husband's former mistress.

A third piece, *Girl in Glitz* (1987), features another of Christopher's models dressed in flowered mini-briefs and a white bra with lace eyelet trim, lying sideways on a couch gazing with a seductive taunt into Christopher's camera lens. Mary seemed determined to remind the world what she'd been putting up with.

At the same time, she was moving closer to her husband professionally. Mary had left Lynne Wynick and David Tuck at Toronto's Aggregation Gallery and was now represented by her husband's long-time agent, Mira Godard, which was an odd move since the two women never really got along. As Mary tells it, Mira had seen *Blue Bath Water* (1983) and wanted to sell it. So, although the move angered Wynick and Tuck, Mary became part of the considerable Godard stable of painters (she represented Alex Colville, perhaps the Canadian industry's most lucrative client).

For her first Godard solo show in May 1985, either Mary or the gallery owner had made the unwise decision to include several watercolours painted to accompany a cookbook by Cynthia Wine titled *Across the Table: An Indulgent Look at Food in Canada.*[2] These charming illustrations reinforced Mary's reputation as a painter who could find beauty in the most mundane of domestic moments, such as a salmon in the sink or live lobsters piled in a rock crevice waiting to be plunged into boiling water. While pleasing as book illustrations, on an art gallery wall the paintings had the *gravitas* of mere pretty pictures—insipid and lacking edge.

A show in 1986 titled *Aspects of a Ceremony* at Vancouver's Equinox Gallery featured edgier paintings, more in line with Mary's feelings, in particular her embittered attitude toward marriage. She had begun to look at marriage as a kind of sacrifice and depicted this in the show's more memorable pieces. She had painted both daughters in their wedding dresses.

Anne in My Garden (1986) is a restaging of her elder daughter's wedding day, with lush greenery in the background that would not have been there during the April wedding. Anne's gown, Elizabethan in style, along with her hair, pinned up and adorned with flowers, nods to a Pre-Raphaelite aesthetic (Anne had become

enamoured of Edmund Spenser's sixteenth-century epic poem *The Faerie Queen* while studying it in her university English course). To place the moment in the late twentieth century, Mary included the overhead telephone wires.

In *Wedding Dress* (1986), Anne's gown hangs outdoors from the branch of a small maple tree in the Salmonier garden. Rather than fluttering gently in the breeze, the dress is ensnarled on the rough bark of the trunk. The mood is a stark contrast to Mary's 1975 work by the same name, which shows a demure Empire-style, pure-white wedding gown hanging, almost as if floating, against a closed bedroom door. In hindsight, Mary recognized that with her 1986 *Wedding Dress* she had turned a celebratory and idealized image into a metaphor of female crucifixion.[3]

A third painting in the Vancouver show, *Barby in the Dress She Made Herself* (1986), matches the power of *Donna* as a portrayal of sadness and vulnerability. Mary and Barby had gone to Toronto to buy a wedding dress but couldn't find anything suitable. So Barby decided to make her own gown, a confection of organza and lace. For the description card accompanying the painting years later, in the 2014 retrospective exhibition, Mary wrote, "I felt that she was not just making a dress for herself—she was making a life for herself."

Of these paintings, art writer Tom Smart argued that Mary was probing the concept of commitment by treating her two daughters, both married in 1984, as manifestations of herself. She may have fuelled such an interpretation, as when she told journalist Robin Laurence that she was fascinated by her daughters' willingness to re-enact a "primitive ritual" of submission.[4]

Anne and Barby's loyalty to their mother means that they are not prepared to publicly discuss their own reactions to these

depictions of their weddings. Perhaps the fact that both these marriages have ended in divorce is the strongest comment.[5]

.

THE TWO PAINTINGS of Donna, plus *Girl in Glitz*, took the spotlight at Mary's November 1987 solo show at the Mira Godard Gallery. Art critic Christopher Hume focused particularly on *Girl in Glitz*, or, as Mary described it, "the gerl in the glitz draaw-ers." She emphasized that the young model had been posing for Christopher's camera and showed a tentativeness in her eyes, as if she didn't know whether she should look sexually interested. Mary told Hume, "People might find it odd to paint a picture of a woman modeling for your husband . . . but I feel I know a lot about her."[6] It was a typical Mary Pratt remark that creates just enough ambiguity to leave the public wanting to know the whole story.

In 1987, Mary produced a remarkable thirty-four finished works in oil, mixed media, watercolour and pastel, along with a litho-graph, *Graduation Dress*. She appeared to grab any topic at hand, from John Crosbie's mackerel (the outspoken Newfoundlander was a Cabinet minister in Brian Mulroney's Conservative federal government at that time) to Fredericton City Hall, shown with rosy bricks and floodlights.

She painted *Venus from a Northern Pond*, featuring the attrac-tive red-haired Paddye Mann. The photo shoot had occurred in the pond at Salmonier, and Mary had taken the pictures. Paddye stood immersed in the freezing cold water, which flowed in and out from the ocean. The finished work presents the nude emerging from the depths of the pond's green waters with her submerged nipples erect from the chill of the water, while sunlight glistens off

her exposed head and shoulders. The result had exceeded Mary's expectations, as she had imagined a body emerging from the depths of their peat-brown pond into the sun. She commented, "I hadn't realized that the sun would continue to wrap around the body, even under the water."[7]

Mary revisited her earlier success painting fish, which had included her iconic 1974 *Salmon on Saran* and *Cod Fillets on Tinfoil*, among several others. She produced *Decked Mackerel, Salmon Between Two Sinks* and *Silver Fish on Crimson Foil*. This time her mackerel lies high and dry on a wooden deck, while the gutted salmon hangs over a double sink. These fish are caught, lifeless, no longer in control. *Silver Fish on Crimson Foil*, although similar to her earlier *Salmon on Saran*, shows a significant difference. She used the same slide but changed the wrapping to red foil; this version emphasized the blood and death that accompanies the catching and preparation of a fish.

Decked Mackerel was ultimately seen by thousands of Canadians from coast to coast. Mary's work was one of seven chosen for a cultural-promotion project called *Painting the Town*, sponsored by Manufacturers Life Insurance of Toronto in 1987. The painting joined others by artists Louis de Niverville, Lynn Donoghue, Yves Gaucher, Frances Pocock James and Jack Shadbolt on four-by-eight-metre superboards erected in nine Canadian cities.

Mary's prodigious output of paintings in the anguished final years of her marriage, many with deeply pained subtexts, again brings to mind the Mexican artist Frida Kahlo, who in the two years after her 1939 divorce from Diego Rivera created many of her best works. Kahlo herself described her paintings as "a ribbon around a bomb." Her *Las Dos Fridas* (1939) is a double self-portrait with the two Fridas holding hands. One is the Frida whom Diego

loved, dressed in traditional Mexican costume; the other, the Frida whom Diego no longer loved, is dressed in white. Kahlo's biographer, Hayden Herrera, described the work: "The vein winds around the Tehuana [Mexican-costumed] Frida's arm, continues through her heart, then leaps across space to the other Frida, circling her neck, entering her broken heart, and finally ending on her lap, where she shuts off the flow with surgical pincers."[8]

Mary's contemporary Joyce Wieland also used her failed marriage as autobiographical subject matter. In *Artist on Fire* (1983), Wieland portrayed herself as the French mistress to Louis XV, Madame de Pompadour, who had been betrayed by her king once his next mistress bore him a son. Wieland's husband, Michael Snow, had taken a mistress who gave birth to a boy. Wieland's *Paint Phantom* (1983–84) is a disturbing piece featuring a phantasmal, naked female and male with the faces of Joyce and Michael. Against a background mainly of black sky with an off-centre full moon, the couple are entwined in battle, with the female's left leg swinging upward between the legs of the man/devil, who has a tail and a purple-veined hunched back.

Mary next turned to fire to express her rage and anger at her husband's behaviour. Her chronic arthritis, exacerbated by stress, had flared up, making it difficult to sit for long at her easel. She reconfigured her studio in order to hang watercolour paper in a large frame on the wall. Then she projected slides of bonfires onto the paper. In contrast to the minute brush strokes of her oil paintings, she used big brushes or spray bottles filled with paint to throw the flames onto the paper. Next, she heightened the colour with neon pastels in shades of brilliant pinks and reds and oranges. Finally, she flowed dark-blue watercolours over the entire paper, making the vivid pastel colours pop through the blue. She called this a

"careless slap and dash of mixing a water-base medium with a waxy medium."

Mary liked to tell a funny story about removing one of these large works from the wall easel. She released all the bottom and side clips and then climbed up on a stool to remove the top clips. She suddenly found herself encased in the paper, which had tidily wrapped itself entirely around her. She carefully tried to get down from the stool but staggered, putting her foot through the paper. Fortunately, the damage was easily repaired by a paper restorer.

Her 1989 show at the Mira Godard Gallery titled *Flames* featured these larger works, including *Bonfire by the River* (1988) and *Bonfire with a Beggar Bush* and *Burning the Rhododendron* (1989). Mary joked to *Toronto Star* art reviewer Christopher Hume that she was furious when she discovered that fire is "just hot air."[9]

Reflecting back on her fire paintings, Mary observed that these large works had expressed that her life at the end of the 1980s had come to some sort of climax. While still denying at the time that she was losing her marriage and her home, the fire images articulated her rage at something important being taken away from her.[10]

Mary thought back to the time when, as a young student at Mount Allison, she had argued with Alan Jarvis that artists did not need to suffer in order to create good work. She realized now that her collapsing marriage had vitalized her and provided an edge to her paintings. She had come to agree with Jarvis. "Artists must have tension and confusions and it is necessary to work one's way through them."

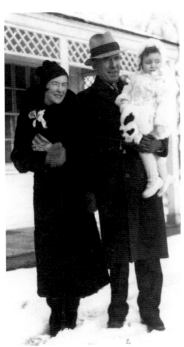

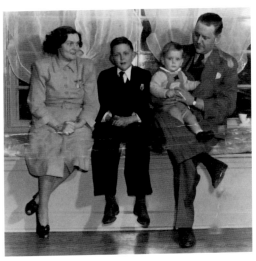

Christine, Christopher, Jack and Philip Pratt in their Waterford Bridge Road home.

Kathleen (Kay) and Bill West with Mary dressed in white rabbit fur in wintry Fredericton circa 1936.

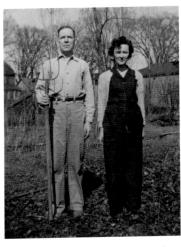

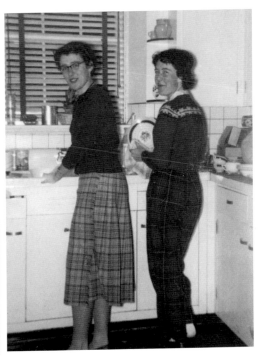

Sisters Mary and Barbara West washing dishes in the family's custom-built kitchen.

Bill and Kay West parodying the painting *American Gothic* in their Waterloo Row garden circa 1946.

Mary West at Mount Allison School of Fine Arts in a first-year still life class.

Christopher Pratt hanging out in his dorm room at Mount Allison in 1953.

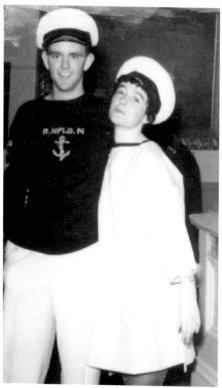

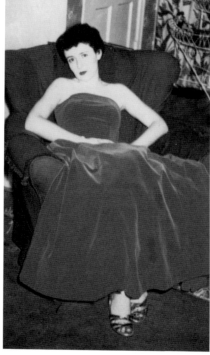

Mary in the red-velvet dress and silver sandals she wore to Mount Allison junior prom.

Christopher and Mary in their nautical costumes for Mount Allison's fall 1955 prom with the theme of *Brigadoon*.

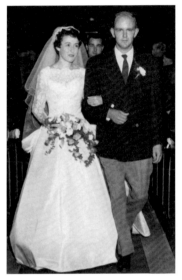

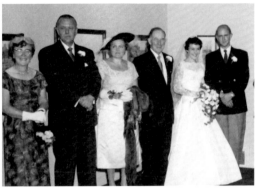

Kay West, Jack Pratt, Christine Pratt, Bill West, Mary and Christopher Pratt.

Mary and Christopher, leaving the altar.

Aunt Myrt, Christopher, Mary and baby John in London in the spring of 1959.

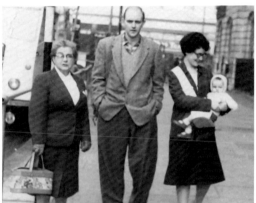

The watercolour *Grosvenor Crescent* was one of Christopher's first assignments at the Glasgow School of Art in 1957. Fellow students were annoyed by this colonial upstart's talent.

Salmonier Cottage in 1961, before it became the Pratts' permanent residence.

Mary in Salmonier's tiny kitchen, whence came feasts.

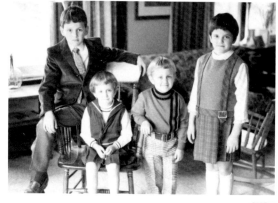

John, Barby, Ned and Anne in their best outfits for Christmas 1967.

Barby and Ned cuddling up with their dad in Salmonier cottage.

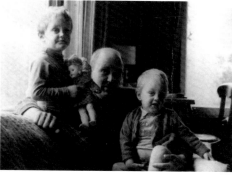

Mary helping Donna Meaney get ready for high school graduation in 1970.

Donna and Mary at graduation ceremony.

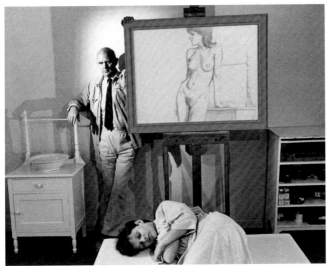

Donna posed with Christopher for celebrity photographer John Reeves in the early 1980s.

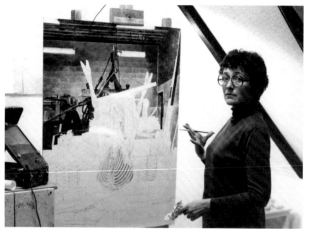

Mary painting her disturbing 1978 picture *Service Station*.

Christopher Pratt communing with Pablo Picasso.

Daughter Anne Pratt crewing for her father. Note the Newfoundland and Labrador flag designed by Christopher.

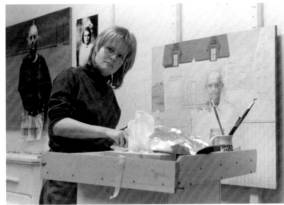

Underpainter Jeanette Meehan in 1998 working on Christopher's self-portrait *My Grandfather's House.*

Opening reception in September 2013 at Emma Butler Gallery, St. John's, with exhibiting artist Jeanette Pratt and her husband, Christopher. In the background is her painting *Christopher with Binoculars.*

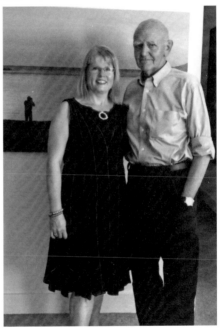

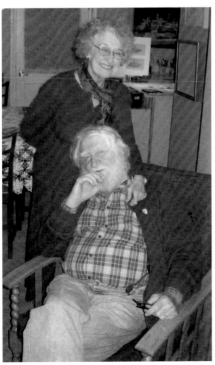

Mary and Jim Rosen in love. They shared interesting conversations about art and literature, which had rarely been the case with Christopher.

Family gathered to honour Mary at the opening of her retrospective at The Rooms, St John's, on May 10, 2013. Anne, Mary, Barby and Mary's sister, Barbara Cross (front). George Cross, John and Ned (back).

Anne, Mary and Barby at the McMichael Gallery greeting fans eager to have Mary sign their catalogue celebrating the 2013 retrospective.

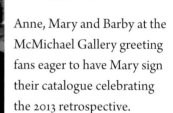

Christopher with Donna Meaney at the May 2013 opening reception at the Mira Godard Gallery in Toronto. This is one of the last times Christopher and Donna were together in public.

The Pratt Brand

NO MATTER WHAT was going on in their marriage in the late 1980s and the following decade, Christopher and Mary Pratt insisted on branding themselves as a successful couple. Outwardly, they appeared to be two thriving artists living in the home they had shared for well over thirty years and going daily to their studios to make some of the most celebrated art in Canada.

In May 1990 they attended the President's Dinner at Toronto's Ontario College of Art, at which they were named Honorary Members. A $500 annual scholarship was named in honour of Christopher Pratt and Mary West Pratt jointly. At the 1992 Mount Allison University reunion, they caught up with fellow alumni and had dinner with their teacher Ted Pulford and his wife. That night Christopher had a jumble of dreams, including one in which he was wandering around in strange rooms full of junk looking for privacy.[1]

During this period, both Mary and Christopher spent a good deal of time away from Salmonier. Mary, who had been appointed to the board of the Canada Council from 1987 to 1993, frequently flew to Ottawa to attend meetings. Christopher, who had given

up competitive sailing, spent time driving and hiking around Newfoundland, with Jeanette as his companion. He found that her enthusiasm for the picnic spots and pit-stop places where he had stopped from habit was infectious and brought new life to his travels.

The Pratts bought a small condo in Toronto's tony Yorkville district, where Mary lived for a short period of time. When she had hip-replacement surgery in June 1991, Christopher flew up to be with her for a few days while she was in the hospital, bringing her two freshly laundered cotton nightgowns. He remained to settle her into St. John's Rehab in north Toronto for several weeks of physiotherapy. Mary knew that it had only been his sense of duty that had brought him to Toronto, and the ironed nighties had likely been given to Christopher by her friend Elsie Power. When he left in late June, Mary was alone, feeling vulnerable and wondering how she would manage when she returned to the condo. Donna Meaney, still living in Toronto but busy with her own life working and raising a daughter, came to help Mary. The two women had continued to let bygones be bygones. Donna sent one of her homemade Christmas fruitcakes to Mary every year.

That August, as Mary's recovery period was coming to an end, Christopher said something that had seemed for several years to be inevitable. He told her by phone that he did not want her to come back to Salmonier—he was happier on his own. As an added jab, he told Mary that she probably belonged in a nunnery. As cruel as his comments were, Christopher had finally put words to his feelings.[2]

Despite her husband's explicit rejection, Mary returned to Salmonier. She could think of nowhere else to go. A decade earlier, she had gone back to the cottage when Christopher had bolted

from the new house in St. John's. She admitted in her diary that in her heart she knew they could no longer find peace with each other. But she also wrote that she had no life without him.

Realizing that Mary had no intention of leaving the family home, Christopher distanced himself. He had finally built the studio he'd been mulling for years, on land across the road from the family home. He had fantasized building a new studio away from Salmonier and had looked at oceanfront property nearby, as well as farther afield in Bay Roberts and Ochre Pit Cove. Not courageous enough to follow through with what he called his daydreams, he compromised by commissioning his brother, Philip, to design the two-storey studio with its own separate printmaking room. He began working in the building in 1990.

Every morning, Christopher walked across the road to his studio and Jeanette, who would meet him there ready to work. She was proving to be a perfect companion, since she went home to her parents at the end of the day and never pressured him to advance their relationship. The more Mary tried to revive the marriage, the further she pushed her husband away. "I dislike the 'we' in my professional life," he wrote in his diary in 1992, "but it is always there, or so my short fuse indicates." At times, in utter frustration, he raged alone in his studio, damaging the walls and even his work.[3] He wanted his freedom to come and go and be spontaneous, without feeling Mary's disapproval, be it open or passive-aggressive. Why this had become such an issue for Christopher is baffling since he had been coming and going quite freely for most of their marriage.

On the morning of Wednesday, January 8, 1992, Christopher was alone in his downstairs print gallery mixing paint with an electric egg beater, a technique he had used hundreds of times in the

past thirty years. This time sparks from a short-circuit in the beater ignited spirits, resulting in a fire that gutted the entire building, leaving a burnt shell with the windows blown out. Jeanette was away in St. John's and Christopher escaped unscathed.

He lost only one small finished oil painting, *Bernadette*, plus all his works in progress. He'd stored the rest in the old studio. As if the fire was not upsetting enough, the insurance company gave him a going-over before paying out; according to the insurer, fires suspected to have been caused for the purpose of collecting an insurance payment occurred with regularity in Newfoundland. Utterly dejected, Christopher returned to the old studio.

Mary memorialized the fire with her oil painting *Lupins in Christopher's Burned Studio* (1996). He had strewn lupin seeds, attractive, tall, pink-and-purple-flowering plants that thrive in the thin Newfoundland soil, on the sides of the path leading up to his studio. They continued to bloom amidst the remains of the burned-out building. To stage the image, Mary picked some and placed them against the charred window frame with its broken glass.

In the wake of the studio fire, Christopher and Mary's increasingly embittered relations exploded one night in 1992 when, lying beside her husband, Mary began sobbing in bed. Christopher rose and declared that the situation could not continue. He convinced Mary to put some clothes and other necessities into their car and drove her to St. John's. Their tenants had recently moved out, and the Waterford Bridge Road house contained only a few bits of furniture.

Christopher hated the sense of guilt Mary provoked in him. He could no longer bear to have her around, and by "her" he meant everything about his wife: "her voice, her laughter, her mannerisms,

her body language, her attitudes—everything except the memory of what seemed to be an earlier 'original' internal self."[4]

Many outsiders would interpret what had happened as a clear case of an unfaithful husband abandoning a middle-aged wife. Overwhelmingly, Mary's women friends sided with her. The Pratt/ Dawe relatives, though, and their St. John's establishment friends generally closed ranks against the New Brunswicker. Suddenly, after three decades in the countryside married to a self-styled bayman and raising four children who had stitched themselves into the fabric of Newfoundland society—not to mention having produced a body of work that had made her one of the island's most celebrated artists and having taken by marriage one of its most celebrated family names—Mary was once again regarded by many of the social establishment as an outsider.

Caught in the middle was that quartet of adult children. High chairs and baby toys were once again scattered around the Salmonier house, with family gatherings becoming bigger as more and more grandchildren arrived. John and his wife, Alix, had four children; Anne and Bob Lamar had two sons; Ned and his wife, Sheila Crosbie, had a son and a daughter; Barby and Russell had two sons. Christmas, Thanksgiving and family birthdays were command performances: the Pratt children, their spouses and the grandchildren were all expected. One in-law pointed out that, despite the palpable tension at these gatherings, the food was always good.

Even with Mary living in St. John's, they manufactured and then perpetuated the image of a married couple who, for artistic reasons, found it more practical to work apart. They made sure to be seen together weekly, dining in St. John's at the Hotel

Newfoundland. (One perhaps apocryphal story places Jeanette waiting in Christopher's car in the hotel parking lot, eating a take-out meal, while Christopher dined inside with Mary.)

Whether out of love or stubborn pride, Mary refused to accept that Christopher could prefer a local, uneducated girl over herself. At the beginning of the affair, when Jeanette and Christopher travelled to the island's west coast to work, Mary was horrified at the thought that someone they knew might see the couple going up to their room in the Glynmill Inn, a high-end hotel in Corner Brook popular with the St. John's elite. The optics of being the betrayed wife enraged Mary.

In 1996 the Pratts agreed to participate in the CBC documentary *The Life and Times of Mary and Christopher Pratt.* This biographical film presented an overview of their personal and artistic lives from childhood right up to the 1990s. Everyone interviewed, from their younger daughter Barby to Donna Meaney to several friends, kept up the myth of an enduring marriage, despite the couple's artistic need for solitude and thus separate homes. Opening and closing shots featured the couple on a rugged, blustery Newfoundland beach collecting stones and reminiscing about their early lives together. Off-camera, they were barely talking.

Not everyone was taken in by the documentary. Their children and in-laws certainly knew of the rancour in the marriage. Mary's close women friends were aware. In Fredericton, she had sought out artist and backyard neighbour of the Wests, Molly Bobak, and confided about Christopher's adultery and her unhappiness. Watching the program, Bobak was left "squirming" at the sight of this charade.[5]

This keeping up of appearances went on for years. In a 1996 article in the art magazine *Border Crossings,* writer Robin Laurence

had mentioned the rumours about an affair between Christopher and Donna.[6] When contacted by the *Globe and Mail* for comment, Mary lashed out: "She was not his mistress. That's a lot of crap." She said she no longer lived with her husband, for reasons of artistic growth. "But we're still very much a family. Just not a family in the usual sense."[7]

As late as 2003, when selected by *Good Times* magazine along with several other Canadian celebrities to describe the character of their family Christmas, Christopher declared: "We're not estranged. I have a studio in St. Mary's Bay; Mary has one in St. John's, and we always get together for Christmas."

Mary sometimes threatened to drop the plot. Quoted in *Maclean's* magazine after being included in the 1997 Honour Roll, Mary confirmed that she and Christopher lived apart, adding: "We both need comfort, but what we give each other is rivalry. And that's too bad."[8] A newspaper reporter from Regina, interviewing Mary at her 2004 show *Simply Bliss*, wrote: "Pratt speaks cryptically, and with hesitation of the sadness, the confusion which, to a significant degree has inspired and influenced her work, but seems content that she now understands and appreciates the things in life that matter." The reporter went on to quote Mary: "I have found painting to be the great saviour."[9]

Even these subtle nods to marital discord allowed Mary, in effect, to take on the public role of betrayed wife. Christopher had been exposed as the errant husband and in private accused Mary of making an art out of being hurt. Mary's autobiographical paintings with sad-sack titles such as *Dinner for One* (1994) and *Ginger Ale and Tomato Sandwich* (1999) announced her loneliness. Describing *Dinner for One*, which depicted a table set for a single diner, Mary acknowledged its sadness. "When I cooked for my

family, I served from the kitchen. Plates were heaped with bright, hot meals. Meals were full of chatter and good times."[10]

Christopher, by contrast, seldom aired his marital problems. If he did, his outbursts were usually preceded by some angry comment from Mary. Reading a book on Matisse, he envied the fact that the French painter's wife, children and models never talked about him. Contrasting that situation with Mary's propensity to make derogatory remarks in public, he noted wryly in his diary, "two out of three ain't bad."[11]

Life Is Not a Rehearsal

WHILE MARY WAS painting out her rage and pain, the trauma of Christopher's studio fire had left him concentrating on the here and now. He wrote slogans on his old studio walls such as "If not now, when?" and "Life is not a rehearsal."

Recognizing the vulnerability of his inventory of works, which were as subject to damage stored in his old studio as the lost works had been in the new one, he decided to donate much of his inventory to public galleries. They would be stored in optimum conditions and he would receive fat tax receipts. The majority went to The Rooms Art Gallery in St. John's.

A number of others went to the Christopher Pratt Gallery when it opened in the summer of 1999 in the refurbished, historical Western Union Building in Bay Roberts. Not only was he honouring his mother, who grew up in Bay Roberts and had been the honorary chairman of the Bay Roberts Heritage Society, but he had found a safe home for the inventory.

In reviewing his huge cache of sketches and studies, Christopher discovered drawings and ideas that he had explored long ago but never pursued. "In the process of doing the inventory all of these

things keep coming out of the drawer and I'd think, 'why didn't I ever do anything with this?'" he told an *Evening Telegram* reporter.[1] From these resurrected concepts he created some fifty mixed-media pieces. Their subject matter referred to earlier and happier times, such as rambles on the Cape Shore and days passed at the family's Southeast River cabin, and reached back to periods in his early manhood when he had worked at the American naval base at Argentia. *Night Nude: Summer of the Karmann Ghia* (1994), which featured a nude Donna, consisted of gouache and coloured pencils over a watercolour that came from sketches and photographs from that 1970 photographic project *North American Time Zone.*

Emma Butler, owner of the eponymous gallery in St. John's, convinced Christopher to mount a show of his mixed-media pieces, *Images of Memory.* For the show, which opened in late November 1994, he selected twenty-two pieces that were all highly autobiographical. "I mean, obviously my cousins and friends recognize that very clearly."[2] For a person so controlled and reticent, this show remains arguably the most revealing disclosure of his character and thoughts. His cousins and friends might have recognized a notable absence in the works, however: Mary.

Back in the old studio, he and Jeanette continued to work together every day. It was a companionable scene, with her underpainting at one end of the studio and Christopher working across the room. As Jeanette prepared one canvas, he could finish another or draft in preparation of his next idea.

Previously, he had completed two or three large oil paintings a year. From now on, and through the first decade of the twenty-first century, he doubled his yearly output. Mira Godard was thrilled and busily showcased them at her Toronto gallery. With more

works available, private collectors were now more likely to buy one of his major works, which until then had largely been within reach of only public art galleries and corporate collectors.

The *Toronto Star*'s art critic Christopher Hume had been paying close attention over the years to Mira Godard's Pratt shows. In 1993, shortly after the studio fire and Mary's move to Waterford Bridge Road, Hume found Christopher Pratt's works to be filled with images of solitude and isolation. Christopher agreed that *Moose and Transport* (1993) and *A Room at St. Vincent's* (1992) reflected his sense of loss and futility after his studio fire.[3] (The reference to St. Vincent's was loaded. At that time, revelations of physical and sexual abuse of boys in a St. John's orphanage run by the Roman Catholic Christian Brothers dominated the news.)

Moose and Transport, as the title suggests, shows a rather non-threatening moose standing on the highway with a transport truck bearing down on it. Although stepping into Alex Colville territory—Colville's enigmatic 1954 painting *Horse and Train* evoked horrendous tension from a similar circumstance—Christopher's painting conveyed simply the inevitability of the unwary moose being run down, an all too common occurrence on Newfoundland's roads.

The 1995 show featured five large new oil paintings, each of disturbingly empty indoor spaces, such as *Basement with Two Beds* (1995). This time Hume found the silence of the depressing images deafening. Along with the paintings, the show featured a lithograph print (one of only one hundred) titled *Christmas Eve at 12 O'Clock*, the title taken from a poem by Thomas Hardy. Showing the back of a man, lantern in hand, walking toward a shed, it bore a marked similarity to the work of another major Newfoundland artist, the printmaker David Blackwood.[4]

Christopher ended the 1990s with his Thirtieth Anniversary Exhibition at the Mira Godard Gallery, featuring no fewer than twenty-two new works. Hume described as Pratt's magnum opus the painting *Deer Lake: Junction Brook Memorial* (1999), which pays tribute to Newfoundland's Deer Lake hydro power plant built in 1922, years before Colorado's famous Hoover Dam. Christopher called it a "kind of functional Parthenon in the wilds of Newfoundland." In his portrait of the power station at night, its long rows of windows radiate light.[5]

Also in the show were his sketches and paintings of the now-defunct Argentia naval base, where Christopher had spent the summers of his youth working as a surveyor. Among the works were studies of a deserted communications bunker as well as a neglected trailer park that had once provided off-base housing for American servicemen.

One unique work took viewers away from the places of Christopher's past and into a dimension he wasn't often open to sharing. It was a collage called *Self-Portrait: Who Is This Sir Munnings?* (1998). Munnings had, in fact, been an esteemed British artist who despised modernism and had made disparaging remarks about Picasso. The great artist had responded, "Who is this Sir Munnings?" In Pratt's work, he had photocopied a snapshot of himself onto tissue paper and glued it into the foreground. He thought this particular photo had been saturated with "attitude" and "arrogance" and collaged a photocopy of his Order of Canada pin onto his T-shirt to further poke fun at himself. At the bottom of the piece, he attached a number of childhood photos of himself as well as his first love, Tannie, who continued to haunt him. To this he added lines from a Dylan Thomas poem: "The seed-at-zero

shall not storm, That town of ghosts, the trodden womb."[6] He confessed that he found the Dylan Thomas quotation by chance, closing his eyes and sticking his finger into a book of his collected poems. This entire collage is about two people who are the ghosts of their former selves—Christopher past middle age and Tannie, who had died in her mid-twenties.[7]

It is not surprising that Christopher knew of this incident with Picasso. From his earliest days as an aspiring artist, he had been fascinated with Pablo Picasso, the Spanish-born artistic genius who lived to the age of ninety-two. No two artists could contrast more completely. Think of the Minotaur versus the moose—the hot-blooded Mediterranean and the reserved Newfoundlander. This polar opposition fascinates Pratt, although he has difficulty putting it into words. Pablo Picasso and Andrew Wyeth were two of the best-known artists when Christopher was growing up, and while he never liked Wyeth's style, he had always been attracted to Picasso's joie de vivre.

At times Christopher has strained to suggest similarity with the Spanish genius. He has, for instance, compared his young lover Donna to Picasso's mistress and model Marie-Thérèse Walter, whom the Spaniard met when she was seventeen and he was forty-five and a married man. Into one of his 1996 collages, *Me and Others*, which consists of photographs of various people in Christopher's life, including Mary, Tannie and himself, he inserted several images of Picasso as well as a newspaper clipping announcing the death of Dora Maar, one of Picasso's muses whose life he'd made intolerable.

With his trademark wit, Christopher had explained his reasons for calling one of his sailboats *Dora Maar*. It was the perfect name for a boat, he said: "Dora" close to the word *dory*, and "Maar"

sounding like *mer*, the French word for sea. When he jumped on board the boat, he would say, "Just like Picasso," eliciting moans from family and friends who had heard the joke many times before.

At a photo session in Salmonier in the 1980s, John Reeves took several playful photographs of Christopher wearing a T-shirt with a large black-and-white image of Picasso's face. In one shot, the two men bear an uncanny physical resemblance, with their bald heads and prominent ears, and eyes gazing upward.

The painting styles of the two artists had much less in common. Picasso used thick layers of pigment with bold brush strokes, working quickly in free form, often painting a work such as *Femme Accroupie*, which features his last mistress and wife, Jacqueline Roque, in a single day. Over his long career, he reinvented his style frequently—spanning his blue and rose periods, and African period, to cubism and surrealism. Passionate and ebullient, an extrovert who sucked up energy from other creative forces, never pandering to dealers and buyers, the charismatic Picasso at no time doubted his talent.

Christopher, on the other hand, is an introvert who needs solitude and has always been concerned with how people perceive him. His style is compulsively neat, with imperceptibly tiny brush strokes. At times he is filled with self-doubt and has gone so far as to call himself a fraud, writing in his diary that he has got by thanks to "a measure of 'smarts,' combined with some training in Engineering/Architectural drawing and a modest sense of design. Not talent, and certainly not love or even attention to the usual enthusiasms of a painter . . . but for all that, as a craftsman and a picture maker, I stand by my work."[8]

Picasso and Pratt do share some similarities. Both have a strong work ethic. As Christopher reminded art writer Joan Murray, "We

think of Picasso as being the arch-libertine. We think of him in pubs and clubs and bullfight rings and so on and so forth, and we forget that he worked almost every day all his life from about four in the afternoon until two in the morning."[9]

They both exude masculinity and possess a sexual power. Women were attracted to them. One young female journalist whom Christopher took sailing found him to be very attentive and sexy, with beautiful arms and hands. And both men were attracted to women much younger than themselves. Perhaps their greatest likeness, however, was in their treatment of their wives.

CHRISTOPHER'S STAR HAD long since ascended at home, but he remained a dull glimmer in the firmament of the global art market. Mira Godard would not be dissuaded, however, and she made one more concerted attempt to gain him international recognition. In 1997, she mounted a show at her Toronto gallery, exhibiting Christopher concurrently with Lucian Freud, one of Britain's most famous contemporary painters. Freud's small exhibit featured paintings of his daughters Esther and Bella (he sometimes posed them nude) along with a self-portrait of his craggy face with a bulbous, reddened nose; Pratt's canvases were devoid of humans. Describing the pair as unlikely artistic bedfellows, one Canadian critic found the two painters had a surprising synergy: both men explored loneliness in their own distinctive style.[10] Another, Judy Stoffman of the *Toronto Star*, homed in on their marked difference, stating, "If Freud revels in the unruliness of his human subjects . . . Pratt prefers the hard disciplined forms of bridges, boats, machines."[11]

Mira Godard had been trying for decades to develop an international market for Christopher's work. In 1976, when still connected with the Marlborough Gallery in midtown New York, she had introduced Christopher in a solo exhibition that included several melancholic oil paintings, such as *Station* (1972), *Institution* (1973) and *Landing* (1973). In the catalogue, writer Michael Green struggled to relate Pratt's work to the American art scene by stressing that his subject matter is a system of formal relationships "quite as abstract in its way as anything in the work of Mondrian, Newman or Rothko."[12] Ironically, back in Canada, all three of these paintings were extremely successful. *Landing*, which had been in a private collection, sold at auction in 2012 for $198,000. *Station* now hangs in the Confederation Centre Art Gallery in Charlottetown, and *Institution* is in the collection of the National Gallery of Canada.

Godard had fought a long battle on her client's behalf. Back in November 1982 she had arranged a solo show in London, England, of Pratt's paintings, prints and drawings at Canada House in Trafalgar Square. He and Mary attended a dinner given by Canada's High Commissioner to the UK, followed the next day by an official reception. An article in the *Newfoundland Herald* reported that the show had received not one mention from British art critics. Christopher joked to *Herald* reporter Kathleen Winter that the surprisingly large turnout to the opening was likely a crowd of expatriate Canadians who had come for the free wine. The fact that it had been government sponsored and held in Canada House rather than in one of London's prestigious commercial galleries contributed to its rebuff. The show went on to Canadian embassies in Paris, Brussels and Dublin.

Godard had good reason to keep trying. A few of Christopher's Canadian contemporaries were gaining international recognition.

The powerful American art critic Clement Greenberg champi-oned Jack Bush's work, which was in the tradition of post-painterly abstraction. Bush's first New York show had been in 1962, and as a result he had been picked up by the André Emmerich Gallery, which showcased cutting-edge works by such major painters as Milton Avery, an American, and David Hockney, a Brit.[13]

Alex Colville, who urged Christopher to seek out an American agent, has works in the Museum of Modern Art in New York City as well as museums in Vienna, Paris, Rotterdam and Berlin. Colville is the artist most often compared to Christopher Pratt, perhaps for their similar styles, and perhaps also because both Atlantic realist painters chose a quiet rural life of relative isolation. But they differed in a significant respect: Colville was prepared to spend more than a few fleeting nights out in the world if that's what international success required of him.

In the early 1950s, Colville went to New York, where he made a fortuitous connection with Edwin Hewitt, a strong supporter of magic realism, who gave him a solo show in 1953 at his Hewitt Gallery on Manhattan's Upper East Side. There Colville met Lincoln Kirstein, the wealthy, cultured promoter who had brought dancer/choreographer George Balanchine to the United States, and who had a strong regard for magic realism. Kirstein owned at least two of Colville's early 1950s works, which went to auction in 2011. Twice Colville accepted a position as visiting professor, first at the University of California in 1967 and then at Berliner Künstlerprogramm in Germany in 1971. While Christopher Pratt stayed proudly at home, Alex Colville promoted himself and took opportunities for international travel. The results spoke for them-selves. Of the Colvilles put up for auction by Kirstein, *Woman, Jockey and Horse* (1952) sold for C$370,500.

In a moment of self-reflection, Christopher realized that Mira Godard, as a player in the international commercial art world, must have been frustrated to promote a painter of what he called his "limitations": "She has the challenge of convincing people that I am the real thing and getting the relatively modest prices (relative to real, international stars) she does for my work," he wrote in his diary. Pratt admitted to himself that he had avoided trying to "guts-it-out living somewhere else and risked trying to survive the whirlpools in the mainstream."[14] He preferred to be that proverbial big fish in a small pond.[15]

Entering a new century, Christopher in 2000 tore down the old studio attached to the house and replaced it with a high-ceilinged, airy space with skylights and windows. It leads directly off from the renovated kitchen. Workstations bookend the room, one for Christopher and one for Jeanette. Between them stood a massive table with metal filing drawers underneath to store paper supplies and earlier prints between pieces of acid-free paper. A three-seater couch and corner table filled with collectibles from outdoor trips provided a nook for meeting guests. Beside the door to the outside, pairs of boots were tidily placed. A hallway between the studio and office displays his collections of Newfoundland stones along with numerous species of flora and fauna. Collecting smooth beach pebbles in shades of purple, green, rusty orange and striated black and white had long been a favourite Pratt family pastime. At the end of each visit to the beach, the children were forced to choose from their cache only two stones to take home.

In the office, two drafting tables are littered with old-fashioned drafting tools, including protractors, rulers and slide rules. A large cabinet with deep sliding drawers holds copies of his silkscreens and lithographs. Built-in shelves provide space for his art supplies.

One shelf holds a row of Dundee marmalade jars, each filled with a specific colour of pencil, all with precisely sharpened points. Another shelf is filled with books, among which are some of his small leather journals, his own published books and books on technique such as *On the Mastery of Water-Colour Paintings*[16] and *The Artist's Handbook of Materials and Techniques*,[17] as well as several books on Picasso.

Christopher requires absolute tidiness and control in his work environment. The formality of his process has always slowed his output, but in light of what was happening to his wife, that pace may have been serving him well after all.

Banished

BY THE END of the twentieth century, Christopher found himself at the very highest level among painters in Canada, his stature outmatched by only a few. One of those few, who was standing next to him in almost all respects, was a painter whom he knew extremely well: Mary Pratt.

One decade after Christopher's cross-country VAG retrospective, Fredericton's Beaverbrook Art Gallery in 1995 sponsored a major exhibition titled *The Art of Mary Pratt: The Substance of Light*, which for the next two years toured to eight Canadian cities, attracting a record-breaking total of 100,000 visitors.

As Christopher Pratt was a son of Newfoundland, Mary West was a daughter of New Brunswick. Two of the province's wealthy and influential family dynasties—the Irvings and the McCains— helped to finance Mary's show. The Irving family, who had one of the largest private collections of Mary's works, financed the publication of the hardcover book written by the curator of the Beaverbrook Art Gallery, Tom Smart. Marion and Harrison McCain provided funding for the exhibition. Both Arthur Irving and Harrison McCain paid tribute to Mary at the opening, which was

followed by a lavish reception with wine flowing, sumptuous hors d'oeuvres and fresh flowers everywhere.

Not everyone liked Mary's photorealism. Molly Bobak, an artist of equal standing to Mary, attended the opening reception and was struck to find a room filled with paintings of middle-class subject matter being enjoyed by middle-class people. But she was in awe of Mary's prodigious output.

When the exhibition opened at Toronto's Art Gallery of North York in July 1996, Blake Gopnick, a young doctorate in art history from Oxford University, savaged it in the *Globe and Mail*. Labelling her a middle-class painter of domestic kitsch, he concluded that "a generous reading of some of Mary Pratt's subjects can just about keep her work from its place in the Greeting Card Hall of Fame."[1]

In spite of these criticisms, Mary had caught up with her estranged husband in public recognition. In 1997, she gained the nation's highest accolade: she was named a Companion of the Order of Canada, thus joining Christopher, who had received the same honour in 1983. When inducted into the Newfoundland and Labrador Art Council's Hall of Fame in 1994, she had followed Christopher by only two years.

And then she exceeded him. In 1997 Mary Pratt was recognized as an outstanding person in the field of Canadian arts when she was awarded the $50,000 Molson Prize. She joined Alex Colville as a recipient of the honour. Despite his multiple successes, Christopher has never achieved this prestigious award. An in-law remarked that Christopher could barely manage a weak smile at the news of Mary's win.[2]

A short while after receiving the Molson Prize, Mary took part in a radio interview promoting the need for a new art gallery in

St. John's. Among her comments was her observation that very few people were really interested in an art gallery, and that most preferred to spend their leisure time drinking beer. As soon as these words left her lips, she realized she had been undiplomatic—her prize money (although awarded through the Canada Council for the Arts) having been funded by the Molson Foundation, which carries the name of a brewery that thrives by selling the beer people were drinking when not looking at paintings. But Mary's manner of speaking was often clever and funny and politically incorrect, and she got away with the momentary lapse of diplomacy.[3]

But Mary didn't come out ahead of her husband in all respects; the selling price of her works remained (and remains) lower than his. Some reasons for Christopher's advantage are evident and understandable. His works are larger canvases, and he has been famous for much longer. So, for example, in the mid-1990s a Mary Pratt oil painting sold in the high $20,000 to low $30,000 range, while a Christopher Pratt might have sold in the low $60,000s. The highest price paid for a new Mary Pratt work was $60,000, in 2012, while Christopher's top selling price to date (for a new work) is $158,000, in 2013.[4]

The most obvious reason for the price differential is a historical gender bias toward men in the world of art. The first curator of modern and contemporary art at New York's Metropolitan Museum, Henry Geldzahler, told a story on himself that exemplifies the prejudice still present as late as the early 1970s. He had been putting together the exhibition *New York Painting and Sculpture 1940–1970*, and bumped into friend and artist Alice Neel, who had recently painted his portrait. When she inquired what piece of hers he wanted for the show, he replied, "Oh Alice, when did you turn pro?"[5] Neel, one of twentieth-century America's

foremost figurative artists, only began to receive recognition in the 1970s, after years of labouring in poverty.

A survey of Canadian artists, "Waging Culture," first undertaken in 2007 and updated in 2012, found that male artists sell 50 percent more paintings annually than female artists.[6] In order to sell paintings, an artist must be known. The collecting practices of Canada's provincial and city art galleries, plus Ottawa's National Gallery of Canada, directly impact the success of living artists and determine whose works are most in demand. The NGC is the single largest investor in Canadian art, although the greater percentage of works are acquired by donation from wealthy patrons seeking tax relief. From the start of Christopher Pratt's artistic career, the NGC championed his art, and from as early as 1961 bought his art for the national collection. Today the NGC owns fifty-nine Christopher Pratt artworks, including four paintings, two drawings and fifty-three prints. In 2005 the NGC sponsored a solo show, *Christopher Pratt: All My Own Work.*

The NGC holds in total fifteen works by Mary Pratt, including one oil painting, *Red Currant Jelly* (1972), the work included in the 1975 show *Some Canadian Women Artists.* It was acquired for $600. The NGC owns three of her lithographs, including *Kettle on Stove Top* (1975), a crayon lithograph donated by Christopher in 2005, one drawing, and a wooden-boxed portfolio of ten colour woodcuts titled *Transformations* done by Mary in partnership with the master Japanese printmaker Masato Arikushi. Neither the NGC nor the Art Gallery of Ontario, one of the largest art museums in North America, has featured a solo exhibition by Mary Pratt.[7]

Despite the impact of gender bias in the art market, both Pratts have been high earners. Neither ever applied to the provincial government or the Canada Council for grants. In their marriage,

neither spouse worked a job with medical benefits or a pension plan. Mary candidly admitted that she knew she could sell "the food thing," meaning her popular photorealist oil paintings of fish, jellies, fruits and cakes. In her crisp way, she went on to say that, as a painter, "you have no pension but a saleable background." Mary always feared running out of money and, with her literary contemporary, the late writer Margaret Laurence, shared "old bag-lady syndrome"—a state of anxiety not exactly warranted given either's success, but one very unlikely to be experienced by Christopher.

.

IF MARY COULD not generate the same prices for her work as her rival, she could compete income-wise by painting many more pictures. She produced work for four commercial art galleries: the Emma Butler Gallery, St. John's; the Mira Godard Gallery, Toronto; the Douglas Udell Gallery, Edmonton; and Equinox Gallery, Vancouver. Usually galleries have strict rules about exclusive representation rights, but Mary Pratt could dictate her own rules. In the mid-1990s she split her time between St. John's and a rented condo in Vancouver, doing nothing but painting—sometimes from seven in the morning until after midnight. In some cases she polished off little pieces in a single long evening—the 1996 watercolour of peaches in a bowl on a small crocheted doily she painted for a Douglas Udell Gallery show, for instance. Her output was immense. While the photorealist oil paintings were laborious, she also produced pencil drawings, mixed media, pastel on paper, watercolour and pastel.

Providing new pieces for multiple dealers taught Mary to paint more quickly than ever before. A thematic show titled *The House*

inside My Mother's House at the Mira Godard Gallery in June 1995 featured oil paintings, pastels and prints. She commissioned two glass artists to re-create the architectural plans of her childhood house in clear glass and to place a small red dollhouse in one of the rooms to represent the dollhouse Bill West had made for his two beloved daughters. Mary described it as the heart inside the house. She had taken only two or three months to complete all the works for the show, instead of her previous three months for a single painting. The heightened pace came at a sacrifice.

The *Globe and Mail's* critic, John Bentley Mays, recognized that Mary's production-line painting routine had begun to compromise her work. Describing Mary as working "in a queasily comfy middle range of domesticity," he wrote that she was "wobbling between too-fast and too-fussy paintwork." In that same review, he praised *Self-Trussed Turkey* (1995), suggesting Mary had captured in that ugly and dead turkey the way many people feel at "bad, cramped times."[8] She dealt with Mays's criticism as she did with most unpleasant experiences: she blocked it out. "After considering it for a while, I thought, 'Oh well, I think I'm going to just forget about what he said because it isn't valuable.'"[9]

Mary proved naive in admitting to Christopher Hume that she had produced the new works for her June 1996 Mira Godard show in six weeks. In his review for the *Toronto Star*, Hume mentioned that she had finished *Bananas by the Sea* (1996), over-ripened, mottled brown-and-yellow bananas against a background of rippling dark-blue water, and *Sunday Dinner* (1996), a slab of raw red beef marbled with cream-coloured fat incongruously resting on a silver tray, just days before the show.[10] This work, in which she used only flat red paints to enhance the intensity, was still drying when she shipped it to Toronto. While artists can render good

work quickly, Mary was running the risk of potential buyers inter-
preting her remarks to suggest that she was dashing out paintings
just to make a quick sale. She risked flooding the art market with
product, making the available works less exclusive and possibly
decreasing their investment value. However, demand for Mary's
work did not falter, and it continued to sell.

On the heels of Mary's Beaverbrook touring show in St. John's
in February 1997, gallery owner Emma Butler convinced her to
have a commercial show that April. Mary told a St. John's *Telegram*
reporter that she "didn't have one piece done."[11] She worked fran-
tically to create new oil paintings such as *Morning Coffee* (1997)
and *Floating in a Pink Bowl* (1997), which featured pears in the
pink glass bowl. She agreed to sell works she had held back, such
as *Light from the Dining Room Window* (1995) and *Light from a
Jade Tree* (1995), and the iconic *Donna with a Powder Puff* (1986).
Studies for Lupins was a mixed-media collage on paper with the
edges of the paper burned. The upshot of this frenzy was that
Newfoundlanders had a rare opportunity to buy a Mary Pratt from
the show. All the pieces on exhibit soon bore the red dot signifying
"sold," slapped on the label accompanying them.

No matter what the critics said, collectors in Toronto, Calgary
and Vancouver continued to buy up everything Mary could pro-
duce. Almost every December since 1986, Equinox Gallery had
offered a December show of new Mary Pratt works—yet another
deadline on Mary's calendar. Her sales continued to deny the crit-
ics' concerns that she was producing too much work. She rarely
turned down a charitable cause. A consciousness-raising art show
for survivors of breast cancer at Toronto's Royal Ontario Museum
had requested a piece. Mary painted *Bread Rising* (1994), combin-
ing the imagery of rising bread dough with the horror of the rapid

growth of cancer cells.[12] Mary's struggles with childhood osteo-arthritis and then rheumatoid arthritis inclined her to say yes when asked to participate in the fiftieth-anniversary fundraiser for the Arthritis Society of Newfoundland and Labrador. She, along with Christopher and their elder son, John, decorated birdhouses for an auction.

Ironically, Mary, the outsider or "come-from-away," made one of the greatest contributions to Newfoundland arts and culture when the then premier, Brian Tobin, in 1999 invited her to become the co-chair of a committee tasked with making a public art gallery a reality in St. John's. Called The Rooms after the simple gable-roofed sheds on the waterfront known as "fishing rooms," the project encountered heated opposition from vested interests. The adjacent Catholic Basilica of St. John the Baptist had proudly dominated the St. John's skyline since 1855 and had no desire to share this distinction. The proposed site for The Rooms was on the underground ruins of Fort Townsend, which was established in the early eighteenth century to guard St. John's harbour and stood until 1870, when the imperial garrison withdrew. However, the location had been deemed a National Historic Site of Canada in 1951, which caused historians and archaeologists alike to resist construction. As with the controversy over Christopher Pratt's flag design, Newfoundlanders took to the radio shows to protest and challenge any change.

Even the choice of architects, which included her brother-in-law, Philip Pratt, created controversy. Mary worked incredibly hard at fundraising and convincing politicians that the cultural facility would greatly enhance the reputation of Newfoundland, comparing its potential impact with that of the Sydney Opera House in Australia. Finished in local polished granite, brushed

aluminum and vast amounts of dark glass, The Rooms, which houses the province's art gallery, archives and museum, opened in 2005, and its huge glass windows provide a spectacular view of the city's harbour.

Mary's former son-in-law, Russell Wangersky, acknowledged that it was her relentless work, both publicly and behind the scenes, that made The Rooms happen. Mary herself claimed her participation in creating The Rooms as one of her proudest accomplishments. Not only did her work continue to sell, but her influence in her chosen city overcame any attempt to disregard her as an outsider. Through relentless will, Mary Pratt had determined her considerable place in Newfoundland's political and social life. Resolving the problem of her marriage to Christopher, however, was proving a more difficult task.

·

A THERAPIST WOULD likely have used the word "enmeshed" to describe the relationship between Mary and Christopher. Though their marital war raged on, whenever Mary travelled away from Newfoundland, she seemed unable to stop herself from phoning Christopher, even though his curt responses made it clear her calls were not welcome. In 1996, when she was in Vancouver for several weeks, she noted in her diary: "He never misses an opportunity to be nasty. After I talked to him, I reeled away from the phone and cried like a baby for some time . . . to all intents and purposes in his life he has banished me."[13]

Christopher recognized that optics placed him in the role of miscreant while Mary perpetuated the image of the wronged wife. She simply would not accept the breakup of their marriage. In

another of their futile telephone conversations, he accused Mary of making an art out of being hurt, and Mary fired back that he had made an art out of hurting. For whatever reason—coercion, guilt or honour—Christopher felt obliged to drive the hour from Salmonier to pick Mary up from the airport whenever she returned to St. John's. In early April 1996, when he himself returned from a trip to Toronto, Christopher dropped into Mary's house for breakfast, which quickly turned tense, and he left declaring that he would never live with Mary again—"nowhere, n'ver."

That autumn, they went to one of their favourite hiking spots, Mad Rock near Bay Roberts, but the day turned sour: Christopher accused Mary of ruining his career, adding that everything would be all right if she could just "keep her fucking mouth shut." Returning to Waterford Bridge Road, Christopher snatched up two of his paintings, *The Porch Light* and *Bernadette Putting on Her Stockings*, and stormed back to Salmonier.

Although Mary seemed too attached to her husband to define her own boundaries, Christopher also felt dependent on his wife; she had, all those years ago, coaxed and guided him into becoming an artist. During a particularly emotional episode in 1996 when Mary was helping Christopher and Philip clean out their parents' home after Christine had moved into long-term care, her husband had become overwhelmed. Mary had taken him into her arms, and she records in her diary that he told her he couldn't bear it that she didn't love him anymore, because she was the only one who understood his paintings.

For all their private and public squabbling, neither wanted to appear as the villain by filing for divorce. Mary had made several pointed inquiries about divorce to a personal lawyer friend but had never fixed an appointment to begin divorce proceedings. As

the century came to a close, she and Christopher seemed doomed to cycle forever between the recrimination that came when they had anything to do with one another and a deep-seated fear of a life without the other one in it.

Father Christmas

ONE DAY THE doorbell rang at the Waterford Bridge Road house and, as Mary described it, she opened the door to behold Father Christmas—a rotund older chap with whitish-red long hair, a bushy beard and eyes she would never forget: "How they twinkled!" He was James (Jim) Mahlon Rosen, an American professor emeritus in art history who had ended up living at the bottom tip of Newfoundland's Avalon Peninsula in the fishing outport called Trepassey. Mary had recently published a memoir, which Rosen had read, and he had phoned to congratulate her. Being polite, she said that if he was ever in St. John's he should drop by. Rosen interpreted the invitation literally and beat a quick path to her door.

Jim Rosen—Jewish, bohemian, urban, scholarly, widely travelled—was the antithesis of Christopher Pratt. She couldn't resist the attention and company. Two years older, Rosen had been born in Detroit, Michigan, during the Depression. He had studied art and art history at New York City's prestigious Cooper Union and at Wayne State University, Detroit, and had a Master of Fine Art in painting from Michigan's Cranbrook Academy of Art. At Cooper Union, he had taken an evening figure-drawing class with

Franz Kline, a groundbreaking American abstract expressionist painter. Rosen also knew and was deeply influenced by Meyer Schapiro, the Columbia University art scholar who was an expert on early Christian and medieval as well as modern art.[1]

To support himself over the years, as well as two ex-wives and three children, Rosen had been a professor of painting and art history. His academic career had taken him to the University of Hawaii, the University of California, Berkeley, to Santa Rosa Junior College, and Augusta College in Georgia. He had accumulated an impressive assortment of grants, awards and honours, as well as artist's residencies in Spain and Italy.

Just why Rosen should have ended up late in his life in a small, isolated Newfoundland outport is not at all clear. Money undoubtedly had something to do with it. How he came to live there is more clearly discerned. Rosen had received an artist's residency in the mid-1990s at Pouch Cove, a small community near St. John's. Subsequently, he found a very inexpensive house to buy in the fishing community of Trepassey, a couple of hours' drive from St. John's on the southeast tip of the Avalon Peninsula.

Beginning in 2004, Mary's diaries include long, detailed entries that describe the stimulating ideas and discussions she was enjoying with her own private art history professor. Mary had always loved learning and gossiping and debating with interesting people. Now she had this one all to herself.

Before long, she discovered Rosen to be a thoroughly sensual person. Soon after they had become a couple, Mary was boasting to friends that he knew his way with women. She had written in *A Personal Calligraphy*: "So long ago, since I've been held with anything other than a convenient clasp. I would be lying if I said I didn't care. Even when I don the smart armor of cynicism, I'm sure

what disarms my laughing friends is the knowledge that behind it lies a longing for love that is so terrible I can't even face it."[2] It was a brave and bold leap of faith to start a love affair in her late sixties.

With a new love in her life, Mary was finally able to face a lingering necessity. She had long hoped that Christopher would tire of Jeanette and come back to her. But in 2004, twelve years after moving into the Waterford Bridge Road house and only after she had another man in her life, she divorced her husband of nearly fifty years.

Mary and Jim began to travel. She accompanied him to Philadelphia when he gave lectures at the Pennsylvania Academy of the Fine Arts. In New York City, Rosen introduced her to friends, such as the pre-eminent art historian Dr. Irma Jaffe. She found herself in the famous diamond district in midtown Manhattan, where Jim knew dealers with the best prices and was buying her a diamond engagement ring. In 2005 they set off to study and enjoy the finest of Italian Renaissance paintings in Venice, Florence and Siena. He took her to Ferrara, in northern Italy, where he had been the artist-in-residence at the Gallerie d'Arte Moderna in 1984. He made all the arrangements for their tour and had selected specific paintings that he wanted Mary to see.

Finally Jim broached the subject of moving in together. He was comfortable in Trepassey, with his studio and vast collection of art books, but he was lonely, living in an isolated, windswept village overlooking a fish plant. Mary's spacious and elegantly designed home, with its empty ground-floor studio, must have been very tempting. Once Mary had accepted that she would not be returning to Salmonier, she had turned her artist's eye fully on 161½ Waterford Bridge Road. The backyard was a very long but narrow space of rubble ending at the Waterford River. She filled

it with a beautiful garden through which ran a rambling rock stream with no water but a small bridge curving over it. Her son John had suggested this river of grasses with its ribbons of silver and lines of violet and dark red.

She planted a tumult of rhododendrons, azaleas, blue Icelandic poppies, irises, lupins, serviceberries, plants that blaze with colour, as well as a katsura tree that turns golden in the fall. She planted sage and savory to walk through and intermingle their pungent smells. From her second-floor deck she could sit and contemplate the beauty of what she had created. She installed an elevator from the basement to the fourth floor, a device much loved by the grandchildren and much appreciated by her arthritic joints.

She could look out over the garden from beneath the high ceiling of her living room as well, surrounded by paintings by herself and Alex Colville. A small Henry Moore lithograph adorned a wall, along with a drawing by Christopher and large works by her photographer son, Ned, and painter daughter, Barby. For over a decade, Waterford Bridge Road had been home, and every inch of it reflected its owner and sole occupant.

Mary was ambivalent about the idea of Jim Rosen moving in, and they continued to visit back and forth. Her children were wary of the intentions of this American interloper. Ever watchful, Mary's sister, Barbara, living in the West family home in Fredericton, thought Rosen was "an old smoothie" (she also noted with slight disapproval that he liked to tell off-colour jokes). In her diary, Mary wrote that she was not blind to his motives but allowed, as well, that she and Rosen were useful to one another. In his mid-seventies, he suffered from a plethora of ailments, but as an American living in Canada he had no coverage for medical care. Mary, meanwhile, no

longer had much faith in love, but she did value having someone who was reliably kind, attentive and generous in her life.

Disregarding her family's concerns, Mary married Jim on June 27, 2006. She recorded in her diary, "My name is Mary Rosen." Jim and his large dog moved in and he claimed the downstairs studio. He kept his Trepassey cottage.

In December 2008 the couple undertook an even more ambitious tour. This time they visited both Spain and Italy, starting out in Madrid's famed Prado Museum to sketch the Goyas. Sadly, Mary's sketches were lost when her purse was snatched in Madrid. Taking a train on New Year's Eve, they celebrated with champagne in their sleeping car together with other passengers. Never in her wildest dreams could the Mary Pratt living in Salmonier with four little children have imagined that she would one day spend a New Year's Eve with a second husband on a train, popping corks with strangers somewhere en route between Spain and Italy. While psychologically open to new experiences, physiologically, Mary's aging body protested, and she felt sick during much of the trip. Her family and children were amazed that she had been able to make any of these trips at all, as her health had become delicate. But no matter the difficulties for Mary, only she knew what a miracle the experience had been.

.

JAMES ROSEN HAD painted whenever he could find the time during his busy academic career. Over the years his work had appeared in several solo and group shows, and many are owned by world-class art museums, including New York City's Metropolitan

Museum of Art, Museum of Modern Art and Whitney Museum of Modern Art, as well as such international galleries as the Palazzo Schifanoia in Ferrara, Italy, and London's Victoria and Albert Museum.

Enamoured of the Italian tradition, Rosen paid homage to Renaissance religious artworks with a particular technique known as encaustic painting. He began by copying a work such as Giotto's *Ognissanti Madonna*, now held in Florence's Uffizi Gallery. He then covered the entire canvas in layers of liquid wax emulsion, creating an effect similar to a veil over the colours beneath. The result was a painting that at first sight looks like a single greyish-white waxy rectangle. Rosen describes these works as "hiding in plain sight" or "concealed in the open." Viewers must take time to study the canvas before the underlying image emanates outward. In the fall of 2010, a major retrospective of Rosen's paintings, watercolours, drawings and prints from the 1950s onward pointed to Rosen's use of the encaustic technique and what his works demanded of viewers. Held at the Museum of Contemporary Religious Art (MOCRA) at St. Louis University, Missouri, its title was *James Rosen and the Capable Observer*. Sadly, poor health—he had diabetes—prevented him from attending this major retrospective of over one hundred of his works.

In an interview about the show, Rosen cited the Hellenistic Jewish scholar Philo and a story about Joseph from the Biblical book of Genesis as inspirations for this idea of the artist holding something back so the observer, or "capable viewer," becomes part of the work. He explained, "I had in mind always that the observer should be part of it, and I was the first observer."[3]

A smaller version of Rosen's retrospective with sixty-seven works—small charcoal drawings, abstracts and several of his

encaustics—came to St. John's Leyton Gallery in March 2011, but it certainly did not draw the same attention as a gallery show by either of the Pratts. His erudition, one of the charms he'd brought to Mary's life, was lost on her friends. They gossiped instead that he was exploiting Mary's affluence—there was the air of an old hippy about him that accompanied his American accent.

On philosophical grounds, it seemed inevitable that the marriage could not last. She and Rosen began to quarrel about the nature of painting itself. While Mary had immensely enjoyed studying the products of the greatest Renaissance minds, she stood firm in her conviction that artistic inspiration came from the real world. Effectively, she was challenging his expertise: she would paint influenced by the way she felt about the subject and not by his standards of historical excellence or contemporary invention. The widening gap between them—heightened by the fact that Rosen had a tendency to pontificate and was untidy—was exacerbated by her greater success as a painter. She sold every canvas she put a brush to, while Rosen remained relatively unappreciated.

Whatever the cause that ultimately tipped the scales, by 2012 Mary and Jim had parted. He returned to Trepassey and not long afterwards left Newfoundland to live close to his son in Brooklyn, New York. Mary went back to living alone.

Driving to Venus

CHRISTOPHER PRATT FEELS his art is introspective, a process of searching inwardly for his own humanity. However, in the first decade of the twenty-first century, his paintings quite openly pronounced his love for Jeanette. *Sunset at Squid Cove* (2004), likely the most autobiographical oil painting Pratt has ever done, features Jeanette sitting in the passenger seat of their silver CR-V while he stands outside the car using binoculars to look across the water. He wanted to show the world his joy at being in that specific place with the person he loved. He called *Sunset at Squid Cove* and *Solstice Drive to St. Antony* (2008) deeply felt "labours of love."[1]

In his Venus road series, including *Driving to Venus: On the Burgeo Road* (2000) and *Driving to Venus: From Eddie's Cove East* (2000), he celebrated what he described as his "sense of freedom and release." These driving-inspired images of a road curving and arcing into the distance with the orb of Venus beckoning in the dusky-blue sky were a declaration of his love for Jeanette. In particular, *Driving to Venus: A Long and Winding Road* (2001), which borrowed its title from a Beatles song, celebrates his joy at returning from St. John's to Salmonier and thus going home to Jeanette.

While *Love in Late Summer* (2002) appears to be another of Christopher's "window" paintings, the drawn venetian blinds indicate that the painting is concerned less with architecture and more with the value of private and intimate space.

Since the mid-1990s, Christopher and Jeanette had been driving regularly to Corner Brook to visit Sir Wilfred Grenfell College's printshop and work on his lithographs with master printer George Maslov. These road trips became more frequent over time. With Jeanette usually behind the wheel, they took the silver Honda CR-V to the relatively isolated south coast, where they enjoyed time at Sandbanks Provincial Park, to the west coast's Gros Morne, up the Great Northern Peninsula and homeward bound across the island and finally south on the Trans-Canada. They drove in all seasons and all types of weather, from August sunshine to winter whiteouts to pea-soup fogs. At dusk, the passenger took on moose-spotting duty, scanning the ditches for the possibility of an enormous animal bolting onto the road. They drank limitless takeout coffee and Thermoses of astringent tea to wash down bagels and cream cheese with partridgeberry jam. They loved diverting to Trout River on the straight road with the barren red-clay tablelands on one side and boglands on the other, ending up at the ocean and their favourite restaurant, the Seaside, where hangs a picture signed Christopher and Jeanette Pratt, looking happy and healthy.

Photography replaced fishing as Christopher's motivation for constantly leaving Salmonier. The long drives and visits to familiar places were also "time-out-of-life"—an admitted form of escape, clocking five hundred miles in the black of night alongside his "soulmate," Jenny.

In mid-January 2005, after returning from a road trip to Deer Lake and Trout River, Christopher asked Jeanette if she was

getting tired of these repetitive trips. He wrote: "She shakes her head slowly and emphatically: 'No. How about you?' 'Never.'" But there must have been some tedium driving always to the very same places and making endless pit stops at the Tim Hortons dotted across Newfoundland, where he ordered the same food every time —twelve-grain bagel, double toasted, plain cream cheese and jam on the side, a medium dark-roast coffee with a splash of milk. He admits that he doesn't have to stray very far from his routines to find himself well outside his comfort zone. In Jeanette, he'd found someone whose ambitions or curiosity wouldn't drag him away from where he liked best to be.

·

AFTER HER FATHER died in 1994, Jeanette had continued to live nearby at Point La Haye, where she took care of her mother. Only in 2005 did she move in with Christopher, and even then only part-time. That year at his Prince of Wales school reunion, Christopher worried how his classmates would respond to his nearly thirty-years-younger girlfriend. He wrote in his diary of his relief at their warm welcome of Jeanette. "Everybody seems to be happy for us, which means a lot to me especially, since I am the old comrade."[2]

It was only after Mary divorced Christopher in 2004 that he felt comfortable with Jeanette accompanying him on trips to the Mainland for gallery openings and receptions. He still felt uneasy during the overwhelmingly crowded reception for the exhibition of his works at the Winnipeg Art Gallery on October 4, 2006, when a journalist asked about Jeanette, who was at his side. Christopher had yet to publicly declare his relationship with

Jeanette, or what he called "the new reality," referring to Mary's recent second marriage. Jeanette stood quietly by, dressed conservatively and accessorized with simple jewellery, her blond hair worn smooth and long. Her outport accent had softened, and she appeared self-confident and entirely at ease.

Christopher and Jeanette married on April 12, 2007. He asked her to sign a pre-nuptial contract and made all the arrangements for a quiet civil wedding. Jeanette, wearing a dove-grey gown with a white chiffon shawl and carrying long-stemmed white roses, remembers it as one of the happiest days of her life. She had waited a very long time to marry the man she loved.

Jeanette had been acutely aware that Christopher had not initiated his divorce from Mary and had only married his long-time studio assistant after Mary had wed James Rosen. He had kept Jeanette dangling as his mistress for over two decades, but she had never walked away. The Pratt children, especially Ned, believe that if Jeanette had not hung in so long, their parents would have eventually reconciled. Mary herself simply could not believe that this simple outport girl with so little formal education could usurp her place in Christopher's life. Christopher, she claimed, had once said to her, "Jeanette has come and Jeanette will go."

Once married, Jeanette and Christopher continued to be inseparable companions. Christopher had inherited a large network of in-laws, many of whom lived in the area around Salmonier. The Pratt children made some effort to get along with both parents' new spouses. However, having a stepmother younger than any of the four Pratt siblings didn't help. In that 1996 CBC TV documentary, filmed four years after their separation, Barby, perhaps the closest to her father, had struggled on-camera but failed to rationalize her parents' relationship. For his part, Christopher felt

guilty that his affair with Jeanette had influenced John's decision to leave Newfoundland for Ottawa. John maintained that he'd left St. John's for his own reasons and not because of his father's young mistress. Ned, only a year older than Jeanette, was more inclined to point fingers at her, and he has always blamed her for taking Christopher away from Mary.

All four of the Pratt children have divorced, which is a fairly striking statistic. The two eldest offspring, although artistically talented, turned to other professions. Both have worked for the federal government—John as a lawyer in Ottawa and Anne in the field of communications in Ottawa and Edmonton. Barby and Ned remain in Newfoundland and pursue artistic careers —Ned as a photographer of exceptional talent and Barby as a gifted painter.

Barby has carried perhaps the greatest burden of emotional support, with both parents leaning on her for companionship. After completing a bachelor's degree in English from Acadia University in Nova Scotia and turning down the opportunity to attend the Ontario College of Art and Design, she trained through a process of self-education. She appears to have inherited the combined talents of her parents, learning by osmosis from being in their studios during childhood and later helping Christopher in his studio. She has her father's precision and her mother's ability to capture the translucence in light.

By 2003, Barby had her first solo show at the Art Gallery of Newfoundland and Labrador. Titled *Out of Fashion*, the collection riffed off fashion images from glossy magazines. *A Man and His Car* (1996) shows a woman encased from the shoulders down in a dress of metallic silver with a bodice reminiscent of the front grille of a luxury automobile. In *The Barren Bride* (1998), the entire

foreground is filled by the back of a sitting woman wearing a full-skirted dress in pale pink and a darker pink sash with exquisitely painted roses trailing down. The background is a typical scene of the Newfoundland barrens, with undulating greenish-brown scrublands and grey rocks. Along with her parents' talents, Barby Pratt inherited their sardonic wit.

She has also inherited her parents' talent for heartbreak. Following her divorce from Russell Wangersky and her two sons growing up and leaving home, she faces empty-nest syndrome in St. Philips on the outskirts of St. John's. Her last commercial show in 2015 at St. John's Emma Butler Gallery focused on young ballerinas. In her artist statement, Barby wrote, "I often wonder why I am the person I have become. What are we taught to expect? What makes a woman?" She told the *Telegram* arts writer, Joan Sullivan, that she did not personally know these young girls whom she had photographed at a dance school, but she hoped that they hadn't yet experienced the darker side of life and still thought of life as a fairy tale.[3] This begs the question if little girls should ever be encouraged to view life as a fairy tale.

When asked about the influence of his father on his photography, Ned said that neither of his parents pushed the children in any direction. Both influenced them to see the beauty in many things and in many ways, even if those things seem mundane to others. Ned has a BA in art history from Acadia University and studied photography at the Nova Scotia College of Art and Design. After struggling for many years to earn a living as a commercial artist, he came into his own as a photographer, with works garnering high prices and landing in countless corporate collections.

In September 2018, Ned Pratt became the third Pratt to have a show curated by Mireille Eagan at The Rooms. Titled *One Wave*,

his exhibition of stripped-down, bare and spare photographic compositions of aspects of the Newfoundland landscape bears an uncanny resemblance to the art of his father. He shares an affinity with Christopher for Newfoundland sheds, a subject he returns to time and time again. "It's all about form, and the fact that I have been photographing sheds for such a long time," he said, echoing Christopher's comfort with both the architectural and the familiar. "It's nice to see what you can do with them."[4]

FOR NEARLY THREE decades, Jeanette had been the faithful underpainter. In a convoluted diary entry written on July 30, 2008, Christopher noted that Jeanette's devotion to being "a full-time and enthusiastic assistant had evaporated as her priorities, however expressed, have of necessity shifted elsewhere." He was referring to the fact that Jeanette had been spending much of her time away, caring for her mother, Gertrude, who died in May 2008.[5]

In St. John's on a hot and sultry September afternoon in 2013, the Emma Butler Gallery held an artist-attended reception for the show *New Works: Jeanette Meehan and Darren Whalen*. Although Christopher was suffering from a bout of sciatica with pain in his lower back, he stood stoically in the gallery for the entire reception. He had given his underpainter, and wife, a three-month leave of absence to allow her the time to ready her own show. She exhibited eleven oil paintings done in the same realist style as her husband's.[6]

Following in the tradition of art apprentices throughout the ages, Jeanette had learned her painterly skills by performing as the assistant to a professional. In recent years, her underpainting

role had greatly expanded to laying in much of the colour in Christopher's paintings. He conceptualized and designed the work, and crafted the final touches. Historically, master painters have often used assistants to actually paint a canvas. Some contemporary painters have no qualms about using either studio assistants or young professional artists to do more than the underpainting. Today, both Damien Hirst and Jeff Koons, international top-sellers, rely on trained artists to work unsupervised on pieces that they sign.

And then the person whom Christopher called the "most constant companion I have ever known"[7] became inconstant and left him in 2015.

Jeanette had never had children. She endured decades of being hidden in the shadows, publicly unacknowledged while Christopher perpetuated the myth of his marriage. She had suffered derision and snubbing from the Pratt children and from Mary and her friends. She had been the subject of nasty gossip about her making the rounds in St. John's, for instance that Christopher had sent her to elocution classes. She remained in the seclusion of Salmonier, never feeling comfortable having a drink around Christopher or smoking a cigarette. She chauffeured Christopher endlessly, and always to the same places.

Her three decades with Christopher hadn't been entirely burdensome. Jeanette had experienced life far beyond the narrow existence she would have led had she married her local boyfriend. She'd stood at the side of a celebrated and genuinely brilliant artist, meeting distinguished politicians, writers, gallery owners and other famous artists. She had travelled with him frequently across the country. She lived with financial security and had obtained social standing in her own community.

Jeanette offers no explanation as to why she left Christopher; she did, and that's all she has to say about it. It's possible that, approaching fifty, she felt she had little room left to grow if she stayed in Salmonier, that she would not experience much more in life than she already had. While still married, she and a girlfriend travelled to Italy to see the works of Renaissance masters, breaking with Christopher's self-imposed ban on travelling abroad. He has remained adamant in his position that he gets his inspiration from Newfoundland's landscape. To this day, Christopher Pratt has never been to Continental Europe.

Jeanette's departure came as a shock to Christopher, although his faithful secretary, Brenda, had warned him that he was about to be ditched. Afterwards, he was stoic in public, but Jeanette's leaving devastated him. Initially he tried to remain in contact, meeting her once a week in St. John's for coffee. Agreeing to a financial settlement, Jeanette had moved into her own home outside the city. Eventually the weekly coffee dates stopped.

Among the several aphorisms Jeanette has posted on her Facebook page is: "Life only comes around once, so do whatever makes you happy, and be with whoever makes you smile." Mindful of it or not, she is endorsing Christopher's motto that "life is not a rehearsal." If his painting brought her under his wing, his simple philosophy may have inspired her to set herself free.

Christopher remains alone in Salmonier.

When the Eider Ducks Fly

PABLO PICASSO SAID that painting is just another way of keep-
ing a diary. In the Pratts' senior years, time did not sit still for them.
They continued to paint, often on very personal themes. There
was, after all, a lot to tell. Perhaps too much for the canvas alone to
share, as both also published reflections and musings in memoirs.

Mary was the first to publish, with her 2000 book, *A Personal
Calligraphy*, which included carefully chosen journal entries, re-
prints of some articles and speeches she had made, plus thirty
colour reproductions of recent paintings. She had written in 1994
that an artist is born with the desire to find what is perfectly pleas-
ing to the eye and brain—to find, both intellectually and sensu-
ously, the personal calligraphy of the title. Marketed as "a glimpse
into Mary Pratt's creative mind," the book won a non-fiction award
from the Writers' Alliance of Newfoundland and Labrador. This
is the book that Jim Rosen had read and about which he phoned
to congratulate her.

Next came a book of Christopher's poetry. Published in 2005,
the slim volume was titled simply *A Painter's Poems*. Poetry had

been a part of Christopher's life since childhood, when it had been a tradition to write doggerel to include in birthday and Christmas cards. Along with prizes in the Newfoundland Government Arts and Letters competitions for his early 1950s watercolours, he also took first prize for his poetry. No doubt, being the great-nephew of Canada's unofficial poet laureate, E.J. Pratt, impressed the judges.

There had been a long incubation period for this book, as his first two (female) editors had discouraged him, suggesting that his work needed a lot of revision. However, the third editor, Tom Henihan, a highly respected Irish poet who had landed up in St. John's, helped prune and refine his poems. While certainly not a vanity press, Breakwater Books, a regional publisher, has given many a Newfoundlander an opportunity to see their book in print after they had exhausted all attempts with mainstream publishing companies. Friends and family were equally weighted in their opinion about the wisdom of exposing himself to possible embarrassment. Christopher wrote in the preface, "I thank the friends who encouraged me to get on with it, and equally whose who, with as much good will have counseled me otherwise."

Christopher felt the fifty selected poems were honest and deeply felt expressions that he wished to share with the world. However, he admits that his poems, like his paintings, are oblique and coded rather than expressing direct emotions. His control and self-containment cannot be breached.

Christine, his mother, is the subject of "I Never Asked You Why." She had had a major stroke in 1996 but lived until the fall of 2001. In this poem, Christopher lamented that he never fully understood his mother, and his last stanza declares:

No—you have crossed a line
and seen things that confirm
your life-long understanding of futility.[1]

More forthright than the poems themselves are the illustrations —four collages—in particular *Self-Portrait with Ghosts* (1996), which contains a strip of the same photo of Tannie running along the middle, while along the bottom runs a series of photos of Christopher spanning the years from childhood to present. In the top left corner is a photo of Jeanette, and superimposed are drawings—one of Christopher and the other of a nude. Noticeably absent is any image of Mary. The cover of the collection is illustrated with his *Self-Portrait: Who Is This Sir Munnings?* True to his habit, he read his poetry to audiences close to home, at Newfoundland literary festivals such as the March Hare and Writers at Woody Point.

Ordinary Things: A Different Voyage, published in the summer of 2009, was Christopher's offering of diary excerpts. Unlike Mary's handsome hardcover book with glossy coloured pictures, his was a paperback with small black-and-white photos. Since he controlled the selections, the contents presented Christopher as he wished to be seen. To be fair, amidst his observations about others, he occasionally cast himself in an irritable light. Christopher explained that he felt an immense presence in the ordinariness and dignity of things that have nothing going for them beyond the fact of their existence. In reference to his refusal to move away from Salmonier in particular and Newfoundland in general, he wrote, "It is why Mary Cassatt ought not to have gone to Paris and why Georgia O'Keeffe and Emily Carr did better staying at home."[2] Again, he attended literary events in Newfoundland, including another appearance at

the Woody Point Festival, but this time also another farther afield, at the Word on the Street Festival in Halifax that September.

In addition to books written by Christopher and Mary, a total of five books written about them during the period from 1995 to 2015 confirmed the public's ongoing fascination with the Pratts and their work.[3] Art curator and writer Tom Smart wrote two of these. He had curated the show *The Art of Mary Pratt: The Substance of Light*, mounted in 1995 by the Beaverbrook Art Gallery in her hometown of Fredericton, and wrote the show's hefty biographical catalogue. This coffee-table book focuses on the works themselves as the discussion point about Mary's life. Smart turned his attention to Christopher Pratt in 2013, publishing *Christopher Pratt: Six Decades*—again a large coffee-table book—with 140 works, including some reproduced for the first time.

Christopher somewhat regrets the publication in 2015 of his third and most recent book, *Thoughts on Driving to Venus: Christopher Pratt's Car Books*, which he has described as a sort of homage to Jeanette that chronicles their car trips from 1997 to 2014. In this case, the car book excerpts were chosen by editor Tom Smart, who undoubtedly conferred with Christopher but had the leeway to choose material that he thought would interest readers. While many of the passages convey the monotony of these long trips, interspersed are revealing memories, a few of them very unflattering toward Mary. In an entry written on December 8, 2005, he remarked on his current happiness and his desperate unhappiness in the last years of his first marriage. "Why did I pound myself on the head with my fists, throw things and put my fists through the walls, hurl my work across the studio all the time—before Mary left Salmonier—and never since—except four or five times; always at 161½ Waterford Bridge Road."[4]

The final entry on December 3, 2014, reads simply, "8:00: Back home in Salmonier. God is good."[5]

.

MARY HAD ONCE commented that her paintings were her pension. Both Pratts worked throughout their seventies. Their dealers were keen to encourage them to keep up their pace. The Mira Godard Gallery regularly hosted solo shows that resulted in good profits.

Mary's friend Elizabeth Nichol, the owner of Vancouver's Equinox Gallery, had convinced her and the master Japanese printmaker Masato Arikushi to work jointly on a major print project. Over a ten-year period, the pair created *Transformations*, a limited edition of seventy-five sets, each comprising ten prints. The series was a roaring success, grossing well over a million dollars.[6]

In 2004, Regina's MacKenzie Art Gallery mounted a show called *Simple Bliss: The Paintings and Prints of Mary Pratt*. It featured a set of the ten prints in *Transformations* in addition to more than a dozen oil paintings and some graphite-on-paper works.[7] Robin Laurence's catalogue essay stated that Mary's fruits suggest a persistent association between sexuality and mortality, most particularly in the oil painting *Pomegranates and a Knife* (1999), in which, as Laurence puts it, "seeds and pieces of pomegranate (long a symbol of fertility) are strewn promiscuously across a white linen table napkin, their juice seeping like blood into the cloth."[8]

Mary was asked to paint Adrienne Clarkson's official portrait after she left office as Governor General in 2005. On a Thursday in February 2007, Mary, dressed in a black lace long-sleeved dress, stood in Ottawa's Rideau Hall in front of the covered portrait. The

unveiling revealed a figure standing in freshly fallen snow wearing a full-length blue wool Inuit parka with wolf-fur trim. Since the original photograph had been taken at Salmonier in wintertime, almost a quarter century earlier, Mary asked her photographer son, Ned, to update Adrienne's headshot to capture a truer representation of her in 2007. Mary thought that Clarkson, standing with one boot thrust forward and gazing into the distance, looked like a "Tibetan warrior."

Mary managed to produce enough new works for a 2011 exhibition titled *Inside Light* at Vancouver's Equinox Gallery (although Liz Nichol died in 2000, her gallery continued to represent and promote Mary's work). She then had her twelfth solo show, *New Works and Works on Paper*, featuring both new and older works, at Mira Godard's in 2012.

As Mary's health deteriorated, her output dwindled. Along with her chronic rheumatoid arthritis, she had developed another autoimmune disorder, Sjögren's syndrome, which among its many symptoms includes dryness of the eye, making it impossible for Mary to do the fine detailing in her photorealist paintings.

Christopher, in better health and with the assistance of Jeanette's underpainting until she left him, continued to work at a steady pace, and every two to three years had accumulated enough pieces for a solo show at the Mira Godard Gallery. Godard had never liked everything he painted, and he benefited from her frank criticism. Early in their association, she had warned Christopher: "Green doesn't sell." Blue did, and looking back on his life's work, it is clear that he heeded her advice. He favours deep, strong colours such as cobalt blue, French ultramarine, viridian and alizarin crimson.

Of the pieces in his 2008 show, Mira did not like *The Pine Marten Project*, an anomaly in the context of his recognized style.

On one of his driving trips, he had passed through a conservation area protecting the Newfoundland pine marten tree, a species endangered by clear-cutting practices. His outrage was both visual and political. The painting derived from that anger is of a barren landscape with few trees left standing; the silver trail from a jet climbs through the waning dusk light. Godard may not have liked it, but all of Christopher's paintings made them both a tidy profit.

A show to mark the fortieth anniversary of his being repre-sented by Godard was scheduled to open on September 18, 2010. Christopher flew to Toronto, but she was not at the gallery to greet him. To his shock he learned that his agent was only days away from death, having kept her terminal condition a private matter. In fact, his show was the last one planned and installed in her lifetime. He made an emotional visit to her apartment to say his goodbyes. She died on September 20 at the age of eighty-two. Speaking about her legacy, Christopher said Mira had "changed and upgraded the understanding of 'professional' in the visual arts in Canada."

She had been an integral part of Christopher's life since 1970. Despite his aversion to leaving Newfoundland, he made trips to Toronto whenever she requested his presence at dinners with his wealthy collectors, both corporate and private. With his charis-matic Newfoundland charm and wit, he beguiled these high-power clients. He had made a special trip in 1982 to participate in the tenth anniversary of the establishment of the Toronto Mira Godard Gallery. Several of her artists had sent designs for cakes. The bakery Gavroche Gourmand had created Christopher's trout-shaped cake with scales and fins of green kiwi fruit.

He had always defended Mira in the media. Her perceived aggressive tactics, such as poaching artists from other galleries,

had made her unpopular with rivals, who tended to be men. Some competitors called her the Barracuda. Christopher commented that Mira had committed the great Canadian sin of being successful, and that was why she wasn't liked.

The Pratts—or rather their work—appeared together in 2012 in a Mira Godard Gallery group show called *The Self-Portrait Show*. They were in the company of such illustrious artists as Lucian Freud, Alex Colville, Joe Fafard and Takao Tanabe. Christopher submitted the mixed-media *Collage Self-Portrait: Positive Spin* (1998–2012), a large, square mixed media on canvas that he had been working on now and then for fourteen years. The foundation of the work is an altered, incomplete version of *A Room at St. Vincent's*, his first painting after the 1992 studio fire. At the compositional core of the work are two large elements, a photograph of Christopher and a tracing paper outline in red of the model for *Night Nude: Summer of the Karmann Ghia*. Around these focal points are photographs spanning his life: himself, his family, friends, Mary on the left side, Jeanette on the right, and yet again his first love, Tannie Lake, who seems to haunt his imagination as persistently as his memories of the women he married. He added Newfoundland stamps, miscellaneous scraps of paper such as his aunt Myrt's recipe for "orange gin," and some of his diary jottings. Unobtrusively, he glued on a small dry-fly fishing lure to further invoke his connection to the land and water. The piece is a homage to himself and his love of Newfoundland.

In *The Self-Portrait Show*, Mary had two pictures: *Early Morning in My Bedroom* (2000) and *Silver Bowl in Salmonier: A Self-Portrait* (2011). *Early Morning*, a Fauvist-style mixed-media work, shows Mary's looming shadow on the wall, while a porcelain Imari jar seemingly floats slightly off-centre. *Silver Bowl*, a more recent

watercolour, captures a reflection of a small, distorted Mary with her camera within the silver vessel. The picture's colour palette is soothing, with cool greens, blues and purples. The catalogue's author, Dr. Eva Seidner, grouped Mary in the artist section titled "Reflections," while Christopher was placed in the category of "Totems of the Self."

.

BEING TWO OF Canada's best-known living artists, Mary and Christopher Pratt were each celebrated with blockbuster shows in the twenty-first century. The National Gallery's 2005 major retrospective titled *Christopher Pratt: All My Own Work* was arguably the pinnacle of Christopher's exhibition career. The title referred to the spring of 1959, during Christopher's visit with Myrt to London's National Gallery in Trafalgar Square, where he had seen the man arranging his modest paintings outside the gallery with the sign, *All my own work*. Pratt's exhibition, highlighting more than sixty of his large-scale oil paintings from the last twenty years, along with study drawings, marked his seventieth birthday. Jeanette, his four children, brother Philip, cousin Janet Gardiner (née Dawe), Mira Godard and many other friends joined the celebratory dinner in his honour in the National Gallery foyer.

This show went on to Halifax's Art Gallery of Nova Scotia, The Rooms in St. John's and the Winnipeg Art Gallery, with the final venue being Quebec City's Musée national des beaux-arts du Québec. Along the way, friends and relatives made a point of attending the crowded receptions. In Halifax, several old friends from Mount Allison reminisced about their student days. To his delight, his daughter Anne joined him at the packed reception in Winnipeg.

Throughout this celebration of her former husband, Mary kept her distance. Christopher speculated in his diary that perhaps she thought it would be easier for both of them if she stayed away. During his speech in his hometown, he became emotional when he described his deep-felt appreciation of his ex-wife's "solidarity and warmth in the early years."[9]

Catching up with Christopher, Mary had her own retrospective, featuring seventy-five paintings spanning five decades. It opened in St. John's at The Rooms in May 2013, and toured across Canada until 2015. The exhibition was accompanied by a hardcover catalogue with an eye-catching cover of the painting *Jelly Shelf* (1999). At the grand opening on May 10, Mary's four children, her sister, Barbara, Jim Rosen and Donna Meaney celebrated in her company. Many of the collectors from across Canada who had loaned works attended.[10] Christopher reciprocated the distance Mary had kept from his exhibitions, but attended shortly after the opening with his daughters and confessed his admiration at the sight of so many of Mary's finest works.

Newfoundland television personality (turned federal Member of Parliament) Seamus O'Regan interviewed Mary onstage at The Rooms during the St. John's opening. (A seasoned interviewer, O'Regan rarely got in a word.) Not everyone praised Mary at the show. In a panel discussion, the writer Bernice Morgan commented that although she admired Mary for her discipline, she felt her persona was as finely tuned as her art. In other words, Mary presented herself in public as she wished to be seen. Fellow panellist and art scholar Victoria Scott stated that Mary's work never takes the viewer outside autobiography, and although her themes appear intimate, in reality there is no authentic intimacy. Scott interpreted *Smears of Jam, Lights of Jelly* (2007), which includes two

nearly empty jars of homemade jam, as Mary deliberately creating a legacy about Pratt coupledom.

When the show moved to the McMichael Gallery outside Toronto, Mary attended thanks to the generosity of fellow New Brunswicker Arthur Irving, one of Canada's wealthiest men and her life-long patron. He had flown her to Toronto on his private jet. The queue to have Mary sign copies of her catalogue snaked right around the foyer of the gallery. Energized by the accolades, she hung in for the entire afternoon, including a public interview conducted by the show's curator, Mireille Eagan of The Rooms, during which Mary was in top form, making the audience laugh with tales such as the story of Ed Williams's moose. Eagan reminded Mary that she had insisted that two of her works—*Service Station* and *This Is Donna*—be paired on adjacent pages in the catalogue. Mary had described Donna in this painting as confident and primitive in her attitude. There is no doubt about the message that Mary wanted to convey—it had to do with predatory males and defiant females.

Even at this late stage in her life, Mary could not stop competing with her ex-husband. She brought to the public's attention the fact that some of Canada's major galleries, such as the National Gallery of Canada and the Art Gallery of Ontario, did not accept the touring show. She complained to a *Globe and Mail* reporter: "I feel terrible about that. Because Christopher's work always goes to those places and I just can't get in."[11]

Mary finally had her moment at the National Gallery of Canada when her one painting owned by the gallery, *Red Currant Jelly*, was chosen for the Masterpiece in Focus exhibition series in 2015. In this ongoing series, the gallery explores a single work in depth. The exhibit, titled *Mary Pratt: This Little Painting*, was accompanied by

a video interview in which Mary described the piece as a "brave little painting" and reminded viewers that she had little time for art in her early career. Mireille Eagan, with financial backing from Irving Oil, played a major role in arranging the selection of Mary's single painting owned by the National Gallery.

But Mary's 2015 victory at the National Gallery was overshadowed by a large Christopher Pratt show called *The Places I Go*, which opened in May of that same year at The Rooms. Once again, the energetic and intelligent Mireille Eagan was the driving force behind a celebration of one of the ex-spouses. She had organized *The Places I Go* to commemorate ten years of Christopher Pratt's work on the occasion of the tenth anniversary of The Rooms.

As the exhibition title indicates, these paintings, mainly oils, tracked the places he and Jeanette had returned to time and time again. He said that he had returned to "all the places I have ever been" and where he'd recorded his thoughts for his car books, documenting how, over the years, the landscapes had changed. Back in his studio, he reviewed his notes and photographs and went back into his memories to conjure up meditations on place for the 2015 show.

Argentia Interior: The Ruins of Fort McAndrew (2015) began as a watercolour, and he decided it would make a wonderful large oil painting. Just weeks before the Newfoundland painter Gerry Squires died in 2015, he spoke about this particular work, describing it as "quintessentially perfect."[12]

While some gallery attendees may have seen it as an interior of an empty industrial building with rusted pipes and electrical panel boxes and windows facing a blue sea and grey-blue sky, Squires recognized its perfect composition and balance. He had been amazed at how Pratt had managed to represent the rust on the cement and

the minute details, underlining and highlighting each cement block. This is likely Christopher's final Argentia painting.[13]

A GROUP OF FIVE investors/collectors had bought another of Pratt's paintings of the abandoned naval base, *Argentia: The Ruins of Fort McAndrew: After the Cold War* (2013), and donated it to the permanent collection at the National Gallery of Canada.[14]

The large picture (103 by 203.5 centimetres) captures the outside of the eerily deserted fort with its control tower. In his acceptance speech, the NGC's director and CEO, Marc Mayer, emphasized that Christopher Pratt had for over fifty years been "a much beloved artist on the Canadian scene and one of our most significant painters." The five philanthropists had paid $158,000, the highest price to date for a new Christopher Pratt, which set the benchmark for any future work of that size.

This transaction reveals much about the state of art in today's world and its role as a commodity. Gisella Giacalone, the owner/director of the Mira Godard Gallery, was part of the group who had bought the painting and donated it to the NGC. To be sure, this donation provides the gallery-going public with the opportunity to view a significant work by one of the country's most popular living artists. But behind the scenes it provides something else, and not just a tax receipt for the donors. The purchase and donation sets a standard price for Pratt's future paintings, which would in turn be sold by the Mira Godard Gallery. The prices in his Mira Godard show in September 2017 had gone up considerably: three smaller oil paintings were priced from $58,000 to $128,000, and all three had red stickers on their labels by the time the show opened

to the public. The gallery also released a few signed prints that had been held back, and they ranged from a low of nearly $6,000 up to $19,000. Collectors, both corporate and private, are seeing increasing profit from their investments in Pratt art.

In today's international art market, dealers hold considerable power, from deciding which artists will be promoted to setting the prices. For all the clever manoeuvring of Godard or her successor, no Canadian art dealer comes anywhere close to the power of such international figures as Larry Gagosian, who manages dozens of living artists, such as American Jeff Koons, as well as estates including that of Pablo Picasso. The revenues of Gagosian's worldwide galleries are about US$1 billion annually.

As many of Christopher's earlier patrons have died, the works they purchased decades ago are turning up more frequently in Canadian art auctions. To date, the highest auction price for a Christopher Pratt work is C$210,000 for his 1969 oil painting *House in August*, which topped the previous record of C$198,000 set in 2012 for his 1973 oil painting *Landing*. His prints range in auction price from the low thousands up to $10,000.

·

AGING CAME AS a shock to both Mary and Christopher. Christopher had not anticipated living his final years alone in Salmonier. In 2009, while reviewing some recent photos, he found himself looking at an old man, someone he hardly recognized. He wryly noted, "The person 'looking out' doesn't look like that."

While Mary resigned herself to a life alone, she watched her health slowly deteriorate. From childhood she had had a sickly and nervous constitution. By the end of her active painting life,

her long hours of torquing her body from projector to canvas had created such severe scoliosis, or curvature of the spine, that breathing problems resulted. She continued to suffer from rheumatoid arthritis and other autoimmune disorders. When Mary was still able to talk on the phone, Christopher would check in either with Barby or with their mutual secretary, Brenda, to see if his former wife was up for a conversation. They would talk about old times and Christopher would sign off by telling her, "You're still a good old broad," which provoked gales of laughter from Mary.

Mary died at home on August 14, 2018, with all four of her children in St. John's. During the last weeks of her life, Christopher drove in from Salmonier nearly every day to sit with her. The children released a thoughtful statement stressing that there had never been a time in Mary Pratt's life when she had not been a painter. They spoke of their parents' intense and complex marriage that ended in divorce, and the fact that Mary had then married Jim Rosen, who had taken her "to see first-hand the marvels of Italian Renaissance art." They remarked on their parents' renewed friendship near the end of her life.

Canada's national media described her as the "acclaimed East Coast painter." Her ex-son-in-law, writer and newspaper columnist Russell Wangersky, called her a "velvet force that was careful to hide being a hammer, except when necessary."[15] The *New York Times* ran a lengthy obituary titled "Mary Pratt, 83, a Realist Who Elevated the Prosaic" with an accompanying visual of the National Gallery of Canada's *Red Pepper Jelly*.

In the weeks leading up to her death, Mary had ensured that she would be remembered by the world as she wished to be. In St. John's two weeks after her death, friends and family gathered to celebrate her life. Mary had orchestrated the entire event,

from choosing the venues to the music and readings. St. Andrew's Presbyterian Church, known to locals as the Kirk, with its old-fashioned ambience of dark wood, cream-coloured walls and stained glass windows, quietly filled with guests as organ music played and bells tolled. An urn filled with Mary's ashes stood on a table in front of the altar beside a photograph of her taken by Ned Pratt, and flanked by vases of pink and red roses. John Pratt, bearing an uncanny resemblance to his father, escorted the Right Honourable Adrienne Clarkson up the aisle to sit in the family pews.

Christopher sat with his daughters. Donna Meaney was conspicuously absent. The service began with the official provincial anthem, "Ode to Newfoundland," with its lyric "we love thee, smiling land," which emphatically announced where Mary's loyalties had lain. Though under an hour long, the service displayed the same attention to impeccable detail as one of Mary's paintings or a dinner she placed on the table.

At the reception on the third floor of The Rooms, guests were treated to the expansive view of the St. John's harbour. Attendees were reminded that they were standing in "the House That Mary Built," acknowledging her role in establishing the city's cultural epicentre. Half her ashes rest in a vault in St. John's Mount Pleasant Cemetery close to the grave of her one-day-old son David. It's a space large enough for two urns and awaits the remains of Christopher Pratt.

The war that had raged in Mary's head at the beginning of her marriage to Christopher over the conflicting worlds of her parents' Fredericton gentility and the chaos of the Pratts' life in St. John's never stopped. Her ashes are split between her adopted city and her hometown.

A duplicate service celebrating her life occurred in Fredericton in late November 2018. The four Pratt children joined Mary's sister and friends to inter the other half of the ashes in Fredericton Rural Cemetery, followed the next day by a memorial service in the family church, St. Paul's and Wilmot United Church, and a well-attended reception at the Beaverbrook Art Gallery.

Reflecting on death, Mary had observed that while nothing of the living part of us remains, all we can hope to leave behind is some idea—image, sound, smell—that is contained in something that in itself has no life.[16]

Christopher continues to work without Jeanette's considerable input as underpainter. He now paints on a much smaller scale and more frequently opts for watercolour as his medium. He carries on with his pilgrimages up the northern coast of Newfoundland, with a variety of companions: his two daughters recently, as well as Mireille Egan, Josée Drouin-Brisebois (senior curator of contemporary art at the National Gallery of Canada) and Kenneth J. Harvey, director of the 2018 documentary *Immaculate Memories: The Uncluttered Worlds of Christopher Pratt*.

He relies heavily on Brenda Power, who in 1994 returned to work as the administrative assistant for both Pratts, dividing her week between Salmonier and the house in St. John's. After working for Christopher in the early seventies she had moved away to take secretarial training, married Alan Kielley and raised a son. She remains the epitome of discretion and somehow managed to manoeuvre herself through the most bitter years of the Pratts' marriage. They simply could not have functioned professionally without her. Along with all the secretarial tasks, which included dealing directly with gallery owners, tracking down images, handling copyright issues and managing their financial accounts, she

kept her eye on their general well-being, right up until Mary's death. She continues to assist Christopher and has started to do some underpainting.

Barby and Ned take time away from their own artistic schedules to be with their father at Salmonier. A housekeeper comes in regularly to do the chores. A black-and-white cat with no name rambles around the studio. Christopher drives into St. John's for a regular dinner date with his cousin Sonia Ryan (née Dawe). Often he drives to the closest Tim Hortons to kill some time and buy his dinner.

In a 2002 poem, "The Eider Ducks," Christopher predicted his own death:

No, do not ask me how I know or why,
But when the eider ducks fly down the river I will die.[17]

Epilogue

THIS HAS BEEN a difficult book to write. It has been nearly two decades since I paid my first visits to Christopher Pratt in his home and studio in Salmonier and to Mary Pratt at her St. John's home. I accompanied Richard Gwyn, who, with his late wife, Sandra Gwyn, both influential Canadian journalists, had become close friends with the Pratts. Christopher considered their first meeting significant enough to include it in his published chronology: "1966—Meets Richard Gwyn and Sandra Fraser Gwyn, who become fast friends and mentors." He added, "Richard and Christopher warmly agree to disagree on most things political!"[1] The Gwyns played a major role in promoting the Pratts in the national media. Even before meeting them in person, Sandra Gwyn, writing for *Time* magazine, had reviewed Christopher's painting *Woman at the Dresser*, a selection for the 6th Biennial Exhibition at the National Gallery of Canada.[2]

By the time I made their acquaintance, Mary and Christopher had lived apart for well over a decade, although they kept everyone guessing as to the state of their relationship, still appearing

together at public events and vowing in the media that they were still very much married.

I first came to Newfoundland in the summer of 2002, accompanying Richard to a tiny community called Eastport, where he had a saltbox cottage. From the first morning, when I looked out the kitchen window to the sight of the ocean, with seagulls swooping overhead and the sound of waves lapping onto Clay Cove beach and the smell of the startlingly fresh air, I fell in love with outport Newfoundland. Once Richard realized that it would be nearly impossible to extricate me from the summer cottage, he thought it best to get married.

Richard and I returned every summer. Each time we turned off the Trans-Canada Highway and drove along the Salmonier Line, the metal mailbox labelled *C. Pratt* provided welcome assurance that we had arrived. A short walk up the wide expanse of green lawns gave us a glimpse of the pond with the surrounding forest of mainly coniferous trees. We would knock on the side door of the blue clapboard house. If we arrived at lunchtime, it was always the same menu—tomato soup and a sandwich. If it was later in the day, it was coffee in the sunny living room with expansive windows looking out at the pond. We were always given a tour of the workspace, where the studio cat made its appearance.

When we went for afternoon tea at Mary's home in St. John's, it felt like entering one of her paintings—large windows looking out onto a cultivated garden with bright flowers, her kitchen with its red sink, and her iconic painting *Supper Table* hanging on the wall. On early visits, she baked exquisite scones and served them at the dining room table on delicate chinaware.

Being a "fly on the wall" during our annual summer drop-in visits to each Pratt household, I began to build up some understanding

of these two pre-eminent Canadian visual artists who, not surprisingly, were complex yet plainly vulnerable people. Mary's emotions and turmoil are exposed in her paintings, while Christopher's control and orderliness emanate from his.

In 2012, having finished a biography of Celia Franca, the founder of the National Ballet of Canada, I was searching for another project. An inkling of an idea had been brewing in my head, but I felt awkward and hesitant to acknowledge it. By then, I had been married to Richard Gwyn for nearly seven years and was acutely aware of the optics of being seen as someone taking advantage of her husband's connections or even worse, trying to emulate Sandra Gwyn, who had written about Mary Pratt. But I realized that people are intrigued with the Pratt story, raising an eyebrow over the same nude model being used by both artists, for instance. Christopher is often written off as a chauvinist, while the feminist movement took up Mary as a symbol of the downtrodden wife.

Over the years, I had become comfortable being with the Pratts. Mary was an easy conversationalist and loved to trade ideas and gossip. She thirsted for stimulation. I also took to Chris's dry sense of humour and found myself bantering back at his witty remarks. I became preoccupied with questions such as what if they had never met each other—would they have both become professional artists? And how did they achieve almost a celebrity status in cultural Canada? And why didn't they remain married? I decided I'd try to answer those questions and many others.

By no means is this an authorized biography. While Mary's candid diaries are open to the public at the archives of Mount Allison University, Christopher guards his papers at The Rooms Archives with an embargo that extends ten years after his death. He reluctantly allowed me access to letters he wrote to his parents

during his years away at Mount Allison and the Glasgow School of Art. I have visited both Pratts many times in person, attended gallery openings, and contacted them countless times on the phone and by e-mail. Both were extremely gracious and patient, but understandably anxious about what I would write.

This is not a scholarly analysis of the art of two of Canada's best-known painters, although hopefully any discussion of their work is lucid and knowledgeable. (Several art experts—among them David Silcox, Tom Smart, Joyce Zemans, Jane Lind, Sandra Gwyn and Gerta Moray—have published excellent books on Christopher's and Mary's art.) *Art and Rivalry* is, rather, an examination of the union between two visual artists—both with driving ambition to be recognized. What began as a partnership, albeit favouring Christopher as the primary artist in the family, turned into a bitter rivalry. With the decline in Mary's health, the couple entered into a sort of grudging mutual respect and spent time reminiscing about their lives together.

Yes, Mary had always intended to become a professional artist herself, but she unquestioningly subordinated her goals to Christopher's. Many have attributed Mary's change of heart to the outburst of second-wave feminism in the mid-1960s, when Betty Friedan and others began to challenge middle-class housewives to be honest about how they really felt in their subservient roles. But Mary took great pride and joy in caring for her family. The failure and bitterness of the Pratt marriage did not come as a result of the feminist movement.

There might be readers who will accuse me of trespassing in these private lives. However, the Pratts have never turned down the opportunity for media attention. From the time when their children were all at home to as late as 2018, together or individually,

the Pratts have agreed to the intrusion of journalists or film crews into their lives.

Both Mary and Christopher welcomed me into their homes and studios, knowing full well that I was writing a book about them. They tolerated my constant questions, answering some directly while prevaricating on others. I hope I have presented a fair portrayal of the complicated marriage between two of Canada's finest and most enduring visual artists.

Acknowledgements

Since it took me almost seven years to write this book, I have sought help from numerous people, including some who have subsequently retired. In the early years of my research, I received support from archivists Larry Dohey (The Rooms), David Mawhinney (Mount Allison) Caroline Stone (The Rooms) and Pat Grattan. Joan Clark, Anne Hart, Bernice Morgan, Bert Riggs and Ruth Wilson provided context, insights and factual details about Newfoundland culture.

I am indebted to the forbearance of three dear friends—Jennifer Hinrichs, Doreen Millin and Virginia Trieloff—for their expertise in visual arts and art history. I also consulted Joyce Zemans, whose 1986 catalogue, *Christopher Pratt,* prepared for the Vancouver Art Gallery, is a tour de force of information. Private gallery owners Emma Butler (Emma Butler Gallery, St. John's) and Gisella Giacalone (Mira Godard Gallery, Toronto), along with Mireille Eagan, curator of contemporary art (The Rooms), were generous with their time. Two academics—Anne Koval (Mount Allison) and Nathan Greenfield—were truly gracious in sharing their own research. A very special thanks to the Wilson sisters, who nurtured me during my research trips to St. John's.

I interviewed Adrienne Clarkson, Barbara Cross née West, Mayo Graham, Kathleen Knowling, Donna Meaney, Barbara Pratt, John Pratt, Philip Pratt, Jeanette Meehan Pratt, Jim and Bobbie Redpath, as well as Mary and Christopher Pratt on several occasions.

Thanks to Knopf Canada publisher Anne Collins (from whom I appropriated the phrase "plump little Fredericton fruit" from a

stellar profile she wrote of Mary Pratt for *City Women* magazine), senior editor Craig Pyette, copy editor Jane McWhinney, proof reader Tilman Lewis and literary agent John Pearce, who encouraged me to be slightly more bold in my interpretation.

Last but not least, I'm indebted to two mentors. Author Eva Stachniak, whose intellectual rigour awes and inspires me: by example, she has taught me to make that extra effort. And of course, my husband, Richard Gwyn, who introduced me to the expression "to have a sweet pen" to describe someone who writes eloquently. Eva and Richard helped me sweeten my prose.

Bibliography

Books

Alison, Jane, and Malissard, Coralie, eds. *Modern Couples: Art, Intimacy and The Avant-garde*. London: Barbican Centre and Centre Pompidou-Metz, 2018.

Barnes, Julian. *Keeping an Eye Open: Essays on Art*. Toronto: Random House Canada, 2015.

Burnett, David. *Colville*. Toronto: Art Gallery of Ontario / McClelland & Stewart, 1983.

Chaffe, Anne (Director, The Rooms Provincial Art Gallery and Museums). *Ned Pratt: One Wave*. Fredericton: Goose Lane Editions, 2019.

Chawick, Whitney, and Isabelle de Courtivron. *Significant Others: Creativity and Intimate Partnerships*. London: Thames & Hudson, 1993.

Cullum, Linda, and Marilyn Porter, eds. *Creating This Place: Women, Family and Class in St. John's, 1900–1950*. Montreal and Kingston: McGill-Queen's University Press, 2014.

Davis, Ann. *Somewhere Waiting: The Life and Art of Christiane Pflug*. Toronto: Oxford University Press, 1991.

Djwa, Sandra. *E.J. Pratt: The Evolutionary Vision*. Toronto: Copp Clark Publishing, 1974.

Dragland, Stan. *Gerald Squires*. St John's: Pedlar Press, 2017.

Drouin-Brisebois, Josée. *Christopher Pratt: All My Own Work*. Ottawa: National Gallery of Ottawa /Douglas & McIntyre, 2005.

Fenton, Terry. *The Art of Dorothy Knowles*. Regina: Hagio Press, 2008.

Gossage, Carolyn, ed. *Double Duty: Sketches and Diaries of Molly Lamb Bobak, Canadian War Artist*. Toronto: Dundurn Press, 1992.

Greer, Germaine. *The Obstacle Race: The Fortunes of Women Painters and Their Work*. London: Picador edition by Pan Books, 1981.

Gwyn, Sandra, and Gerta Moray. *Mary Pratt*. Toronto: McGraw-Hill Ryerson, 1989.

Harris, Michael. *Rare Ambition: The Crosbies of Newfoundland*. Toronto: Penguin Books, 1992.

Herrera, Hayden. *Frida: A Biography of Frida Kahlo*. New York: Harper & Row Publishers, 1983.

Herwig, Malte. *The Woman Who Says No: Françoise Gilot on Her Life With and Without Picasso*. Vancouver: Greystone Books, 2016.

High, Steven, ed. *Occupied St. John's: A Social History of a City at War, 1939–1945*. Montreal and Kingston: McGill-Queen's University Press, 2010.

Hunter, Andrew, ed. *Colville*. Fredericton: Goose Lane Editions, 2014.

Kavass, Veronica. *Artists in Love: From Picasso & Gilot to Christo & Jeanne-Claude; A Century of Creative and Romantic Partnerships*. New York: Welcome Books, 2012.

Lambton, Gunda. *Stealing the Show: Seven Women Artists in Canadian Public Art*. Montreal and Kingston: McGill-Queen's University Press, 1994.

Leroux, John. *Building New Brunswick: An Architectural History*. Fredericton: Goose Lane Editions, 2008.

Lind, Jane. *Joyce Wieland: Artist on Fire*. Toronto: James Lorimer, 2001.

————, ed. *Joyce Wieland: Writings and Drawings 1952–1971*. Erin, ON: Porcupine's Quill, 2010.

————. *Mary and Christopher Pratt*. Vancouver: Douglas & McIntyre, 1989.

————. *Perfect Red: The Life of Paraskeva Clark*. Toronto: Cormorant Books, 2009.

Lippard, Lucy. "Joyce Wieland: Watershed: Contradiction, Communication and Canada in Joyce Wieland's Work." In *Joyce Wieland*. Toronto: Art Gallery of Ontario / Key Porter Books, 1987.

Marter, Joan, ed. *Women of Abstract Expressionism*. Catalogue of Denver Art Museum. New Haven and London: Yale Press, 2016.

Mellin, Robert. *Newfoundland Modern: Architecture in the Smallwood Years, 1949–1972*. Montreal and Kingston: McGill-Queen's University Press, 2011.

Murray, Joan. *Canadian Art in the Twentieth Century*. Toronto: Dundurn Press, 1999.

O'Neill, Paul. *The Oldest City: The Story of St John's, Newfoundland*. Portugal Cove, NL: Boulder Publications, 2003.

Quinn, Bridget. *Broad Strokes: 15 Women Who Made Art and Made History (in That Order)*. San Francisco: Chronicle Books, 2017.

Pierson, Stuart. *Hard-Headed and Big-Hearted: Writing Newfoundland*. St. John's: Pennywell Books, 2006.

Pitt, David G. *E.J. Pratt: The Truant Years, 1882–1927*. Toronto: University of Toronto Press, 1984.

Pratt, Christopher. *Christopher Pratt: Personal Reflections on a Life in Art*. Toronto: Key Porter Books, 1995.

———— *Ordinary Things: A Different Kind of Voyage*. St. John's: Breakwater Books, 2009.

———— *a painter's poems*. St. John's: Breakwater Books, 2005.

———— *Thoughts on Driving to Venus: Christopher Pratt's Car Books*. Erin, ON: Porcupine's Quill, 2015.

Pratt, Christopher and Jay Scott. *The Prints of Christopher Pratt: 1958–1991; Catalogue Raisonné*. St. John's: Breakwater Books and Mira Godard Gallery, 1991.

Pratt, Mary. *A Personal Calligraphy*. Fredericton: Goose Lane Editions, 2000.

Reid, Dennis. *A Concise History of Canadian Painting, Third Edition.* Don Mills, ON: Oxford University Press, 2012.

Reid, Verna. *Women Between: Construction of Self in the Work of Sharon Butala, Aganetha Dyck, Mary Meigs and Mary Pratt.* Calgary: University of Calgary Press, 2008.

Renner, Rolf G. *Hopper.* Cologne: Taschen, 2011.

Riordon, Bernard, ed. *Bruno Bobak.* Fredericton: Goose Lane Editions / Beaverbrook Art Gallery, 2006.

Smee, Sebastian. *The Art of Rivalry: Four Friendships, Betrayals and Breakthroughs in Modern Art.* New York: Random House, 2016.

Silcox, David P. *Christopher Pratt: Personal Reflections on a Life of Art.* Toronto: Key Porter Books, 1995.

Silcox, David P. and Meriké Weiler, *Christopher Pratt.* Toronto: Prentice-Hall Canada, 1982.

Smart, Tom. *The Art of Mary Pratt: The Substance of Light.* Fredericton: Goose Lane Editions, 1995.

————*Christopher Pratt: Six Decades.* Toronto: Firefly Books, in association with the Art Gallery of Sudbury, 2013.

Sullivan, J.M. *Newfoundland Portfolio: A History in Portraits.* St John's: Jesperson Publishing, 2006.

Sullivan, Rosemary. *Labyrinth of Desire: Women, Passion, and Romantic Obsession.* Toronto: HarperFlamingo Canada, 2001.

Wine, Cynthia, with original watercolours by Mary Pratt. *Across the Table: An Indulgent Look at Food in Canada.* Toronto: Prentice Hall of Canada, 1986.

White, Marian Frances. *Not a Still Life: The Art and Writings of Rae Perlin.* St. John's: Killick Press, 1991.

Whitelaw, Anne, Brian Foss, and Sandra Paikowky, eds. *The Visual Arts in Canada: The Twentieth Century.* Don Mills, ON: Oxford University Press, 2010.

Zemans, Joyce. *Christopher Pratt: A Retrospective.* Vancouver: Vancouver Art Gallery, 1985.

Scholarly Publications

Armstrong, Jen. *Identifying the Other Woman: A Feminist Analysis of the History of the Female Nude in Canadian Art.* Research paper for master's degree, York University, 2004.

Buzzell, Judith E. *Mary Pratt.* Master's thesis. Concordia University, 1989.

Fyfe, Heather Dianne. *Mira Godard: Canada's Art Dealer.* Master's thesis (Art History). Concordia University, 2008.

Koval, Anne. *Mary Pratt: Still Life as Self-Portraiture.* The Artist Herself: Broadening
 Ideas of Self-Portraiture in Canada conference, Canadian Women Artists
 History Initiative (CWAHI), Queen's University, May 2015.

Mastin, Catherine. *Beyond the Artist's Wife: Women, Artist Couple Marriage and the
 Exhibition Experience in Postwar Canada.* Doctor of Philosophy in History,
 University of Alberta, 2012.

Schissel, Wendy. *Her Own "Frame of Reference": A Feminist Reading of Mary Pratt's
 Paintings.* Paper presented to Women's Studies Research Unit, University of
 Saskatchewan, 1991.

Stevens, Caroline. *Working Bodies: Feminist Alternatives to Passive Representation of
 "Feminine" Corporeality.* Master's thesis. Concordia University, 1996.

Documentaries

CBC-TV. "Infused with Light: A Journey with Mary Pratt." *Adrienne Clarkson
 Presents,* 1997.

Gregg, Andrew. "The Life and Times of Christopher and Mary Pratt." Directed,
 written, and produced by Andrew Gregg in association with the Canadian
 Broadcasting Corporation,1996.

Harvey, Kenneth J. *Immaculate Memories: The Uncluttered Worlds of Christopher
 Pratt.* Island Home Productions, 2018.

Rockburn, Ken. *Rockburn Presents Mary Pratt.* CPAC, July 2013.

Notes

Preface

1. John Berger, "Portraits: John Berger on Artists," *New York Times,* December 5, 2015.
2. Victoria Scott, panellist at The Rooms, discussing the Mary Pratt retrospective on May 15, 2013. The other panellists were Bernice Morgan and Bill Rose.
3. Simon Doonan, creative review of Veronica Kavass, *Artists in Love: From Picasso & Gilot to Christo & Jeanne-Claude; A Century of Creative and Romantic Partnerships* (New York: Welcome Books, 2012).
4. Zachary Heinzerling, dir., *Cutie and the Boxer*, documentary, 2013.
5. Robert Fulford, "Subject Lessons: Context Is Key to Power of the AGO's New Alex Colville Exhibition," *National Post*, September 23, 2014.
6. Bridget Quinn, *Broad Strokes: 15 Women Who Made Art and Made History (in That Order)* (San Francisco: Chronicle Books, 2017).

Chapter One

1. The Anglo-Newfoundland Development Company replicated little English towns in Grand Falls and Corner Brook for its employees. A.E. Harris, a British engineer who came to Newfoundland in 1907 to work in management in the pulp-and-paper industry, was a dedicated painter. Harris had mentored as a young boy Reginald Shepherd, who became one of Newfoundland's first professional visual artists.
2. Mary Pratt, *A Personal Calligraphy* (Fredericton: Goose Lane Editions, 2000), 134.
3. Christopher Pratt refers to his mother as "Christine," though her obituary calls her "Christina."
4. *A Personal Calligraphy*, 35–36.
5. Anne Collins, "In and Out of the Kitchen: Mary Pratt," *City Women*, Summer 1982, 61.
6. Christopher Pratt, *Thoughts on Driving to Venus: Christopher Pratt's Car Books* (Erin, ON: Porcupine's Quill, 2015), 115.
7. James Adams, "Pratt's Works Not What They Appear to Be," *Globe and Mail*, October 5, 2013, R7.
8. *Thoughts on Driving to Venus*, 173.
9. Mary Pratt, talk at Wilmot United Church, Fredericton, September 1999.
10. Author interview, Fredericton, August 5, 2013.
11. Author interview with Christopher Pratt, Salmonier, July 14, 2014.

Chapter Two

1. Collins, "In and Out of the Kitchen," 58.
2. Sandra Gwyn and Gerta Moray, *Mary Pratt* (Toronto: McGraw-Hill Ryerson, 1989), 7.
3. Harry Bruce, "A Rarer Reality," *Canadian Magazine*, November 26, 1977, 18–21.
4. After graduating from Dalhousie Law School, Woolridge returned to practise law first in St. John's and then in Corner Brook. He was made a judge in the Supreme Court of Newfoundland (Trial Division) in 1985.
5. *A Personal Calligraphy*, 20.
6. Christopher Pratt, *Ordinary Things* (St. John's: Break Water Books, 2009), 90.
7. Letter, November 1955.
8. H. Ruhemann and E.M. Kemp, *The Artist at Work* (Harmondsworth: Penguin Books, 1951).
9. Adolf Dehn, *Water Color Painting* (New York: Studio Publications, 1945).
10. Norman Kent, ed., *Watercolor Methods* (New York: Watson-Guptil Publications, 1955).
11. *Thoughts on Driving to Venus*, 82.

Chapter Three

1. E.J. took advantage of his brother's hospitality and spent days playing golf on courses around Liverpool. Before leaving for Toronto, Ned had to borrow money from both his brother and sister, as he had exhausted his budget. A decade later, when E.J. was doing research for his poem *The Titanic*, he enlisted the help of Art to undertake some research in England. Inspired by his older brother, Art tried his hand at writing and published his own book of poetry, *Bally Rot*, in 1948.
2. Letter, November 19, 1957, Newfoundland and Labrador Provincial Archives, The Rooms, Pratt Fonds MG-155, Box 17. "This is a disappointment as far as I am concerned because the main reason I came was to learn figures and oil."
3. Joyce Zemans, *Christopher Pratt: A Retrospective* (Vancouver: Vancouver Art Gallery, 1985), 13.
4. *Thoughts on Driving to Venus*, 28.
5. Zemans, *Christopher Pratt*, 13.
6. Letter, October 26, 1957, Pratt Fonds MG-155, Box 17.
7. Letter, Pratt Fonds MG-155, Box 17.
8. Letter, Pratt Fonds MG-155, Box 17.
9. *Ordinary Things*, 85.
10. Zemans, *Christopher Pratt*, 20.
11. Letter to parents, January 5, 1961, Pratt Fonds MG-155.

Chapter Four

1. Pratt Fonds.
2. *A Personal Calligraphy*, 130.
3. Letter to parents, November 30, 1960, Pratt Fonds MG-155, Box 17.
4. Christopher Pratt answering questions from Joyce Zemans, who was writing the catalogue for a Vancouver 1985 exhibition.
5. Peter Neary, ed., *White Tie and Decorations: Sir John and Lady Hope Simpson in Newfoundland, 1934–1936* (Toronto: University of Toronto Press, 1996).
6. Author telephone conversation with Christopher Pratt, August 19, 2015. In discussion about moving to Salmonier, he remembered the first morning had been sunny and he had gone outside and could hear Mary and the children talking in the kitchen. He remembers saying to himself, "Nobody is going to get me out of here."
7. Collins, "In and Out of the Kitchen," 60.
8. Author interview with Christopher Pratt, Salmonier, March 19, 2016.
9. Pratt Fonds MG 155, Press Clippings Box 11.
10. David Silcox, *Christopher Pratt: Personal Reflections on a Life in Art* (Toronto: Key Porter Books, 1995), 211.
11. *A Personal Calligraphy*, 36.
12. Letter from Alex Colville, January 3, 1964, Pratt Fonds MG-155, Box 27, #3.

Chapter Five

1. Sotheby's & Ritchies, Toronto, auction catalogue, February 25, 2002, Lot #140.
2. Author interview with John Pratt, Ottawa, June 3, 2014.
3. John Pratt, "On the Clampets," *Newfoundland Quarterly* 106, no. 1 (2013): 6–7.
4. *A Personal Calligraphy*, 28.
5. Author interview, November 17, 2015.

Chapter Six

1. Telephone conversation with author, May 16, 2018.
2. *Ordinary Things*, 28.
3. Author interview, March 19, 2016.
4. In the 1961 National Gallery of Canada Biennial Exhibition, 75 male and 6 female artists were selected; in 1963, 70 males and 8 females; in 1965, 79 males and 11 females; and in 1968, 64 males and 7 females.
5. Author interview, March 19, 2016.
6. David Silcox collaborated with Meriké Weiler to produce a limited edition book (279 copies) featuring 76 colour plates and 16 black and whites, as well as one original silkscreen. Published by Quintus Press, the edition had the best quality

of papers for the text and photographs, and the strip of leather around the book spine was goatskin, with all the binding done by hand. This book sold for $2,100, the equivalent of almost $5,000 in 2019. Buying the book as an investment has not yet proven to be a profitable project, however. One sold at Waddington's auction in 2016 for under $2,000.

7. Silcox, *Christopher Pratt*, 17.

8. Commercial art galleries are a relatively new institution, appearing in the nineteenth century first in Europe and then in North America. Originally, successful artists were supported by wealthy patrons, both religious and secular, while others were subsidized by family or eked out a mean existence. When Frenchman Paul Durand-Ruel branched out from selling art supplies to also marketing the works of Impressionist painters, others—Ambroise Vollard, Leo Castelli, Jacob Seligman and Peggy Guggenheim, to name only a few— followed suit, setting up commercial galleries in Europe and New York.

9. Mount Allison University, *Community News*, October 2016.

10. Harry Bruce, "Christopher Pratt: Magic as Reality," *Maclean's*, December 1973, 37.

Chapter Seven

1. Rae Perlin, *Evening Telegram* (St. John's), March 25, 1967.

2. Robin Laurence, "The Radiant Way," *Canadian Art*, Summer 1994.

3. Throughout her life, Pflug had been unsure of her talent, since she had little formal art training and to some extent relied on the instruction of her opinionated husband. With her daughters growing up and her husband showing his disappointment in what he perceived as a lack of public interest in his wife's art (even though Christiane's paintings sold out in her first show in 1962 at the Avrom Isaacs Gallery), she lost the will to live and committed suicide by pills on Toronto Island in April 1972.

4. Peter Bell, "Painters of Newfoundland," *Canadian Antiques Collector* 10, no. 2 (1975), quoted from Stan Dragland, *Gerald Squires* (St John's: Pedlar Press, 2017).

5. Catherine Mastin, *Beyond the Art's Wife: Women, Artist Couple Marriage and the Exhibition Experience in Postwar Canada*, PhD dissertation, University of Alberta, 2012, 99.

6. Other photorealist painters are the Americans Robert Bechtle, Charles Bell, Chuck Close, Robert Cottingham, Richard Estes and Audrey Flack.

7. Gwyn and Moray, *Mary Pratt*, 18.

8. Sarah Milroy, "A Woman's Life" in *Mary Pratt* (Fredericton: Goose Lane Editions and The Rooms Corporation of NL, 2013), 73.

9. Laurence, "The Radiant Way," 30.

10. *Ordinary Things*, 54.

11. Peter Wilson, "Fifteen Artists Have Captured the Flavor of Newfoundland,"
 Toronto Star, February 13, 1971. Kay Kritzwiser, "At the Galleries: Fresh New
 Works from the Unarrived," *Globe and Mail*, February 6, 1971.

12. Stephen Kimber, "Mary Pratt, artist" *Atlantic Insight*, September 1979. 24–26

13. Author telephone conversation with Mayo Graham, June 22, 2016.

14. Betty Friedan, *The Feminist Mystique* (New York: W.W. Norton and Co., 1963).

15. Robert Fulford, "There Is a Distinct Female Art, Insists Organizer of Women's
 Show," *Toronto Star*, December 6, 1975.

16. Harry Bruce, "The Fine Art of Familiarity: Mary Pratt Paints as She Lives—
 Close to Her Kitchen Sink," *Canadian Magazine*, November 29, 1975.

Chapter Eight

1. *Ordinary Things*, 58.

2. Silcox, *Christopher Pratt*, 185.

3. Zemans, *Christopher Pratt*, 44.

4. Christopher Pratt, *Ordinary Things*, 60.

5. Christopher Pratt was following a tradition established by the Dutch painter
 Rembrandt, one of the first men in Western art to start drawing regularly from
 nude models rather than copying sculptures from antiquity. In his Amsterdam
 studio around 1646, Rembrandt organized modelling sessions where he and his
 students sketched naked women and men. Rembrandt depicted his models just
 as they were and in direct, straightforward poses. The results, such as the pen-
 and-brush *Seated Female Naked Model* (c. 1661), presenting a fleshy older
 female, challenged the traditional representation of womanliness.

6. For a thorough scholarly discussion of Christopher Pratt's figurative work, see
 Joyce Zemans, "Artist and Model: The Figure" in *Christopher Pratt: A
 Retrospective* (Vancouver: Vancouver Art Gallery, 1985), 42–57; and Tom Smart,
 Christopher Pratt: Six Decades (Toronto: Firefly Books, in association with the
 Art Gallery of Sudbury, 2013).

7. Comment in catalogue *March Crossing: An Exhibition of Recent Screenprints,
 Related Collages and Stencil Proofs*, Mira Godard Gallery, Montreal and Toronto,
 1978.

8. In May 2009, No. 24 of the limited edition of twenty-five prints appeared in a
 Sotheby's Ritchies auction sale with an estimated price between $10,000 and
 $15,000. Surprisingly, it did not reach reserve price and so remained unsold.

9. Christopher Pratt and Jay Scott. *The Prints of Christopher Pratt: 1958–1991;
 Catalogue Raisonné* (St. John's: Breakwater Books and Mira Godard Gallery,
 1991), 17.

10. Zemans, *Christopher Pratt*, 64.

11. Scott, *The Prints of Christopher Pratt*, 63.

12. Unidentifed magazine article in Pratt Fonds MG-155, Box 12, Press Clippings, 1977.

13. *Ordinary Things*, 62.

14. *Thoughts on Driving to Venus*, 101.

Chapter Nine

1. The Mount Carmel kids clustered around Mr. Ted's were among the record-setting 73 million people tuned in that seminal evening.

2. *Ordinary Things*, 34.

3. Silcox, *Christopher Pratt*, 100.

4. Later he used the photograph to paint *Night Nude: Year of the Karmann Ghia*.

5. In my opinion, the most erotic and intimate work in his Donna oeuvre is *Summer of the Karmann Ghia* (1998), in which she is not nude but dressed in shorts and a white T-shirt. Posed on the passenger seat of his yellow sports car, she sits splay-legged with one arm holding up her head as she stares forward. There's a definite Lolita quality to her—a young, sensual girl.

6. Zemans, *Christopher Pratt*, 50.

7. *Ordinary Things*, 51.

8. Lawrence Sabbath, "Transmuting Reality: The Art of Christopher Pratt," *Chimo* 9, no. 1 (February/March 1986).

9. Julian Barnes, *Keeping an Eye Open: Essays on Art* (Toronto: Random House Canada, 2015), 122.

10. Prudence Heward's positioning of the girl against a disorienting cubist landscape background signified her protest at the barriers or "spaces of femininity" still facing Canadian women in the 1930s. Art historian Griselda Pollock coined the expression "spaces of femininity" to describe the idealized self-sacrifice of women for "hearth and home." Heward further pushed the limits by painting nude, black, working-class women such as *Dark Girl* (1935) and *Hester* (1937). These powerful works feature a young black woman seated at the base of a tree framed in a tropical landscape of lush, vibrant blues and verdant green.

11. Mary Pratt Interviewed by Mireille Eagan at McMichael Canadian Art Gallery, January 18, 2014.

12. Verna Reid, *Women Between* (Calgary: University of Calgary Press, 2008), 136.

13. David Livingstone, "The Wrought Irony of the Real World," *Maclean's*, July 6, 1981.

14. Interview with Marie Morgan, "Working at Home," *Banff Letters*, Spring 1985, 6.

15. Interview with Marie Morgan, "Working at Home," *Banff Letters*, Spring 1985, 9.

16. When Donna and her husband, Steve Haines, dropped in for a short visit to the author's cottage in Eastport, August 11, 2015, Donna stated her resentment that

Christopher had apologized to Mary for the affair but not to Donna. Steve added his disapproval of Christopher Pratt's behaviour.

Chapter Ten

1. Ann Johnston, "A Brooding Vision," *Maclean's*, September 21, 1981.
2. Johnston, "A Brooding Vision."
3. Johnston, "A Brooding Vision."
4. Mary Pratt diary, January 24, 1982 (2008.31/1/3/2).
5. Christopher Pratt, "Ranger" in *A Painter's Poems*, (St. John's: Breakwater Books, 2005), 30.

Chapter Eleven

1. Joan Murray, *ArtsAtlantic*, Spring 1979, 39.
2. Mary Pratt Interviewed by Mireille Eagan at McMichael Canadian Art Gallery, January 18, 2014. *Service Station*, shown at Toronto's Aggregation Gallery in 1978, is now owned by the Art Gallery of Ontario.
3. Barbara Yaffe, "Newfoundland's great flag debate grounded for at least six months," *Globe and Mail*, May 17, 1980.
4. *Mary Pratt* was exhibited in the London Regional Art Gallery; Mendel Art Gallery, Saskatoon; Glenbow Museum, Calgary; Art Gallery of Windsor; Art Gallery of Hamilton; Robert McLaughlin Gallery, Oshawa; The Gallery, Stratford; New Brunswick Museum, St. John; Beaverbrook Art Gallery, Fredericton; Memorial University Art Gallery, St. John's; and finally in Toronto at her dealer's Aggregation Gallery.
5. *Ordinary Things*, 54.
6. Johnston, "A Brooding Vision."
7. Christopher Hume, "An Innocence of Dreams," *Toronto Star*, November 24, 1984, M4.
8. John Bentley Mays, "Rock-Steady Hand Molds Nude Figures," *Globe and Mail*, May 15, 1982.
9. Christopher Pratt, cataloge: *Interiors*, Mira Godard Gallery, November 1984. The public did have an opportunity to see *Washstand*, since it had been displayed on an easel in the foreground of a John Reeves photo that accompanied a 1985 article in *Canadian Art*.
10. Reeves completed numerous projects, including *Portraits of (Canadian) Women 1974–77*, in which he took pictures of notable women across Canada from every walk of life. Amidst the half-dozen visual artists was Mary Pratt, sitting at her dining room table with long, curly, dark hair and big round glasses and a dreamy smile.

11. *Ordinary Things*, 60.

12. Marie Morgan, "Masculine/Feminine: Christopher and Mary Pratt," *Banff Letters*, Spring 1985, 3.

13. *Newfoundland Life Styles* 2, no. 2 (1984).

14. Gwyn and Milroy, *Mary Pratt*, 73.

15. Joan Murray, "Joan Murray Talking with Mary Pratt," *ArtsAtlantic*, Spring 1979.

16. Christopher Pratt, "You Came Into My Studio" in *A Painter's Poems*, (St. John's: Breakwater Books, 2005) 33.

Chapter Twelve

1. Christopher had used that particular clapboard wall in an earlier painting, *March Night* (1976).

2. Arnold Edinborough, "Christopher Pratt's hard-edged world," *Financial Post*, April 26, 1986.

3. Gary Michael Dault, "Christopher Pratt: Master of archetype or laureate of the middle way: A dramatic appraisal," *Canadian Art*, Winter 1985, 52. Nancy Beale, writing in *Canadian Forum*, November 1986, also mentioned the duality of the materiality of the painting and the immateriality of what it represented. She took *Whaling Station* (1983) as Christopher Pratt at both his simplest and most complex.

4. Kate Taylor. Retrospective forces self-evaluation on Pratt. *London Free Press*, February 22, 1986.

5. John Bentley Mays, "A New Pratt Emerges: This Is Not the Newfoundland of Getaway Fantasy," *Globe and Mail*, February 22, 1986, D15.

6. *Thoughts on Driving to Venus*, 70.

7. *Ordinary Things*, 94.

Chapter Thirteen

1. The pink sink came from Christopher's aunt's home in Bay Roberts, which he visited as a young man. He described the bathroom as "painted a sort of pubic-pink with black and white details and a pink sink under buzzing blue fluorescent lights." In Christopher's mind, this garish bathroom morphed into a "convent," with the colours emphasizing the inward focus and austerity of cloistered life.

2. Kenneth J. Harvey, *Immaculate Memories: The Uncluttered Worlds of Christopher Pratt*, 2018.

3. Christopher Pratt, "I Had Already Written Poetry for You" in *A Painter's Poems*, (St. John's: Breakwater Books, 2005), 37.

4. Mary Pratt diary, July 17, 1986 (2008.31/1/3/17).

5. Mary Pratt diary (2008.31/1/3/21), Red Hilroy notebook 1986-87.

Chapter Fourteen

1. Mary Pratt diary, August 8, 1986 (2008.31/1/3/17).
2. Cynthia Wine, *Across the Table: An Indulgent Look at Food in Canada* (Toronto: Prentice Hall, 1986).
3. Reid, *Women Between*, 44.
4. Laurence, "The Radiant Way," 35.
5. Other paintings by Mary Pratt in the period 1986–88 included *Student of Ancient Chinese Literature* (1986), *Donna with a Powder Puff* (1986), *Two Trout* (1986), *Child Bringing Flowers* (1987), *Venus from a Northern Pond* (1987), *Bedroom* (1987), *Paperwhites in Crystal on Tin Foil* (1988) and *Pomegranates in a Crystal Bowl* (1988).
6. Christopher Hume, "No Nonsense Pratt Tackles Flesh and Blood," *Toronto Star*, November 15, 1987.
7. Gwyn and Moray, *Mary Pratt*, 170.
8. In *Self-Portrait with Cropped Hair*, Kahlo has cut off her long black hair, is dressed in an oversized man's suit, likely Rivera's, and sits in a chair with a long hank of her hair held between her legs. Her biographer describes this work as an unforgettable image of anger and injured sexuality. Hayden Herrera, *Frida: A Biography of Frida Kahlo* (reprint, Harper Perennial, 2002), 278.
9. Christopher Hume, "Artist Goes from Fish to Fire," *Toronto Star*, December 12, 1989.
10. Canadian Broadcasting Corporation, "Infused with Light: A Journey with Mary Pratt," *Adrienne Clarkson Presents*, broadcast February 1997.

Chapter Fifteen

1. *Ordinary Things*, 87.
2. Mary Pratt diary, August 11, 1991.
3. *Thoughts on Driving to Venus*, 91.
4. *Thoughts on Driving to Venus*, 91.
5. Insights into Molly Bobak's thinking borrowed from the forthcoming book: Nathan Greenfield, *Scenes and a Marriage: The Lives and Art of Molly and Bruno Bobak* (Fredericton: Gooselane Editions, forthcoming [2020]).
6. Robin Laurence, "Pratt Falls," *BorderCrossing*, Spring 1996.
7. Kim Heinrich Gray, "Pratt Spat: What Art Reveals about Life," *Globe and Mail*, May 13, 1996.
8. Brian Bergman, "Mary Pratt: *Maclean's* Honour Role," *Maclean's*, December 22, 1997.
9. Nick Miliokas, "Artistic Partnership a Transformational Experience," *Regina Leader-Post*, September 27, 2004.

10. Comment beside the painting *Dinner for One* (1994), oil on canvas: "This is probably a cold chicken—bought from a supermarket—inside that casserole. And that plastic container holds some essential salad. Both of these things indicate a life lived alone. When I cooked for my family, I served from the kitchen. Plates were heaped with bright, hot meals. Meals were full of chatter and good times. And so this painting indicates a major change in my life. It's rather sad."

11. Christopher Pratt, *Ordinary Things*, 117.

Chapter Sixteen

1. Mark Vaughan-Jackson, "After the Fire . . . ," *Evening Telegram* (St. John's), November 25, 1994.

2. Vaughan-Jackson, "After the Fire. . . ."

3. Christopher Hume, "Christopher Pratt's New Work Rises from Studio Fire's Ashes," *Toronto Star*, October 13, 1993.

4. Christopher Hume, "Images of a Life Devoted to Art: Christopher Pratt Has Dedicated His Art to Celebrating 'the Power of Ordinariness,'" *Toronto Star*, November 12, 1995. In March 2017, one of these prints sold at auction for C$6,875.

5. Catalogue: "Artist's Statement. Pratt" Christopher Pratt at Mira Godard Gallery. A 30th Anniversary Exhibition, November 6-20, 1999. *Deer Lake: Junction Brook Memorial* was bought by Christopher Pratt collectors David and Margaret Marshall and donated to the National Gallery of Canada, where it hangs in the boardroom.

6. Welsh poet Dylan Thomas (1914–53) wrote "The Seed-at-Zero Shall Not Storm" in 1935. Thomas's lyrical, emotional poetry often celebrated nature.

7. Christopher selected the collage *Self-Portrait: Who Is This Sir Munnings?* as the cover of his book *Ordinary Things: A Different Kind of Voyage.*

8. *Thoughts on Driving to Venus*, 137.

9. Joan Murray, "*MD* Talks with Christopher Pratt," *MD*, October 1986.

10. Betty Ann Jordan, "The Lonely Journeys of Freud and Pratt," *Globe and Mail*, February 1, 1997.

11. Judy Stoffman, "Deep Freud Etchings," *Toronto Star*, February 13, 1997.

12. Michael Green, *Christopher Pratt*, catalogue for Marlborough Gallery, New York, December 1976.

13. Canadian Michael Snow, who spent a decade in New York in the 1970s, became known internationally for his work in numerous media, including installations, film, photography and painting. As recently as 2018, the Guggenheim Museum Bilbao, Spain, featured a Michael Snow exhibition titled *Closed Circuit*. The museum described Snow as "one of the towering figures of contemporary art."

14. Christopher Pratt, *Ordinary Things*, 91.

15. Participation in the Canadian pavilion of the Venice Biennale has eluded both Christopher and Mary Pratt. Being selected provides an artist with the opportunity to be seen by international public and commercial gallery representatives. Contemporaries such as Harold Town, Alex Colville, Ulysse Comtois, Michael Snow and Paterson Ewen have had their glory moments in Venice. The Pratts became lost amidst the burgeoning Canadian artists pushing the envelope with a wide range of media and experimentations.

16. Adrian Hill, *On the Mastery of Water-Colour Paintings: With Practical Demonstrations* (New York: Pitman, 1947).

17. Ralph Mayer, *The Artist's Handbook of Materials and Techniques* (London/New York: Faber & Faber, 1940).

Chapter Seventeen

1. Blake Gopnick, "Mary Pratt's Perfect Pictures," *Globe and Mail*, July 20, 1996.

2. In 2006, Mary received Newfoundland's Excellence in the Visual Arts "Long Haul Award," which recognized a substantial contribution to the visual arts, six years ahead of Christopher. It had been in recognition of her substantial role in establishing the St. John's art gallery The Rooms. Although Christopher had designed and donated the image for the Newfoundland flag, he did not receive his "Long Haul Award" until 2012.

3. In relating this tale to the author, Mary giggled as she admitted that some of the remarks she has made in public are "quite unforgivable—they just come out of my mouth." Author interview, June 4, 2014.

4. Information from Gisella Giacalone, owner/director of Mira Godard Gallery, in telephone conversation, March 23, 2019.

5. David Salle, "Outing the Inside," *New York Review of Books*, December 7, 2017, 58.

6. "Waging Culture: A Report on the Socio-Economic Status of Canadian Visual Artists" delved into the visual artists' sources of revenue, art practice expenses and time use. The original report covered the 2007 calendar year, but it was updated in 2012. It is the most comprehensive study of artists in Canada since the Statistics Canada Canadian Cultural Labour Force Study of 1993. Supported by the Art Gallery of York University, Toronto, the study was done by Michael Maranda.

7. Joyce Zemans and Amy C. Wallace, "Where Are the Women? Updating the Account!,"*RACAR* XXXVIII, no. 1 (2013). This study found that while the Art Gallery of Ontario had mounted seven exhibitions of contemporary male artists over a specific decade, only two exhibitions by female artists were mounted. In 2010 the NGC reintroduced the biennial to showcase recently

acquired contemporary art. The inaugural exhibition included 39 men artists and 19 women. In 2012, 34 were men and 11 women.

8. John Bentley Mays, "The House inside My Mother's House," *Globe and Mail*, June 1, 1995.

9. Mary Kubacki, "Mary Pratt Speaks Her Mind," *ArtsAtlantic*, Winter 1995.

10. Christopher Hume, "Mary Pratt Lives to Paint," *Toronto Star*, June 16, 1996.

11. J.M. Sullivan, "Mary's Light," *Evening Telegram* (St. John's), February 9, 1997.

12. *Survivors, In Search of a Voice: The Art of Courage.* After three months at the Royal Ontario Museum, the show travelled across Canada. However, the Art Gallery of Windsor, the National Gallery of Canada and the Art Gallery of Ontario declined to take the show on the basis of its sociological orientation and questionable curatorial direction.

13. Mary Pratt diary, February 9, 1996.

Chapter Eighteen

1. Rosen had twice been married. His first wife had been a teenage sweetheart from Detroit, and they had two daughters. With his second wife, Mignon, he had a son, Jeremy, now a successful executive in the social-media industry living in New York.

2. *A Personal Calligraphy*, 60.

3. MOCRA (Museum of Contemporary Religious Art) Voices Podcast, June 4, 2011. Interview of James Rosen by Father Terrence Dempsey on the exhibition *James Rosen and the Capable Observer*.

Chapter Nineteen

1. *Thoughts on Driving to Venus*, 184. Christopher later realized that he had been symbolically as well as literally pointed in the direction of the home of Alex and Rhoda Colville. Mira Godard appeared not to like this work, perhaps because it seemed to imitate Colville too closely.

2. Christopher Pratt, *Ordinary Things*, 127.

3. Joan Sullivan, "Caught in the Moment," *Telegram* (St. John's), June 26, 2015.

4. Catalogue "One Wave," The Rooms, 2018.

5. Cancer visited the Meehan family twice more, causing the deaths of two of her brothers, Casmir in 2012 and Dominic in 2014. In both instances Jeanette took an advocacy role with the medical system, which meant that she spent long hours at the hospital.

6. *Bollard: Admiral's Beach* (2013), *Breakwater at Green Island Brook* (2013), *Tub and Spool* (2013), *Reflection on a Wharf, Azalea* (2013), *Rhododendron, Christopher with Binoculars*.

7. *Driving to Venus*, 11.

Chapter Twenty

1. Christopher Pratt, "I Never Asked You Why" in *A Painter's Poems*, (St. John's: Breakwater Books, 2005), 58.
2. *Ordinary Things*, Prologue.
3. Written works about the Pratts also include hardcover catalogues. *Mary Pratt* has a cover of her iconic *Jelly Shelf* (1999) featuring her luminescent red and yellow colours and, inside, more than seventy-five of her best-known works. *The Places I Go*, the catalogue accompanying The Rooms' 2015 show, features works from ten years of Christopher's travels through Newfoundland.
4. *Thoughts on Driving to Venus*, 91.
5. *Thoughts on Driving to Venus*, 200.
6. Mary's theme was exotic fruits, with a variety of titles such as *A Glow of Grapes on Garnet Glass, Mangos on a Brass Plate* and *Pomegranates in a Dark Room*.
7. The show moved on to the Beaverbrook Gallery in Mary's hometown of Fredericton and the Art Gallery of Nova Scotia.
8. Robin Laurence, "Mary Pratt: Transformations," in *Simple Bliss: The Paintings and Prints of Mary Pratt*, catalogue of MacKenzie Art Gallery, Regina, 2004.
9. *Ordinary Things*, 137.
10. The author and her husband, Richard Gwyn, loaned *Bowl'd Banana* (1981).
11. Karen Pinchin, "A Woman's Work," *Globe and Mail*, July 17, 2013.
12. Interview with author, August 23, 2015, at Squires' home in Holyrood, NL. He died October 3, 2015.
13. Other works based on the Argentia theme included *American Monument: Radio Room, Argentia ca. 1999* (2005); and *Blue Iron Door: American Monument: The Ruins of Fort McAndrew—a.k.a. Argentia, Newfoundland* (2013).
14. The five donors were Gisella Giacalone, Margaret L. Marshall, R. Raso, W.J. Wyatt and Scott Campbell.
15. Russell Wangersky, "The Quiet Charming Revolutionary," *Telegram* (St. John's), August 18, 2018, B4.
16. Mary Pratt diary, November 4, 1991. Mary Pratt, *A Personal Calligraphy*, 93.
17. Christopher Pratt, "The Eider Ducks," in *A Painter's Poems*, (St. John's: Breakwater Books, 2005), 63.

Epilogue

18. *All My Own Work* catalogue, National Gallery of Canada, 2005, 114.
19. Sandra Gwyn, "The Newfoundland Renaissance," *Saturday Night*, April 1976.

Index

CAROL BISHOP-GWYN is a former arts producer at CBC Radio and journalist, published in *The Beaver, Toronto Life, Chatelaine, Maclean's* and *The Globe and Mail*. She holds a Master of Fine Arts from York University and Master of Philosophy from the University of Surrey. Summering in Newfoundland for over fifteen years, she developed a deep knowledge of the province's visual arts scene, along with an excellent general knowledge of Canadian visual arts. She is a board member of the Winterset in the Summer Literary Festival, and has invited writers, musicians and visual artists to participate. Her first biography, *The Pursuit of Perfection: A Life of Celia Franca*, was a finalist for the 2012 Governor General's Literary Award for Non-Fiction and the Charles Taylor Prize for Literary Non-Fiction, and named a *Globe* 100 best book of the year.